THE WORLD'S MOST SEDUCTIVE INSTRUMENT

GUITAR

DAVID SCHILLER

WORKMAN PUBLISHING · NEW YORK

CREDITS: David Arky: iv, 9, 41, 43, 125, 129, 137, 139, 140, 143, 190, 191, 199; Art Resource: Metropolitan Museum of Art 36, 37, 76, 77, 176; Courtesy B&G Guitars: 42; BACKBEAT UK: 1, 6, 9, 11, 13, 15, 22, 25, 33, 34, 35, 38, 39, 51, 52, 56, 57, 58, 59, 60, 64, 68, 69, 71, 90, 92, 96, 99, 102, 103, 104, 105, 107, 108, 109, 112, 116, 117, 122, 132, 133, 134, 136, 138, 141, 146, 150, 154, 155, 159, 160, 164, 165, 166, 168, 169, 173, 174, 178, 180, 185, 186, 187, 188, 192, 193, 203; Bashkin Guitars: 40, 191; Big Hollow Guitars: Todd Powell 195; Borghino Guitars: Battista Lazzarini 191, 206; Thomas Brummett: 18, 30, 79, 118, 151, 158; Collection Musée de la Musique: Jean-Marc Anglés 70; Country Music Hall of Fame: 54, 62, 85; Delta Haze Corporation: 4; Tony Duggan-Smith: 27; Elderly Instruments: 46, 75, 131, 126; Ernie Ball Music Man: 73; Experience Music Project: 45, 49, 66; Stanley Smith: 14, 28, 48, 82, 88, 119, 144, 149, 152, 198; Getty Images: Richard E. Aaron/Redferns 120; Erich Auerbach/Hulton Archives 177; Bettmann 86; Joseph Branston/*Guitarist* magazine 2; Danny Clinch/Contour 115; Donaldson Collection/Michael Ochs Archives 148; The Estate of David Gahr 53; Mat Hayward 72; Robert Knight Archive/Redferns 197; Elliott Landy 100; Mike Maloney/Mirrorpix 17; Larry Marano 32; Steve Morley/Redferns 61; Paul Natkin 128, 196; Michael Ochs Archives 81, 135, 163; Nigel Osbourne/Redferns 63, 74, 80, 107, 113, 121, 123, 130, 161, 175, 189, 204; Jan Persson/Redferns 184; David Redfern/Redferns 202; Jun Sato/Wirelmage 181; Roberto Serra-Iguana Press 93; Silver Screen Collection/Hulton Archive 44; Boris Spremo/*Toronto Star* 24, 170; Jesse Wild/*Guitarist* Magazine 87; Val Wilmer/Redferns 142; Gittler Instruments: 83; Greenfield Guitars: 98, Roger Aziz: 65; Jawbone Press: Nigel Osborne 106, 107, 127, 153; Joshia de Jonge Guitars: David Irvine 183, 190; Murray Kuun Guitars: 19; Lacey Guitars 106; William Laskin Guitars: 26, 190; Courtesy of Martin Guitar Archives: 12, 23; Joshua McClure: 55, 106; McPherson Guitars: 201; Museum of Pop Culture: 101; Marco Prozzo/Experience Music Project/Museum of Pop Culture 20; Ken Parker Archtops: 89, 191; Scott Peterson: 7, 21; Pensa Guitars: Vincent Ricardel 91; Olivier Pojzman: David Belzer 94, 114; Guitar Center 95, 97, 145, 156, 157, 194; Olivier Pojzman 31, 66, 67, 205; Prisma Guitars: 167; Tim Redman: 172, 190; RetroFret: 5; Ribbecke Guitar CD: Mark Grant 200; Ruokangas Guitars: 110, 111, 190; Santa Cruz Guitar Company 124; Smithsonian Institution: Division of Culture and the Arts, National Museum of American History 3, 16, 171; Solomon Guitars: Eliot Maine/George Barker Photography 147; Taylor Guitars 84; Carl Tremblay: 50, 66, 67, 78, 155, 179, 207; James Trussart Guitars: 10; Ulrich Teuffel: 29; Traugott Guitars: 47; Turnstone Guitar Company: 182, 191; Workman: EJ Devokaitis/Courtesy of the Allman Brothers Band Museum at the Big House and Scott Lamar 162; Kenneth Yu: iii.

Library of Congress Cataloging-in-Publication Data is available

ISBN 978-1-5235-0772-6

Design by Lisa Hollander
Front cover photo by David Arky
Photo wizardry by James Williamson
Photo research by Kenneth Yu
Typesetting by Barbara Peragine

Workman books are available at special discounts when purchased in bulk for premiums and sales promotions as well as for fund-raising or educational use. Special editions or book excerpts can also be created to specification. For details, contact the Special Sales Director at the address below or send an email to specialmarkets@workman.com.

INTRODUCTION

Four chords and ten picks ago, or so it seems, the Beatles arrived in America and sent a generation of kids, like me, into the waiting arms of music stores and guitar teachers. I can still remember sitting in a windowless practice room struggling with "Nowhere Man" on a cheap Kay archtop while my teacher, Mr. Mondillo, patiently listened. It not only seemed impossible; it seemed silly. These plodding chords had nothing to do with the Beatles. Besides, I'd started these lessons too late. While all my friends were forming and re-forming bands, saving up for new guitars and amps, trading licks, collecting albums, I was off to the side, reading books and dreaming about writing them.

Yet the Kay kept calling. Though it was the kind of guitar that your parents might buy if neither you nor they knew the first thing about guitars—long gone now, it looked a lot like the Martin R-17 on page 54—it did have two virtues: One, it was easy to play, with the fast, narrow neck and low action of an electric. But more important, it looked cool. No one else had anything like it. Where had it come from? Who made it? And why did it sound so...thin? Especially compared to my friend's jumbo Martin D-35?

Looking for answers to questions like these opened up a different side to the world of guitars—not the player's realm of riffs, chords, scales, and modes, but the beautiful universe of wood, strings, air, and magic. Of genius builders and tinkerers like Lloyd Loar and Leo Fender. Artisans and visionaries like C. F. Martin, John D'Angelico, Ken Parker, and Linda Manzer. And the eccentrics. So many eccentrics.

Because one of the first things to understand about the guitar, one of the things that makes it unique, is that it is not just another musical instrument. Unlike a piano, say, or a clarinet, the template is a work in progress.

THE AUTHOR'S GUITARS:

◀ A 2014 Kellycaster, built for the author by Rick Kelly at Carmine Street Guitars (see page 199) out of wood reclaimed from the renovation of Chumley's, a legendary former speakeasy (and now, post-renovation, a restaurant) in New York City's West Village.

▼ A Santa Cruz H-13, c. 2008, a model whose design was inspired by the 13-fret Gibson Nick Lucas that Bob Dylan played in the mid-1960s.

The principles are still being questioned, tested, experimented with, and improved upon. Wood whisperers, artists and sculptors, engineers, back-to-the-land makers, philosophers, inventors—and musicians of course—all have played, and continue to play, a role in the guitar's evolution. The very basics—like where to put the sound hole, or even whether to use one—are openly challenged, and the tiniest details, from what kind of glue is used to how many times to wind a pickup bobbin, seem forever up for debate.

This same sense of infinite possibility applies to the playing of the guitar, too. It was always the people's instrument, showing up in taverns, accompanying troubadours. It requires no special training. You don't even need to read music. A complete beginner could literally pick up a guitar and within a very short time, maybe only an hour if one has good hand-eye coordination, learn to play the simple three-chord progression that is the backbone of a gazillion popular songs. Try that with a cello! On the other hand, if the guitar really gets its hooks into you, you could spend a lifetime—multiple lifetimes—exploring what it, and you, can do. It plays harmony, melody, rhythm, and every scale imaginable from the basic major and minor to Egyptian pentatonic. (And that's before you explore open tunings.) It's so versatile, too, a quiet friend to sit alone with for hours, noodling, yet always at the ready to accompany any other instrument. It really plays well with others, especially with amplification.

▲ Continuing the Dylan theme—a Reissue '62 Fender Stratocaster, c. 2010, just like the guitar Dylan plugged in when he went electric at the 1965 Newport Folk Festival.

Finally, perhaps, what's most special about the guitar is the physical bond it creates. A guitar has a body. It has a voice. It has a look we can admire, show off, modify, identify with. Players can spend hours, days, a lifetime with it, cradled in our arms. We pack it up and carry it everywhere, and when we meet a fellow guitar lover, we can geek out and speak about guitars for hours. It's both universal, and deeply intimate, as ubiquitous as any other consumable (just walk into your local Guitar Center), and yet, transcendent. It even falls prey to the most believed-in romantic myth: "The one" is out there, just for you. But unlike said myth, no guitar lover ever needs to settle for just one! So turn the pages, and maybe you'll find your next true love . . .

Guitar

The Maltese Falcon of Guitars

..

MODEL: **NEW YORKER CUTAWAY SPECIAL, "THE TEARDROP"**
BUILDER: **D'ANGELICO, 1957**
TYPE: **ARCHTOP ACOUSTIC**

..

OF NOTE: Not only the most unusual guitar D'Angelico made, but also the fanciest, with its teardrop pickguard, curved bridge with the downward point, and six-ply binding • Extended fretboard on the treble side

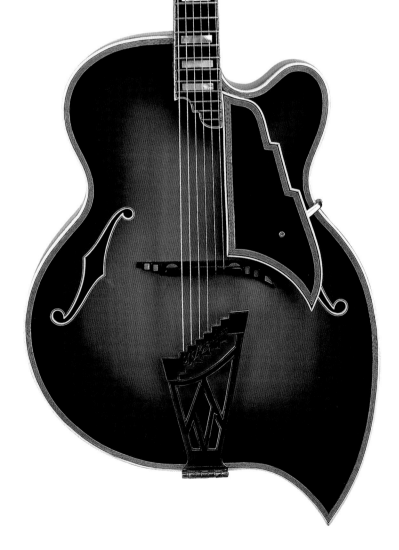

One day a local guitarist named Peter Girardi ("PG" on the headstock) walked into John D'Angelico's shop on the Lower East Side and asked him to build an instrument that would make his nightclub audiences really take notice. D'Angelico came up with an idea to extend the lower body in what he called a "can opener" shape. Years later, after hearing stories about this magical, mythical instrument, the collector Scott Chinery tracked it down—it had resurfaced at a Staten Island guitar store. Chinery scooped it up for the bargain price of $150,000 (he was offered $250,000 for it the very next day). But what really struck him, beyond the singular beauty of the guitar, was how the "teardrop" opened up the sound, creating one of the most powerful archtops he had ever played.

It Will, It Will Rock You

MODEL: **RED SPECIAL,**
 AKA "THE OLD LADY"
BUILDER: **BRIAN AND HAROLD MAY,**
 1963–1965
TYPE: **SEMI-SOLID-BODY ELECTRIC**

OF NOTE: Everything about this guitar is unique—the neck is made of wood from a fireplace mantel, buttons are used for the fret markers, the tremolo arm is fashioned out of a saddlebag holder and capped with a piece of a plastic knitting needle • Original handmade pickups were quickly replaced by a set of Burns Tri-Sonics • A "Brian May Back to the Light" promotional sixpence was added to the headstock

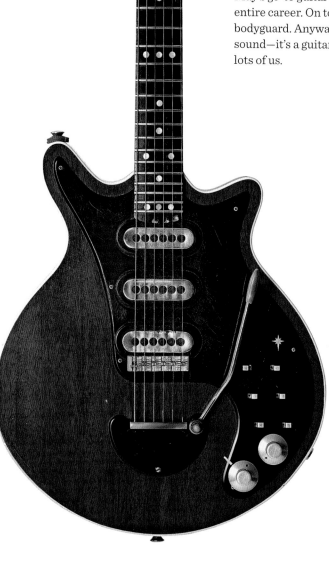

The story of Brian May's Red Special is a rock legend in its own right: an aspiring teenage musician who wanted a proper electric guitar that would "speak to him" . . . a family that couldn't afford to buy one . . . an engineer father who could build anything . . . and a brilliant son who was cruising toward a PhD in astrophysics before meeting a guy named Freddie Mercury. And though created out of makeshift materials found around the house, the fruit of this two-year project is a sophisticated, forward-looking, long-lived guitar as good as, if not better than, anything available commercially. The tremolo alone, built out of a knife-edge and valve springs from a 1928 motorcycle, is a work of genius. The Red Special is an unwavering presence in the life of its owner's music—it's been May's go-to guitar for virtually his entire career. On tour, it has its own bodyguard. Anyway, you know the sound—it's a guitar that speaks to lots of us.

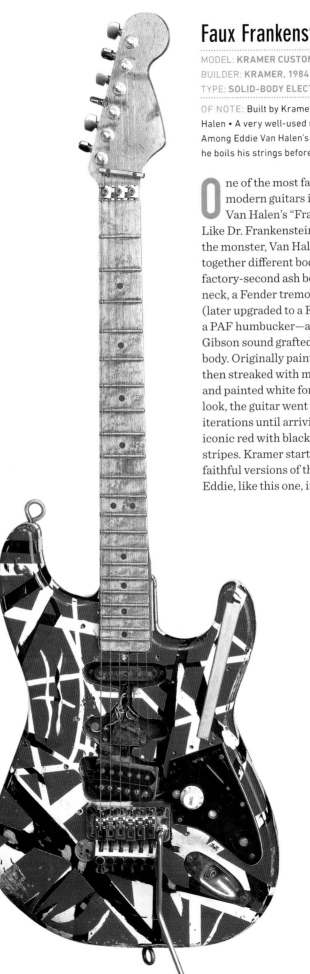

Faux Frankenstrat

MODEL: **KRAMER CUSTOM GRAPHIC**
BUILDER: **KRAMER, 1984**
TYPE: **SOLID-BODY ELECTRIC**

OF NOTE: Built by Kramer, owned by Van Halen • A very well-used neck • Not visible: Among Eddie Van Halen's idiosyncrasies, he boils his strings before using them

One of the most famous modern guitars is Eddie Van Halen's "Frankenstrat." Like Dr. Frankenstein creating the monster, Van Halen brought together different body parts—a factory-second ash body, a maple neck, a Fender tremolo system (later upgraded to a Floyd Rose), a PAF humbucker—and voilà: the Gibson sound grafted onto a Fender body. Originally painted black, then streaked with masking tape and painted white for its dynamic look, the guitar went through many iterations until arriving at this iconic red with black-and-white stripes. Kramer started building faithful versions of the guitar for Eddie, like this one, in 1984.

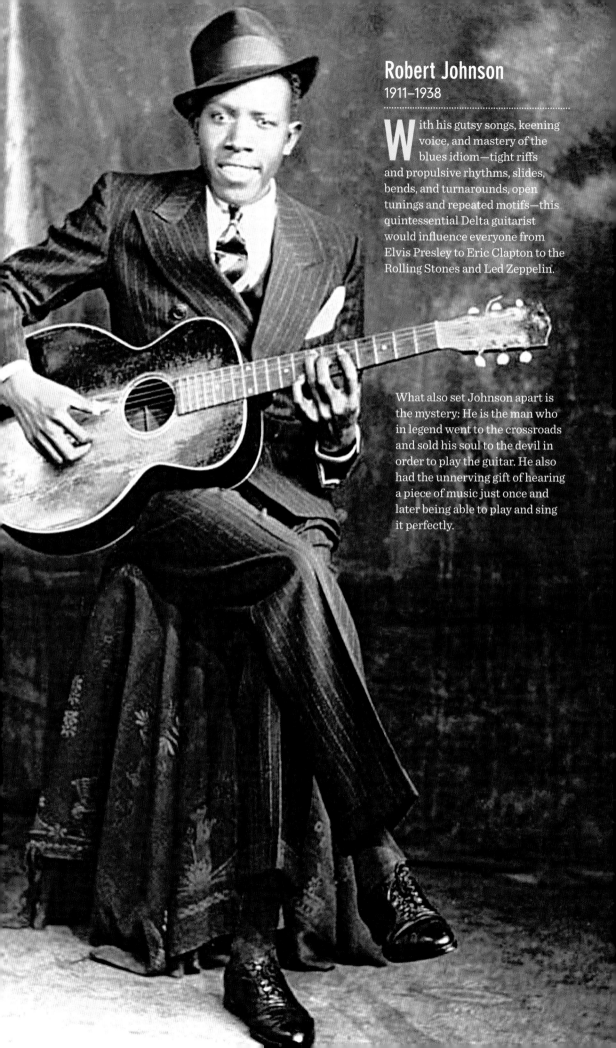

Robert Johnson
1911–1938

With his gutsy songs, keening voice, and mastery of the blues idiom—tight riffs and propulsive rhythms, slides, bends, and turnarounds, open tunings and repeated motifs—this quintessential Delta guitarist would influence everyone from Elvis Presley to Eric Clapton to the Rolling Stones and Led Zeppelin.

What also set Johnson apart is the mystery: He is the man who in legend went to the crossroads and sold his soul to the devil in order to play the guitar. He also had the unnerving gift of hearing a piece of music just once and later being able to play and sing it perfectly.

Blues Machine

MODEL: **L-1**
BUILDER: **GIBSON, C. 1928**
TYPE: **FLATTOP ACOUSTIC**

OF NOTE: Distinctive rounded lower bout
• Lack of a pickguard • Not visible: lack of
a truss rod and a crude system of cross
bracing whose main job seems to have
been to keep the top from falling off

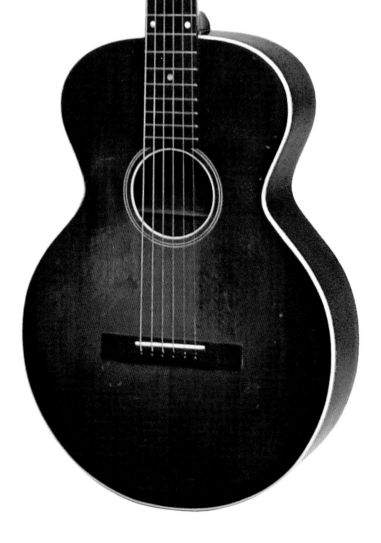

In 1925, Gibson discontinued its small-bodied L-1 archtop, then a year later reused the same designation to launch its flattop business with three affordable small-bodied guitars. These were the L-1 (pictured), the even cheaper L-0, and, a few years later, the 14-fret L-00. Gibson didn't get serious about its flattops until a few years later, when it launched the Nick Lucas (page 118). Still, history played a hand too—in one of the only two known photographs of legendary blues player Robert Johnson (opposite), he's clearly seen holding an L-1, forever imbuing this little guitar with a special significance.

"As Many Strings as Possible"

MODEL: **PIKASSO II**
BUILDER: **LINDA MANZER, 1995**
TYPE: **FLATTOP ACOUSTIC**

OF NOTE: Forty-two strings, four necks, two sound holes, and two ports, not visible • It took approximately 1,000 hours (two years) to build, and when all strings are tuned to concert pitch, the body is under 1,000 pounds of pressure

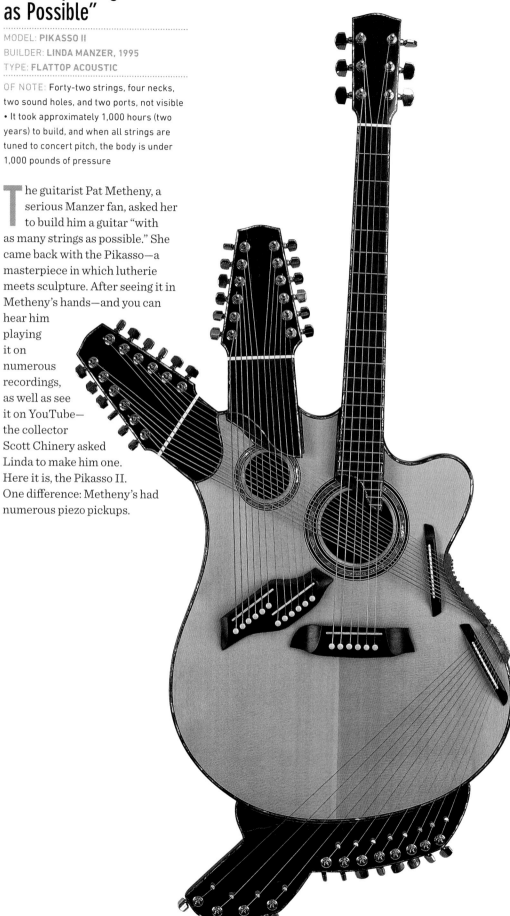

The guitarist Pat Metheny, a serious Manzer fan, asked her to build him a guitar "with as many strings as possible." She came back with the Pikasso—a masterpiece in which lutherie meets sculpture. After seeing it in Metheny's hands—and you can hear him playing it on numerous recordings, as well as see it on YouTube— the collector Scott Chinery asked Linda to make him one. Here it is, the Pikasso II. One difference: Metheny's had numerous piezo pickups.

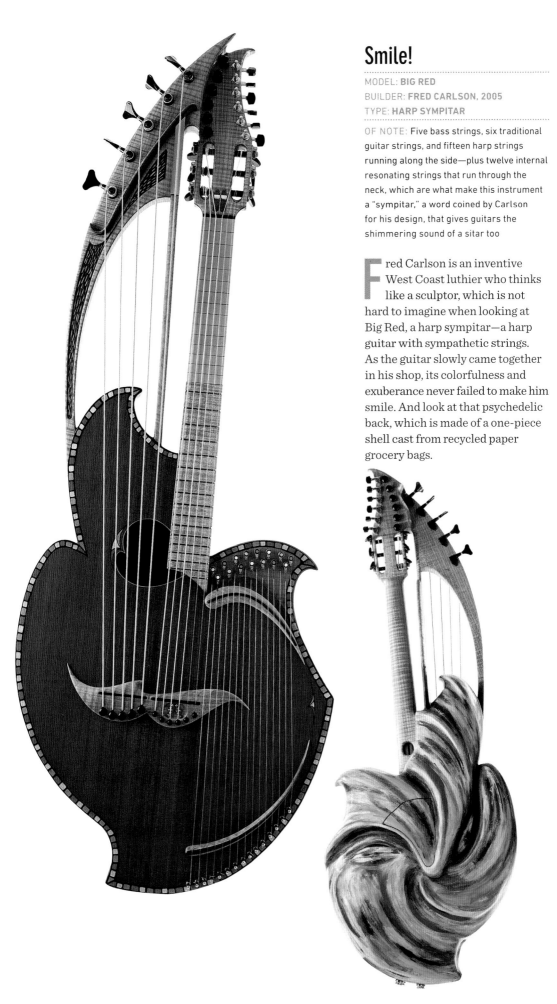

Smile!

MODEL: **BIG RED**
BUILDER: **FRED CARLSON, 2005**
TYPE: **HARP SYMPITAR**

OF NOTE: Five bass strings, six traditional guitar strings, and fifteen harp strings running along the side—plus twelve internal resonating strings that run through the neck, which are what make this instrument a "sympitar," a word coined by Carlson for his design, that gives guitars the shimmering sound of a sitar too

F red Carlson is an inventive West Coast luthier who thinks like a sculptor, which is not hard to imagine when looking at Big Red, a harp sympitar—a harp guitar with sympathetic strings. As the guitar slowly came together in his shop, its colorfulness and exuberance never failed to make him smile. And look at that psychedelic back, which is made of a one-piece shell cast from recycled paper grocery bags.

SOUNDING OFF

What makes a guitar sound like a guitar? On the one hand, it's pretty simple. For an acoustic **FLATTOP**, strings are stretched tight and anchored over a resonant wooden "box" and vibrate when plucked. The vibrations are transmitted by the bridge to the guitar top, which in turn causes the top to start moving. This thin piece of wood, usually spruce, is responsible for up to 90 percent of a guitar's tone, presence, sustain, volume, and all the other fun words used to describe the sound of an individual note or instrument. On the other hand, it's pretty complicated when you factor in all the construction choices that affect the sound: the type and quality of the tone woods for the top, back, and sides, the bracing pattern and types of braces, the position of the bridge, the glue used, ad infinitum.

ANATOMY OF A GUITAR

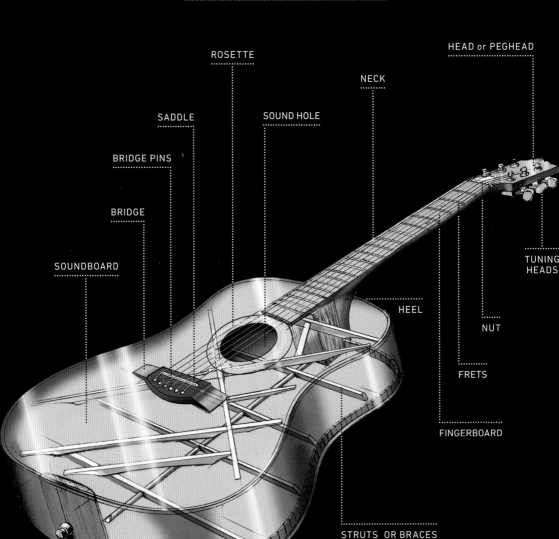

ROSETTE

HEAD or PEGHEAD

NECK

SADDLE

SOUND HOLE

BRIDGE PINS

BRIDGE

SOUNDBOARD

TUNING HEADS

HEEL

NUT

FRETS

FINGERBOARD

STRUTS OR BRACES

With its design adapted from the violin family, an **ARCHTOP** works somewhat differently. The top and back are carved out of thick boards, f-holes are traditionally used in place of a single round hole, two parallel tone bars brace the top, and the strings are not anchored but rather draped over the bridge and held by a tailpiece. When played, the soundboard moves up and down and the pressure is implosive, forcing the body in on itself.

The **ELECTRIC GUITAR**, of course, derives its sound from the pickup and how the rest of the guitarist's rig—amps and effects—processes it. The type of body (solid, hollow, semi-hollow) and wood used contribute to sustain, feedback, and some tone, but it's really all about those little wires. Here are the basic pickups:

Basic Pickups

"Charlie Christian"

Introduced in the mid-1930s, this bar pickup produces a clear, powerful jazz tone, named after guitarist Charlie Christian (see pages 148–149).

Fender Single-Coil

Leo Fender used six magnetic pole pieces, one for each string, with a "single coil" of wire

Single-coil pickup

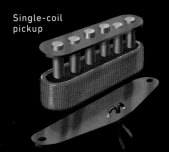

running around them, resulting in a bright, punchy sound that can veer to "ice pick" on the treble end.

Gibson P-90

Gibson's beefier version of the single coil, with a rich but bright sound

Humbucker

Single-coil pickups hum—they're like antennas, picking up disturbances and converting them into a 60-cycle hum, aka noise. In 1954, Seth Lover invented the dual-coil, noise-canceling—"buck the hum"—pickup, resulting in the darker, fatter, bluesier sound of a Les Paul.

Piezo

Piezo electric transducers use crystals or ceramic to register small changes in pressure produced by the strings. They're mounted directly under the bridge and are used more often for acoustic guitars.

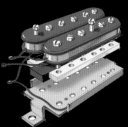

Humbucker pickup

9

Sexy Beast

MODEL: **DELUXE STEELCASTER**
BUILDER: **TRUSSART, 2014**
TYPE: **SOLID-BODY ELECTRIC**

OF NOTE: Body made of hollow steel, which was then allowed to rust • Retro seafoam-green-on-cream paint, weathered knobs, and a Bigsby that looks like it was recovered from a guitar from the '50s • Engraved rose pickguard

Wired magazine called the Trussart Deluxe Steelcaster a "zero-bullshit music machine." It jumps to life in the hands, like a Telecaster on steroids—which explains why some of those Trussart-playing hands belong to a pantheon of guitarists and musicians including Keith Richards, Bob Dylan, Tom Morello, Eric Clapton, Joe Perry, Lucinda Williams, and Billy F. Gibbons, who gave Trussart guitars the nickname "Rust-O-Matics." As for his aesthetic choices, James Trussart—a French-born musician turned LA-based luthier—says, "I wanted to make a guitar that came with a history and a slight element of neglect, of decay, so it had a personality of its own."

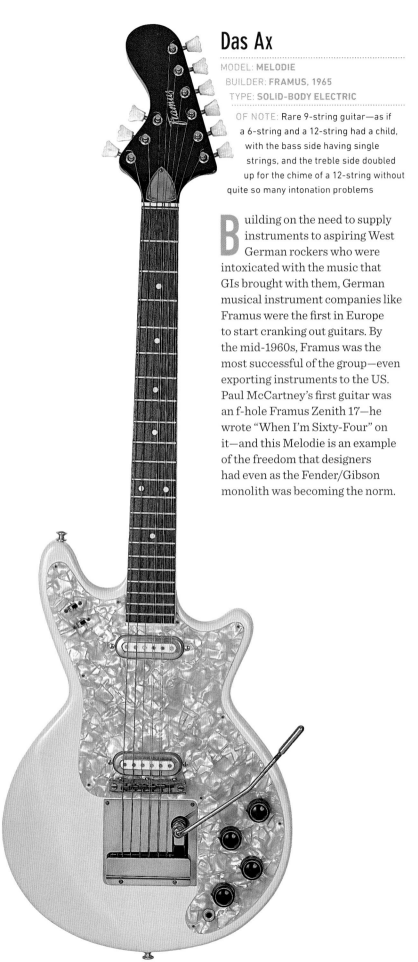

Das Ax

MODEL: **MELODIE**

BUILDER: **FRAMUS, 1965**

TYPE: **SOLID-BODY ELECTRIC**

OF NOTE: Rare 9-string guitar—as if a 6-string and a 12-string had a child, with the bass side having single strings, and the treble side doubled up for the chime of a 12-string without quite so many intonation problems

Building on the need to supply instruments to aspiring West German rockers who were intoxicated with the music that GIs brought with them, German musical instrument companies like Framus were the first in Europe to start cranking out guitars. By the mid-1960s, Framus was the most successful of the group—even exporting instruments to the US. Paul McCartney's first guitar was an f-hole Framus Zenith 17—he wrote "When I'm Sixty-Four" on it—and this Melodie is an example of the freedom that designers had even as the Fender/Gibson monolith was becoming the norm.

Separated at Birth

MODEL: **N-20, "TRIGGER"**
BUILDER: **MARTIN, 1969**
TYPE: **FLATTOP ACOUSTIC**

OF NOTE: The "maw"—as a nylon-string classical guitar, the N-20 wasn't intended to be played with a pick, and Nelson's years and years of performing simply wore it out • Baldwin pickup rescued from Trigger's predecessor • Beginning with Leon Russell, some one hundred friends and artists have signed the guitar

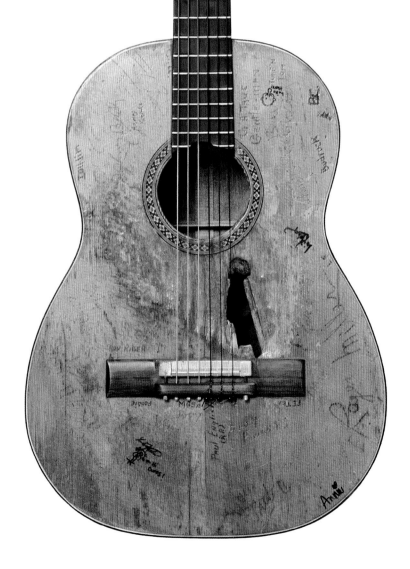

Probably no guitar in the world is as famous and beloved as Willie Nelson's "Trigger," a Martin N-20. The N-20 was Martin's foray into the classical guitar market, a Spanish-style, nylon-stringed instrument. Willie bought it in 1969, sight unseen, for $750, right after a drunk stepped on and destroyed his Baldwin acoustic, and he's been playing it exclusively ever since. Trigger has appeared in more than ten thousand shows, recording sessions, jams, and guitar pulls, and is completely inseparable from the iconic songwriter, guitarist, and singer. The name came much later: "Roy Rogers had a horse named Trigger. I figured, this is my horse!"

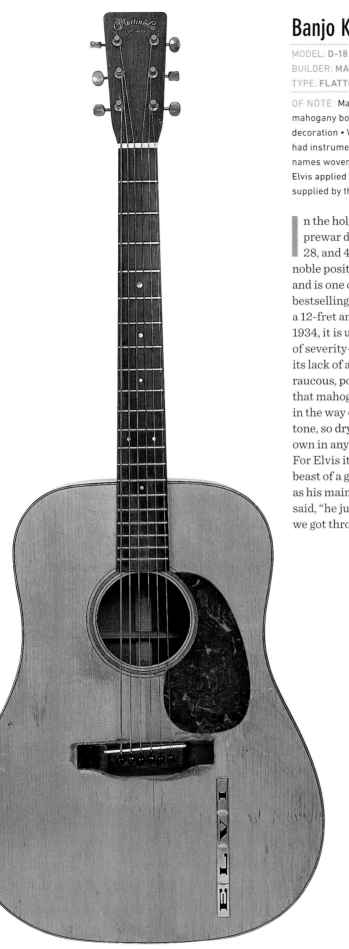

Banjo Killer

MODEL: **D-18**
BUILDER: **MARTIN, 1942**
TYPE: **FLATTOP ACOUSTIC**

OF NOTE: Martin's Style 18 indicates a mahogany body with spruce top and spare decoration • Whereas the big country stars had instruments custom-made with their names woven into the fretboard or body, Elvis applied his name with stick-on letters supplied by the store to customize the case

In the holy trinity of Martin prewar dreadnoughts—the 18, 28, and 45—the D-18 holds the noble position of base instrument and is one of the company's bestselling models. Introduced as a 12-fret and converted to a 14 in 1934, it is unadorned to the point of severity—almost Shaker-like in its lack of appointments—but has a raucous, powerful voice. And with that mahogany body, nothing gets in the way of the pure delivery of tone, so dry and open it can hold its own in any group, banjos included. For Elvis it meant having a perfect beast of a guitar to play rhythm. Or, as his main guitarist, Scotty Moore, said, "he just kept beatin' on it till we got through the set."

Far Ahead of Its Time

MODEL: **VIVI-TONE ELECTRIC GUITAR**
BUILDER: **VIVI-TONE, C. 1933**
TYPE: **SOLID-BODY ELECTRIC**

OF NOTE: Another missing link in the evolution of the solid-body "Spanish-style" electric guitar—i.e., a guitar that derives its sound entirely and exclusively from electricity • Those f-holes—they're painted on • Not visible: beams bolted onto the flat back

Lloyd Loar was an internationally known mandolinist by the age of twenty when he came to Gibson with ideas for improving their mandolins. Gibson signed him on, and for the next five years, he blazed a path of greatness, introducing iconic instruments like an F-5 mandolin and L-5 guitar. He eventually left Gibson and in 1933 founded Vivi-Tone, where he explored his most offbeat ideas, including this visionary single-plank electric.

Don't Sweat It

MODEL: **GUITAR ORGAN**
BUILDER: **GODWIN, 1976**
TYPE: **HOLLOW-BODY GUITORGAN**

OF NOTE: Sixteen mini-toggle switches for the organ, including Sustain, Percussion, Flute, Strings, Trumpet, Oboe, and more • Six "sound holes"—the "S" on the bass side, and five minis under the strings, each covered in mesh

As the electric guitar found its place and started changing popular music, guitarists (and the listeners who loved their music) began craving ever more interesting and expressive sounds. Pedals were one way to go. Another was to change the nature of the guitar itself—mate it, as in this example, with an organ. From Sisme, the Italian owner of Godwin organs, came this magnificent instrument, a hybrid guitar-organ with complicated controls. It featured wired frets divided into six segments so that contact with the individual strings completed a special circuit and opened up a world of sounds and sustain. Some have described it as sounding close to a Hammond B3 organ. But everything had to be kept pristine. A little sweat from the player, and next thing there would be crackling interference.

Uniquely Prince

MODEL: **YELLOW CLOUD**
BUILDER: **DAVE RUSAN/KNUT-KOUPEE ENTERPRISES, 1989**
TYPE: **SOLID-BODY ELECTRIC**

OF NOTE: All the metal hardware is gold colored, including the tuners, knobs, and nut and truss cover • Two EMG pickups, a single coil on the neck, and humbucker on the bridge • Black fret markers using the simplified Prince spade symbol

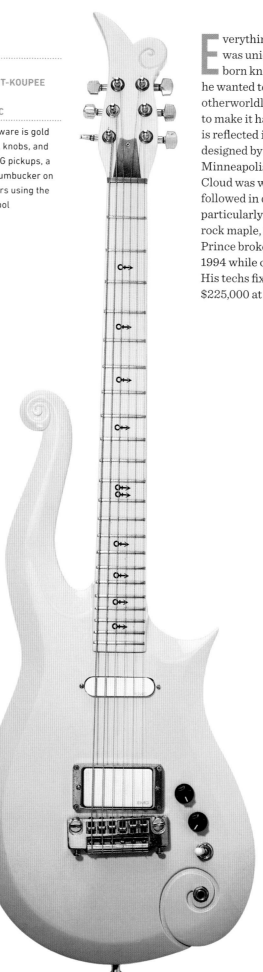

Everything about Prince was unique, as if he were born knowing exactly what he wanted to do, and had the otherworldly talent, focus, and will to make it happen. A little bit of that is reflected in his "Cloud" guitar, designed by Prince and built by a Minneapolis music shop. The first Cloud was white, and four others followed in different colors. Though particularly heavy, with bodies of rock maple, they took a beating— Prince broke the neck of this one in 1994 while on a French TV show. His techs fixed it . . . and it fetched $225,000 at auction in 2018.

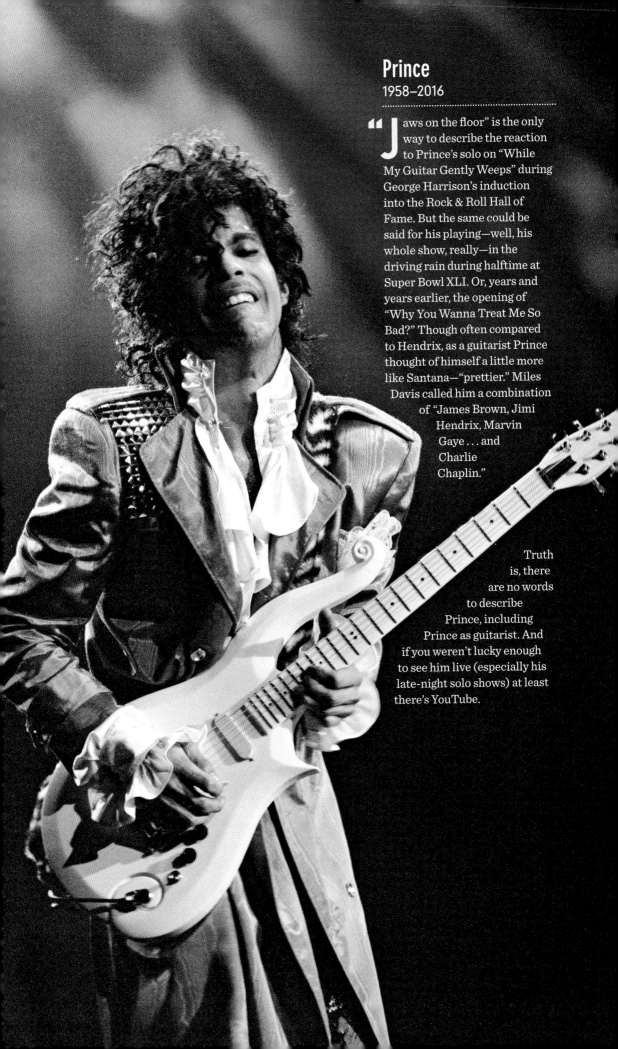

Prince
1958–2016

"Jaws on the floor" is the only way to describe the reaction to Prince's solo on "While My Guitar Gently Weeps" during George Harrison's induction into the Rock & Roll Hall of Fame. But the same could be said for his playing—well, his whole show, really—in the driving rain during halftime at Super Bowl XLI. Or, years and years earlier, the opening of "Why You Wanna Treat Me So Bad?" Though often compared to Hendrix, as a guitarist Prince thought of himself a little more like Santana—"prettier." Miles Davis called him a combination of "James Brown, Jimi Hendrix, Marvin Gaye . . . and Charlie Chaplin."

Truth is, there are no words to describe Prince, including Prince as guitarist. And if you weren't lucky enough to see him live (especially his late-night solo shows) at least there's YouTube.

Original Archtop

MODEL: **STYLE O**

BUILDER: **GIBSON, 1920**

TYPE: **ARCHTOP ACOUSTIC**

OF NOTE: Florentine scroll on the non-cutaway side • Extended fingerboard on the treble side • Distinctive Gibson circular lower bout

Working out of a 10'-by-12' shop in Kalamazoo, Michigan, the eccentric musical inventor Orville Gibson applied violin-making techniques to guitars, mandolins, and a variety of hybrid instruments. The crux of the matter was using a top carved into an arched shape, like a violin's, rather than flat and heavily braced, like a typical Martin, an innovation that allowed the top to be strong and self-supporting. This Style O—"O" refers to the oval sound hole—is a direct descendant of Gibson's original carved-top guitar, and a stylistic sibling to Gibson's fancy F-style mandolin. The Style O lasted from its introduction in 1908–1909 until a few years after the advent of the epoch-making L-5 in 1922.

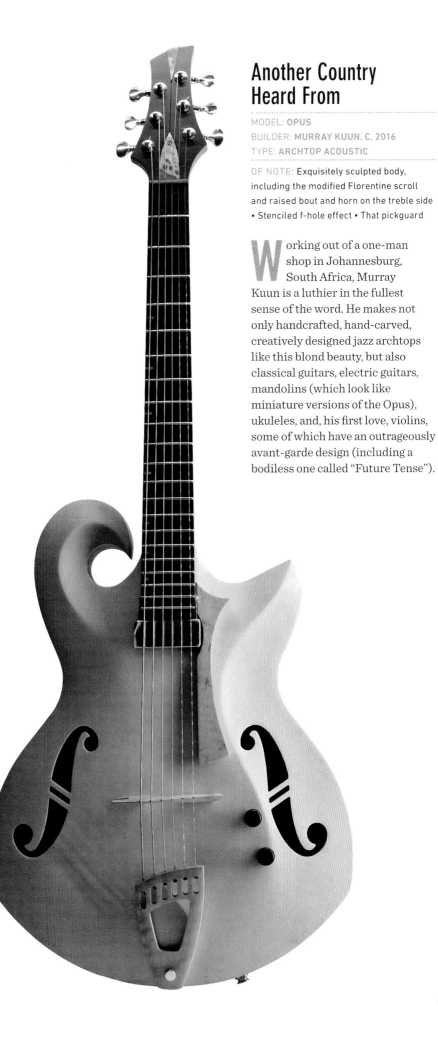

Another Country Heard From

MODEL: **OPUS**
BUILDER: **MURRAY KUUN, C. 2016**
TYPE: **ARCHTOP ACOUSTIC**

OF NOTE: Exquisitely sculpted body, including the modified Florentine scroll and raised bout and horn on the treble side • Stenciled f-hole effect • That pickguard

Working out of a one-man shop in Johannesburg, South Africa, Murray Kuun is a luthier in the fullest sense of the word. He makes not only handcrafted, hand-carved, creatively designed jazz archtops like this blond beauty, but also classical guitars, electric guitars, mandolins (which look like miniature versions of the Opus), ukuleles, and, his first love, violins, some of which have an outrageously avant-garde design (including a bodiless one called "Future Tense").

More Volume!

MODEL: **STYLE 4 TRICONE**
BUILDER: **NATIONAL, 1928**
TYPE: **RESONATOR ACOUSTIC**

OF NOTE: Nickel-plated "German silver," an alloy of nickel, copper, and zinc—this one, which belonged to bluesman Tampa Red, was originally gold-plated, giving him one of his nicknames, "The Man with the Gold Guitar" • The chrysanthemum design signifies National's top-of-the-line model • Tampa Red's name is engraved on the lower bout

George Beauchamp was a Texas-born vaudeville performer who played Hawaiian guitar in his act, and like many players of his time, he had one wish: more volume! But he also had an idea—hook up a guitar with the kind of horn used in early phonographs. He took this brainstorm to the Los Angeles–based inventor John Dopyera, who solved it by using a different part of phonograph amplification—the cone of a speaker. In 1927, Dopyera patented the three-cone configuration—three spun-metal cones in the body joined by a T-shaped bar to convey vibrations from the strings to the cones—that would give birth to the iconic resonator guitar.

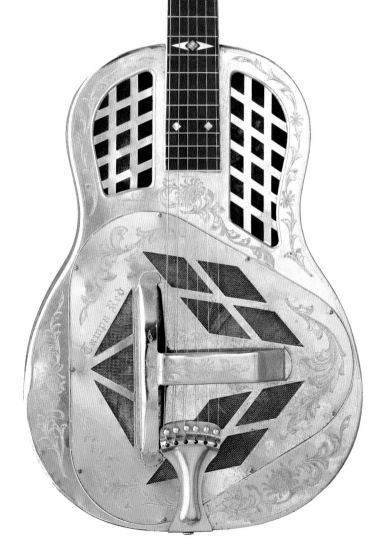

Take a Bite

MODEL: **NORMAN FORBIDDEN FRUIT**
BUILDER: **PAUL NORMAN, 2005**
TYPE: **12-STRING RESONATOR**

OF NOTE: Snake made of lacewood, curly and burled maple, and tiger-eye eyes • Oversize headstock with apple inlay • On the upper left, "rattle" port to give more air to the body

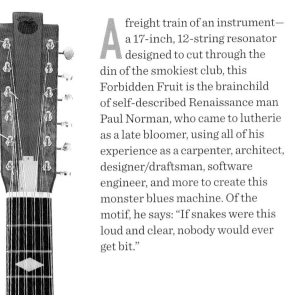

A freight train of an instrument—a 17-inch, 12-string resonator designed to cut through the din of the smokiest club, this Forbidden Fruit is the brainchild of self-described Renaissance man Paul Norman, who came to lutherie as a late bloomer, using all of his experience as a carpenter, architect, designer/draftsman, software engineer, and more to create this monster blues machine. Of the motif, he says: "If snakes were this loud and clear, nobody would ever get bit."

"The Very Best Guitar Money Can Buy"

MODEL: **WASHBURN "BELL" STYLE 5271**
BUILDER: **LYON & HEALY, C. 1929**
TYPE: **FLATTOP ACOUSTIC**

OF NOTE: Ornamentation on the top •
No-name, logo-less slotted headstock •
No pickguard, and a lot of scratchy wear
on the treble side

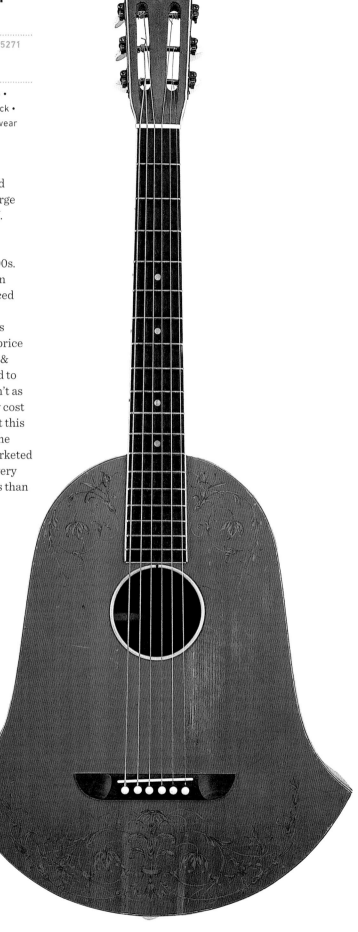

F ounded by Oliver Ditson,
a Boston music dealer, and
two of his associates, George
Washburn Lyon and Patrick J.
Healy, Lyon & Healy was one
of the world's largest guitar
manufacturers by the late 1800s.
Unlike Martin or Gibson, Lyon
& Healy proudly mass-produced
its guitars, many under the
Washburn name, and for years
offered instruments in every price
range. But by the 1920s, Lyon &
Healy's reputation had started to
slide—their guitars just weren't as
good as a Martin, and actually cost
more. One move to counteract this
downturn was the launch of the
upscale Bell, a $195 guitar marketed
to the player who craved the very
best. The model lasted for less than
four years.

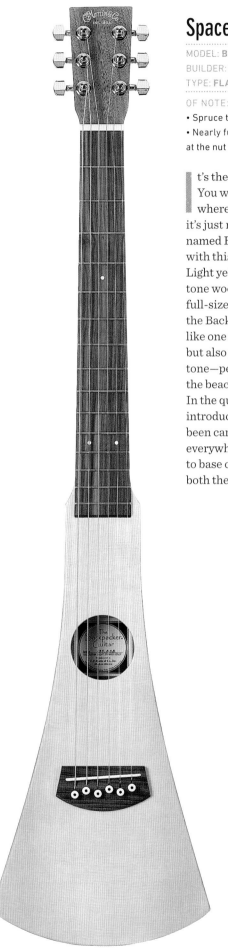

Space Guitar—Literally

MODEL: **BACKPACKER**
BUILDER: **MARTIN, EARLY 1990s**
TYPE: **FLATTOP ACOUSTIC**

OF NOTE: Distinctive psaltery body shape
• Spruce top and mahogany back and sides
• Nearly full-size neck with full 1^{11}⁄$_{16}$" width
at the nut

It's the guitar lover's dilemma: You want an instrument with you wherever you go, but many times it's just not practical. A designer named Bob McNally came up with this radically clever solution. Light yet rugged, made with real tone woods and featuring a nearly full-size neck with a 24-inch scale, the Backpacker® not only plays like one of your guitars at home, but also produces a pretty good tone—perfect for a sing-along on the beach or around the campfire. In the quarter century since Martin introduced the Backpacker, it's been carried and played just about everywhere, from the space shuttle to base camp on Mount Everest to both the North and South Poles.

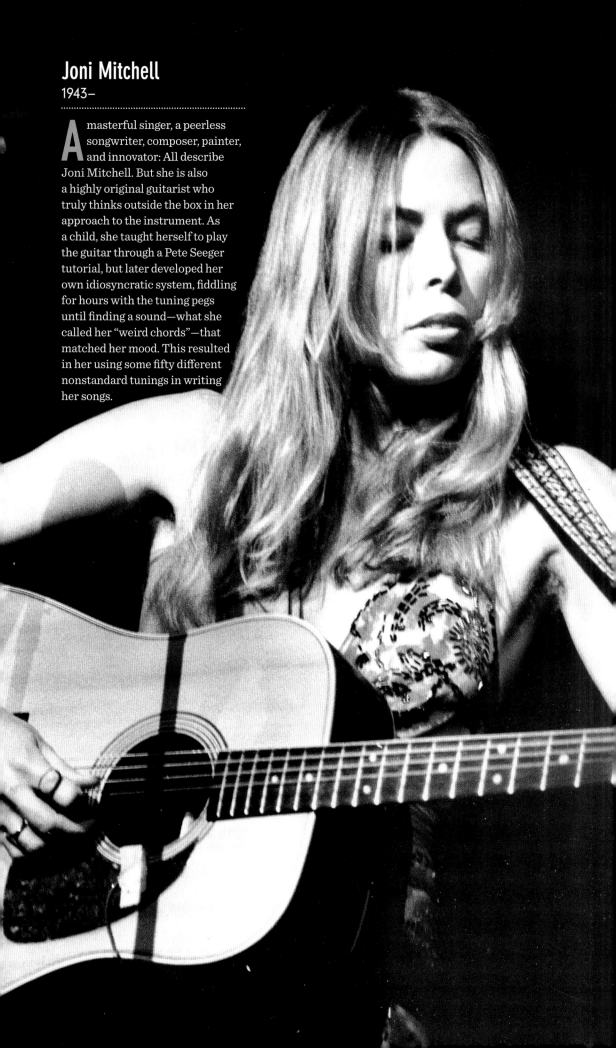

Joni Mitchell
1943–

A masterful singer, a peerless songwriter, composer, painter, and innovator: All describe Joni Mitchell. But she is also a highly original guitarist who truly thinks outside the box in her approach to the instrument. As a child, she taught herself to play the guitar through a Pete Seeger tutorial, but later developed her own idiosyncratic system, fiddling for hours with the tuning pegs until finding a sound—what she called her "weird chords"—that matched her mood. This resulted in her using some fifty different nonstandard tunings in writing her songs.

The Power of Pure Bone

MODEL: **D-28**
BUILDER: **MARTIN, 1941**
TYPE: **FLATTOP ACOUSTIC**

OF NOTE: The D-28 was introduced in 1931—this instrument, built in 1941, with a Brazilian rosewood body and Adirondack spruce top, is the last of the highly covetable prewar D-28s, as World War II irrevocably forced changes in materials and production • That subtle yet so meaningful herringbone—"bone"—trim

In 1916, Martin built the first dreadnought, a big-bodied guitar fancifully named after a German battleship, in collaboration with the guitar department at the New York outpost of Oliver Ditson & Co. Martin made them for a number of years, though the model mostly languished. Then in the early 1930s, Martin dusted off its original paper pattern to meet the same recurring need—how to produce a powerful, versatile flattop with sufficient volume and the deep, bassy tone that is so well suited to vocal accompaniment. It worked.

100% Attention, 100% of the Time

MODEL: **BECAUSE OF CONSTANCE**
BUILDER: **WILLIAM "GRIT" LASKIN, 2017**
TYPE: **FLAMENCO GUITAR**

OF NOTE: The quote on the body is directly from a letter that artist Frederick Varley wrote—"Oh if it were only possible for you people to know what it was like"—which Laskin equates to the way Woody Guthrie etched or wrote "This Machine Kills Fascists" on his guitars • The phrase "Or What?" on the rosette refers to the title of one of Varley's war paintings, and is encircled by two tubes of paint of Varley's favorite colors • Extraordinary inlay on neck and headstock illustrates scenes and interpretations of Varley's life and work

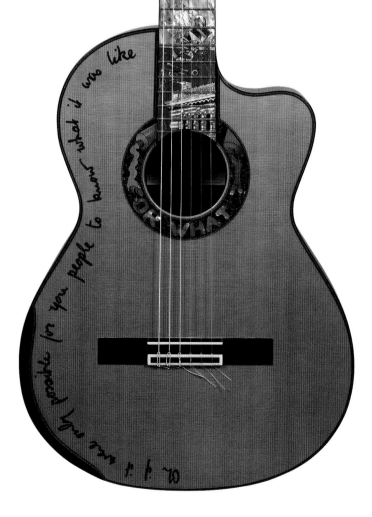

n 2017, the McMichael Canadian Art Collection mounted a show that matched seven prominent Canadian luthiers with Canadian landscape painters from a century before, who were called the Group of Seven. Grit Laskin, renowned for his inlay work, took his inspiration from the artist Frederick Varley, who loved doing portraits and used highly expressive colors. Varley was profoundly moved by what he saw in the fields of France during World War I, which also appealed to Grit's own strong feelings about war. Laskin, who loves doing what others are scared by, chose to make a flamenco guitar—a Flamenca Negra, made of African blackwood.

An Artist Interprets an Artist

MODEL: **ARTHUR LISMER GUITAR**
BUILDER: **TONY DUGGAN-SMITH, 2017**
TYPE: **ARCHTOP ACOUSTIC**

OF NOTE: Carved horn spoon tucked into the headstock, a memento from the art school where Arthur Lismer had been the principal, and Tony Duggan-Smith was a student—he likens it to Citizen Kane's "rosebud" • The guitar has an almost mandolin-like tone, complemented by the eight harp strings within easy reach • Drawings on the harp extension piece and back of the headstock

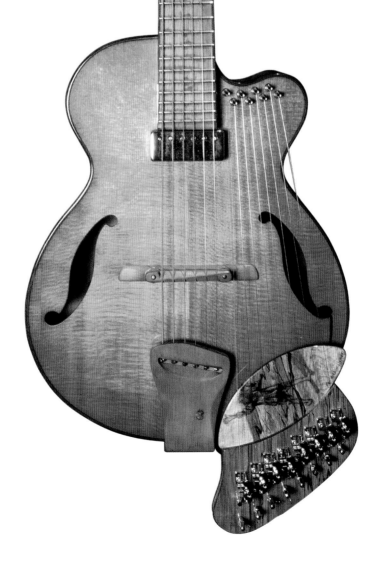

A member of the Canadian guitar-building community that includes Linda Manzer, Sergei de Jonge, and Grit Laskin, Tony Duggan-Smith was one of the seven luthiers involved in the Group of Seven show (see opposite), and built this most unusual small-bodied instrument as his response to the landscape artist Arthur Lismer. Curiously, the luthier Tony Duggan-Smith is now spending his time custom-building "Apprehension Engines," a musical instrument unlike any other that allows a player to create all the creepy sounds you might hear in a horror movie. He built the first for Canadian composer and musician Mark Korven, known for his work on sci-fi and horror films.

Into the Fire

MODEL: **ELECTRO A-22 "FRYING PAN"**
BUILDER: **RICKENBACKER, 1934**
TYPE: **LAP STEEL ELECTRIC**

OF NOTE: Twin horseshoe pickups, single volume knob • Solid cast aluminum body that was originally gold enamel • Neck is scooped and the 22 frets are ridges designed for lap-steel playing •Earlier spelling of "Rickenbacher" on headstock

It may be impossible to say who developed the first electric guitar, but Rickenbacker made history by being the first to manufacture and sell it, offering the legendary lap steel "Frying Pan"—so nicknamed because of its shape—in 1932. Created by George Beauchamp, a tinkerer and guitarist who collaborated with the Dopyera brothers on the development of the resonator (see page 20), the Frying Pan isn't just a museum curiosity. It was made until the 1950s and is still sought out by players for the special tonal quality that comes from a heavy horseshoe pickup and solid metal body.

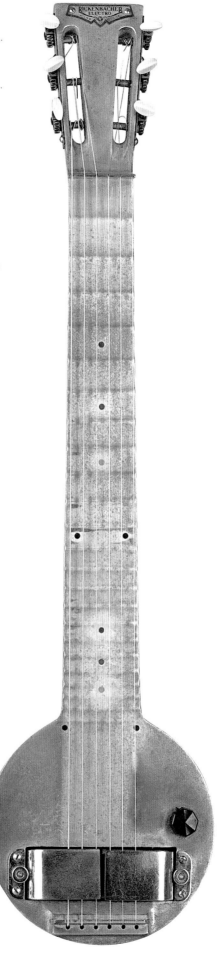

Reimagining the Electric Guitar

MODEL: **BIRDFISH**

BUILDER: **TEUFFEL, 2006**

TYPE: **BODILESS ELECTRIC**

OF NOTE: Everything in this guitar, down to the screws, is custom-made in the Teuffel shop • The "bird" is the cast aluminum piece that holds the neck—the "fish" is the piece that holds the bridge and control box

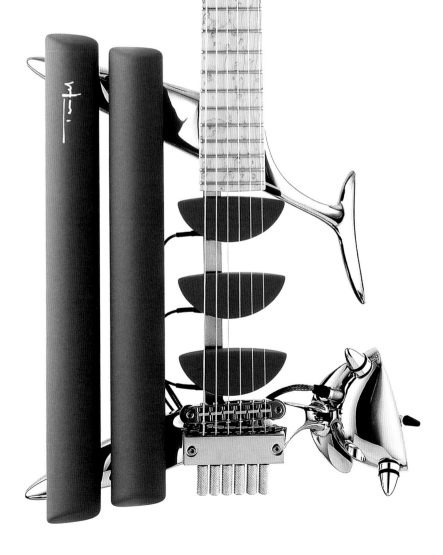

Ulrich Teuffel studied industrial design with a teacher who previously worked at Apple in the 1980s and was trained, he said, to think in concepts. His concept for the electric guitar? Understand all its constituent parts, then reimagine them in a way that allows the guitar to be fully modular. In 1995, he presented the first Birdfish, which puts an unlimited palette of tones at the player's disposal. The two tubes on the left of the "body" are interchangeable tonebars (the instrument comes with one set made of maple and another made of alder) and the pickups—five are available, including two single coils with a vintage vibe and three humbuckers, one P-90, one PAF, one hot PAF—can be changed and placed in any position. There's simply nothing else like it.

A Chorus of One

MODEL: **CIANI 12-STRING**
BUILDER: **CIANI, 1923**
TYPE: **12-STRING FLATTOP ACOUSTIC**

OF NOTE: This instrument was likely
made by John D'Angelico, who apprenticed
with his great-uncle, Raphael Ciani, and
took over the business when Ciani died •
Delicate floral work on the fret markers
and ornate pickguard

Pete Seeger described the
12-string guitar sound as
"the clanging of the bells."
He should know: His recording
of "We Shall Overcome" helped
usher in the second coming of
the 12-string, with its bright,
chimey sound, as a preferred folk
instrument. The origins of the
12-string guitar are obscure—
it likely came out of Italian
workshops, whose luthiers were
already used to making instruments
with double courses of strings, like
the mandolin. And its temperament
is notoriously fickle—it's difficult
to tune and, because of the extra
stress caused by all those strings,
prone to warpage. But what a
sound! Before Seeger, the
best-known players were
two legends of the blues,
Blind Willie McTell and
Huddie "Leadbelly"
Ledbetter.

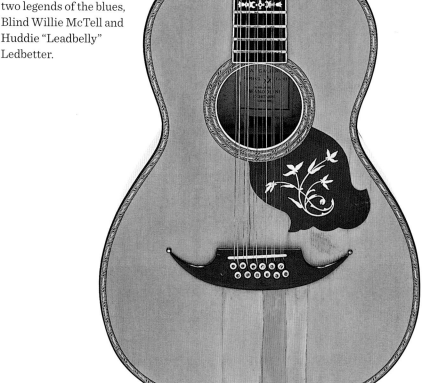

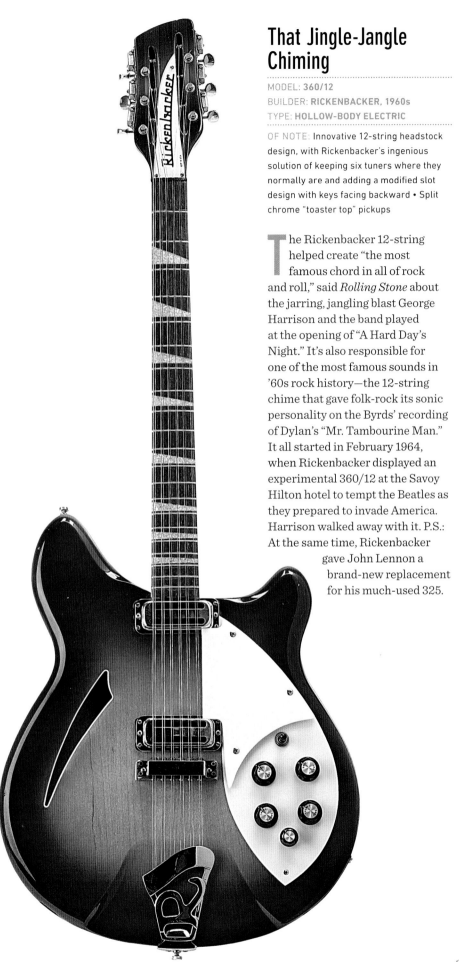

That Jingle-Jangle Chiming

MODEL: **360/12**
BUILDER: **RICKENBACKER, 1960s**
TYPE: **HOLLOW-BODY ELECTRIC**

OF NOTE: Innovative 12-string headstock design, with Rickenbacker's ingenious solution of keeping six tuners where they normally are and adding a modified slot design with keys facing backward • Split chrome "toaster top" pickups

The Rickenbacker 12-string helped create "the most famous chord in all of rock and roll," said *Rolling Stone* about the jarring, jangling blast George Harrison and the band played at the opening of "A Hard Day's Night." It's also responsible for one of the most famous sounds in '60s rock history—the 12-string chime that gave folk-rock its sonic personality on the Byrds' recording of Dylan's "Mr. Tambourine Man." It all started in February 1964, when Rickenbacker displayed an experimental 360/12 at the Savoy Hilton hotel to tempt the Beatles as they prepared to invade America. Harrison walked away with it. P.S.: At the same time, Rickenbacker gave John Lennon a brand-new replacement for his much-used 325.

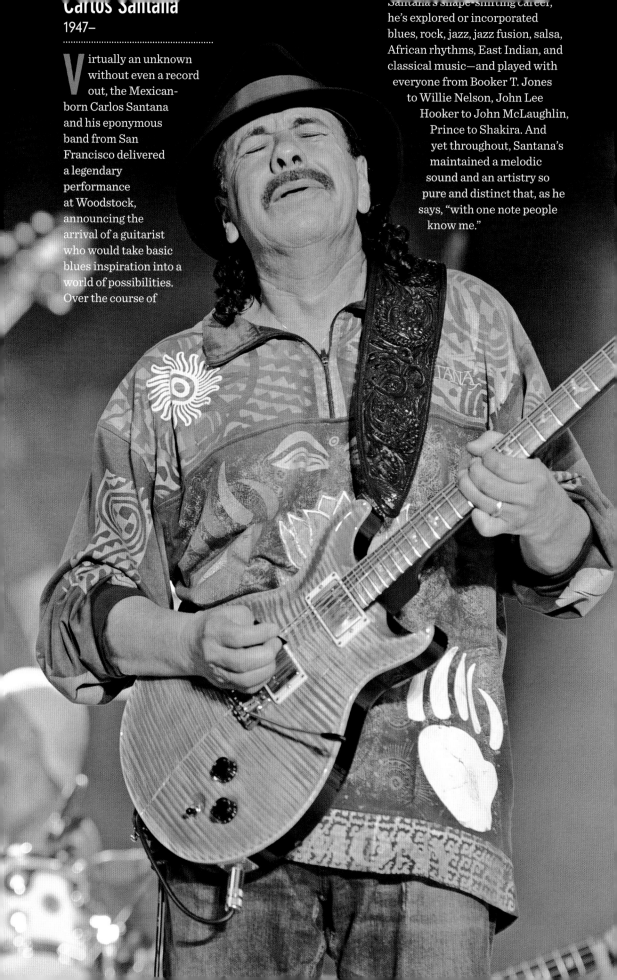

Carlos Santana
1947–

Virtually an unknown without even a record out, the Mexican-born Carlos Santana and his eponymous band from San Francisco delivered a legendary performance at Woodstock, announcing the arrival of a guitarist who would take basic blues inspiration into a world of possibilities. Over the course of Santana's shape-shifting career, he's explored or incorporated blues, rock, jazz, jazz fusion, salsa, African rhythms, East Indian, and classical music—and played with everyone from Booker T. Jones to Willie Nelson, John Lee Hooker to John McLaughlin, Prince to Shakira. And yet throughout, Santana's maintained a melodic sound and an artistry so pure and distinct that, as he says, "with one note people know me."

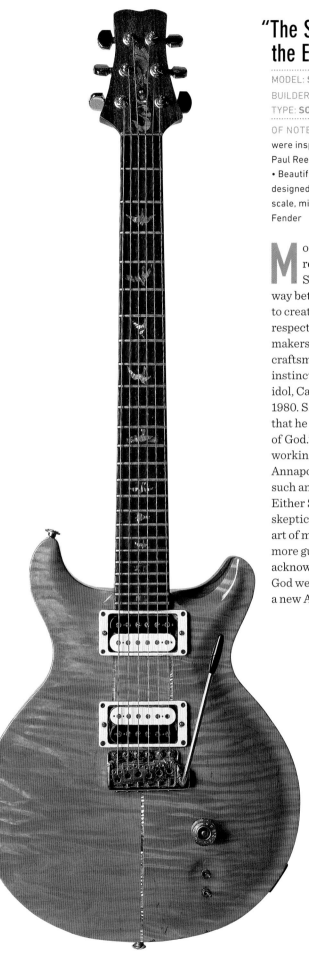

"The Stradivarius of the Electric Guitar"

MODEL: **SANTANA**

BUILDER: **PRS, 1980**

TYPE: **SOLID-BODY ELECTRIC**

OF NOTE: The famous bird fret markers were inspired by a guidebook belonging to Paul Reed Smith's mother, a bird-watcher • Beautiful popping wood grain • In-house designed and wound pickups, and a 25-inch scale, midway between a Gibson and a Fender

More evolutionary than revolutionary, Paul Reed Smith found the middle way between Gibson and Fender to create PRS, one of the most respected and successful guitar makers in America. A sublime craftsman with a musician's instincts, he built a guitar for his idol, Carlos Santana, early on in 1980. Santana was so impressed that he called the guitar "an act of God." How could this nobody working out of a tiny shop in Annapolis, Maryland, create such an amazing instrument? Either Santana was a genuine skeptic, or he was steeped in the art of motivation—it took two more guitars before Santana acknowledged that these acts of God were the acts of a man creating a new American classic.

"The World's *Fastest* Playing Neck"

MODEL: **P46 DELUXE**
BUILDER: **HAGSTROM, 1959**
TYPE: **HOLLOW-BODY ELECTRIC**

OF NOTE: Lots of accordion bling, including the sparkly plastic covering over the body, pearloid or celluloid fretboard and headstock, and control buttons • Two pairs of single-coil pickups separated by a grill—the guitar's body was hollow, and so presumably it could function as an acoustic

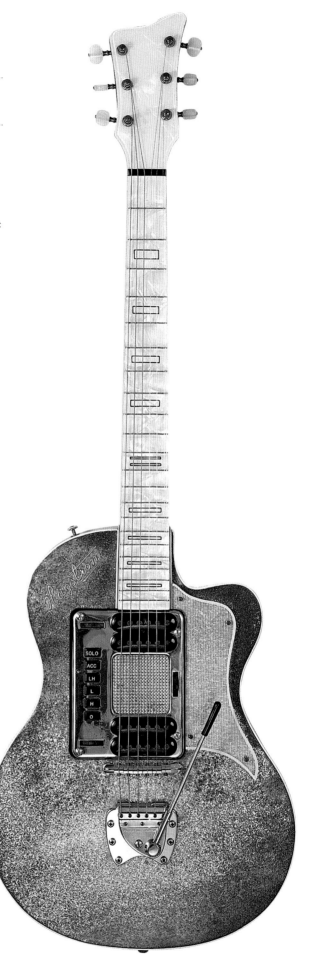

Purists like Martin and originators like Fender were guitar makers from the get-go. But for so many companies, guitars were more like a product line. These companies, like Sweden's Hagstrom, were in the music business, and when tastes changed and the business shifted, they shifted along with it. And so in 1958, as the guitar boom began booming, Hagstrom pivoted from accordions to guitars, though they brought a fair amount of their accordion sensibility—and factory full of materials—to their early instruments. By the '60s and '70s, Hagstrom was manufacturing dozens of different models, even hiring Jimmy D'Aquisto to design an archtop. Lots of players used Hagstroms—Kurt Cobain once had a blue version of this P46 Deluxe—though the brand got its biggest PR boost when Elvis strummed a Hagstrom Viking during the 1968 "Comeback" TV special that relaunched his career.

"A Free-Moving Sound"

MODEL: **BARON**
BUILDER: **DOMINO, 1967**
TYPE: **SOLID-BODY ELECTRIC**

OF NOTE: Four—count 'em, four!—pickups
• Knockoff Fender Stratocaster headstock,
knockoff Gibson SG body • All that chrome

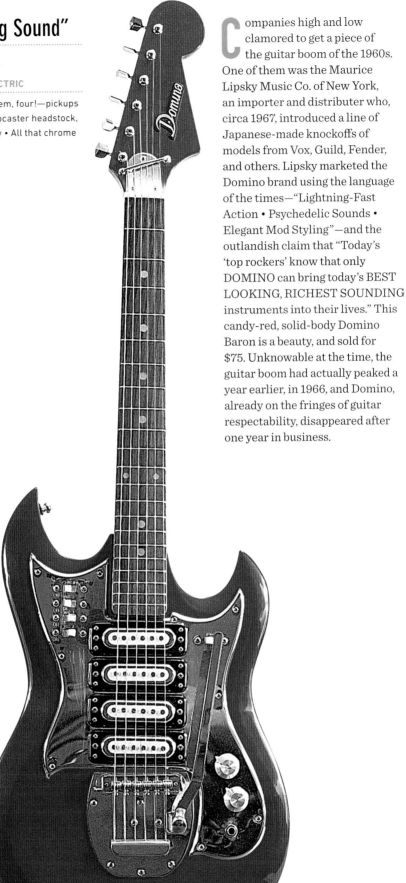

Companies high and low clamored to get a piece of the guitar boom of the 1960s. One of them was the Maurice Lipsky Music Co. of New York, an importer and distributer who, circa 1967, introduced a line of Japanese-made knockoffs of models from Vox, Guild, Fender, and others. Lipsky marketed the Domino brand using the language of the times—"Lightning-Fast Action • Psychedelic Sounds • Elegant Mod Styling"—and the outlandish claim that "Today's 'top rockers' know that only DOMINO can bring today's BEST LOOKING, RICHEST SOUNDING instruments into their lives." This candy-red, solid-body Domino Baron is a beauty, and sold for $75. Unknowable at the time, the guitar boom had actually peaked a year earlier, in 1966, and Domino, already on the fringes of guitar respectability, disappeared after one year in business.

THE FOUR SEASONS

"It started with the wood." Inspired by a cache of very special tone woods that he had collected in his career, contemporary archtop builder par excellence John Monteleone embarked on a project in 2002 that resulted, four years later, in a quartet of extraordinary guitars. Each is different; each is designed to accompany the others; and each offers the guitarist not only a pinnacle of both design and art, including the use of rare materials like gold, silver, diamonds,

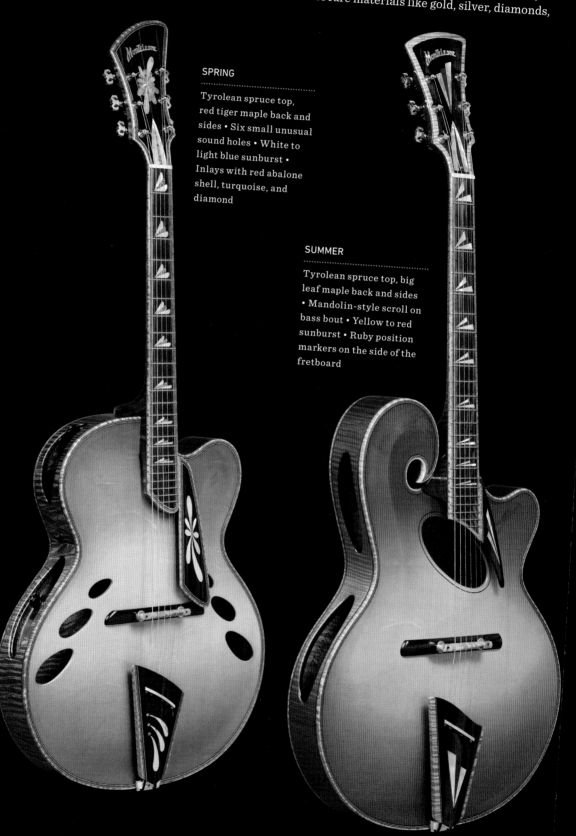

SPRING

Tyrolean spruce top, red tiger maple back and sides • Six small unusual sound holes • White to light blue sunburst • Inlays with red abalone shell, turquoise, and diamond

SUMMER

Tyrolean spruce top, big leaf maple back and sides • Mandolin-style scroll on bass bout • Yellow to red sunburst • Ruby position markers on the side of the fretboard

and rubies, but also secret surprises. A look into the side sound holes reveals the seasonal theme of each instrument continuing on the guitar's interior, with engraved scenes like leaves blowing off a bare tree in Autumn and a shining sun with a sailboat in Summer. Fittingly, the four guitars were unveiled at the Metropolitan Museum of Art for a show on lutherie.

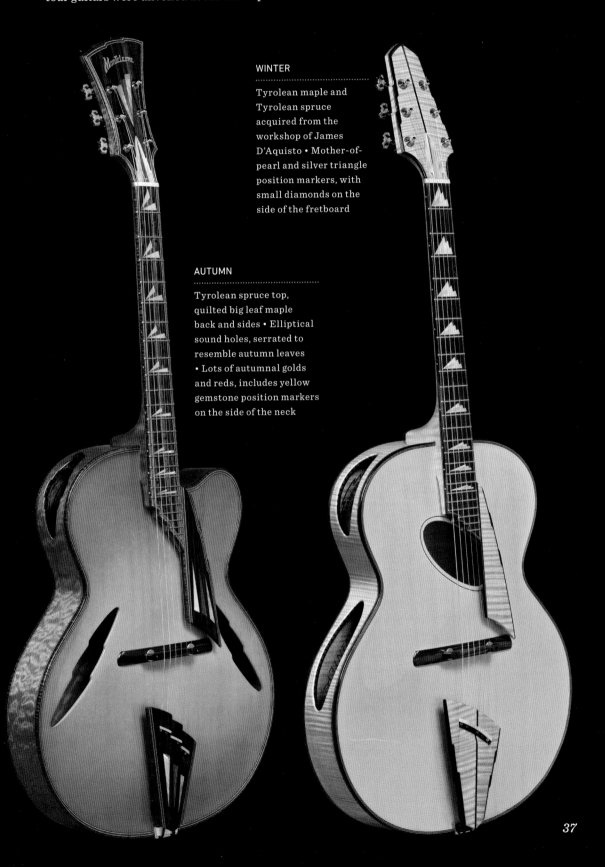

WINTER

Tyrolean maple and Tyrolean spruce acquired from the workshop of James D'Aquisto • Mother-of-pearl and silver triangle position markers, with small diamonds on the side of the fretboard

AUTUMN

Tyrolean spruce top, quilted big leaf maple back and sides • Elliptical sound holes, serrated to resemble autumn leaves • Lots of autumnal golds and reds, includes yellow gemstone position markers on the side of the neck

What Were They Thinking?

MODEL: **CREMONA**
BUILDER: **VEGA, 1932**
TYPE: **ARCHTOP ACOUSTIC**

OF NOTE: Jarring hybrid quality—it looks like an archtop, with its f-holes, but also like a flattop, with its familiar pin bridge • Yes, those are pickguards hugging the f-holes, apparently a later addition • List price was $220, just $55 cheaper than the vastly superior Gibson L-5, making it a classic lemon

With its lovely allusion to the spirit of music—Vega is the brightest star in the constellation Lyra, which refers to the lyre of Orpheus, the legendary musician of Greek myth—Vega was the name given by two Swedish brothers to their Boston-based company. Starting at the turn of the twentieth century, Vega went through various periods of featuring either banjos over guitars or guitars over banjos, but was consistent in creating some especially beautiful and high-quality instruments. Perhaps most famous is the iconic Vega "Pete Seeger" long-neck 5-string banjo. At the start of the Depression, it got more serious about the guitar side and made this highly unusual though unsuccessful archtop.

Curious Hybrid

MODEL: **AIRWAY W2**
BUILDER: **WILKANOWSKI, 1939**
TYPE: **ARCHTOP ACOUSTIC**

OF NOTE: Unique and stunning violin-shaped body • Wood binding, wood tailpiece, wood pickguard—design choices that prefigured by decades how contemporary archtop builders now work • Cat-eye f-holes that testify to Wilkanowski's work with Gretsch

Violin construction inspired Gibson to create the first archtop guitar, but no luthier took that idea quite as far as William Wilkanowski. A native of Poland who learned to make violins as a teenager, Wilkanowski emigrated to America and ultimately built about five thousand of them, first for the Ditson company in Boston, then Gretsch in New York, and then on his own in Brooklyn, where he built violins and violas for the New York Board of Education. Then, the story goes, a friend asked him to make a guitar, and for a few brief years—from 1939 to 1941— he went on a guitar kick, building about thirty of them. Although no two models were exactly alike, this Airway has the typical cello-like points on the upper bout and the forward-looking use of wood throughout.

Artist. Scientist. Luthier.

MODEL: **BERGER 00-12**
BUILDER: **MICHAEL BASHKIN, 2018**
TYPE: **FLATTOP ACOUSTIC**

OF NOTE: Top made of moon-harvested Swiss spruce, an old practice of harvesting the tonewood during a time in the lunar cycle when sap flow is at its lowest • Ebony headstock with delicate art-deco inlay of maple lines and koa accents • Koa and ebony rosette, the pieces altered through a wood-torching process—in hot sand—that brings out different colors and figures

All luthiers have an intimate relationship with wood, but few have a PhD in the subject or have taught tropical forestry. Michael Bashkin brings this knowledge, along with his gifts as a visual artist and passion as a musician, to his work as a luthier, building incredibly responsive steel-string guitars with an unparalleled attention to detail. One thing about the wood—he prefers using more of it, running counter to many boutique builders who try to build as lightly as possible. He believes that it gets him what he wants to hear: an articulate, dry, vintage tone on the low end and a rich, even tone on the highs and mids, "with more information around the note."

"I've Been the Student"

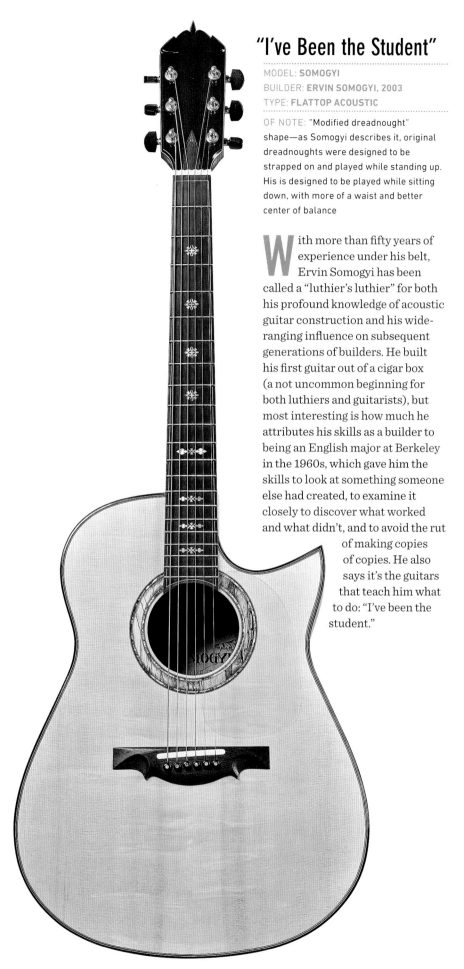

MODEL: **SOMOGYI**
BUILDER: **ERVIN SOMOGYI, 2003**
TYPE: **FLATTOP ACOUSTIC**

OF NOTE: "Modified dreadnought" shape—as Somogyi describes it, original dreadnoughts were designed to be strapped on and played while standing up. His is designed to be played while sitting down, with more of a waist and better center of balance

With more than fifty years of experience under his belt, Ervin Somogyi has been called a "luthier's luthier" for both his profound knowledge of acoustic guitar construction and his wide-ranging influence on subsequent generations of builders. He built his first guitar out of a cigar box (a not uncommon beginning for both luthiers and guitarists), but most interesting is how much he attributes his skills as a builder to being an English major at Berkeley in the 1960s, which gave him the skills to look at something someone else had created, to examine it closely to discover what worked and what didn't, and to avoid the rut of making copies of copies. He also says it's the guitars that teach him what to do: "I've been the student."

That Fat and Throaty Tone

MODEL: **LITTLE SISTER**
BUILDER: **B&G**
YEAR: **2018**
TYPE: **SEMI-HOLLOW-BODY ELECTRIC**

OF NOTE: Small, noncutaway body • The soap bar P-90-style pickups, custom-built and handwound by the luthiers • A mix-and-match of old-school guitar design—slotted headstock, f-holes, brass tailpiece, nitrocellulose tobacco sunburst

The birth of innovation often begins with a simple question. In this case, how did Delta blues artists like Robert Johnson get that big, captivating tone out of a small-bodied guitar? This led designer David Weitzman on a journey that resulted in the Little Sister, a stunning "parlor electric" with a chambered body, slot-head neck, and impeccable retro appointments created by Weitzman and his friends and colleagues at B&G Guitars in Tel Aviv. A marriage of 1920s and '30s guitar design with 1950s electronics, the Little Sister looks back in time in the right way.

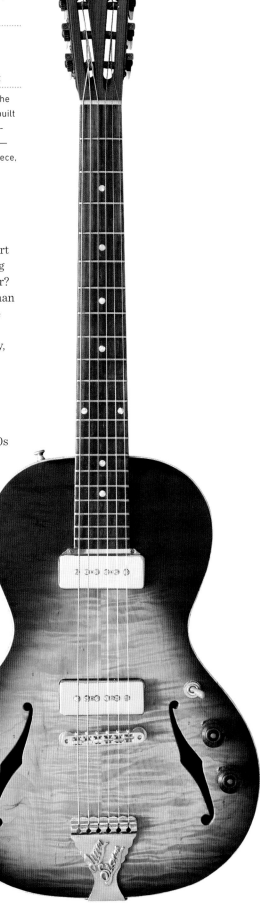

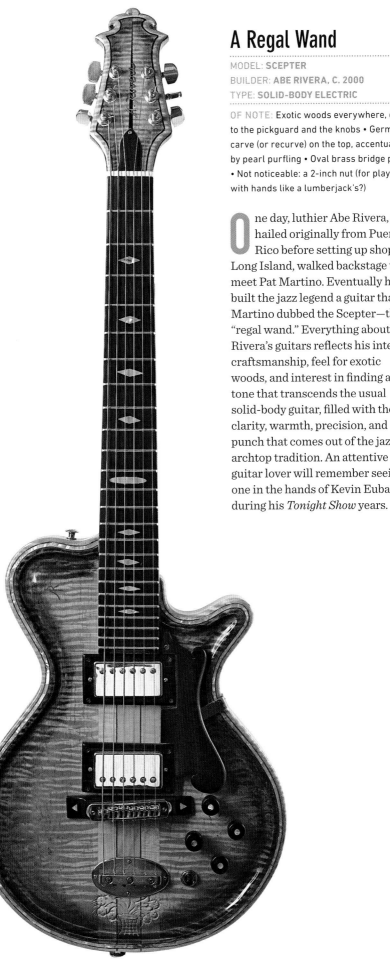

A Regal Wand

MODEL: **SCEPTER**
BUILDER: **ABE RIVERA, C. 2000**
TYPE: **SOLID-BODY ELECTRIC**

OF NOTE: Exotic woods everywhere, down to the pickguard and the knobs • German carve (or recurve) on the top, accentuated by pearl purfling • Oval brass bridge plate • Not noticeable: a 2-inch nut (for players with hands like a lumberjack's?)

One day, luthier Abe Rivera, who hailed originally from Puerto Rico before setting up shop in Long Island, walked backstage to meet Pat Martino. Eventually he built the jazz legend a guitar that Martino dubbed the Scepter—the "regal wand." Everything about Rivera's guitars reflects his intense craftsmanship, feel for exotic woods, and interest in finding a tone that transcends the usual solid-body guitar, filled with the clarity, warmth, precision, and punch that comes out of the jazz archtop tradition. An attentive guitar lover will remember seeing one in the hands of Kevin Eubanks during his *Tonight Show* years.

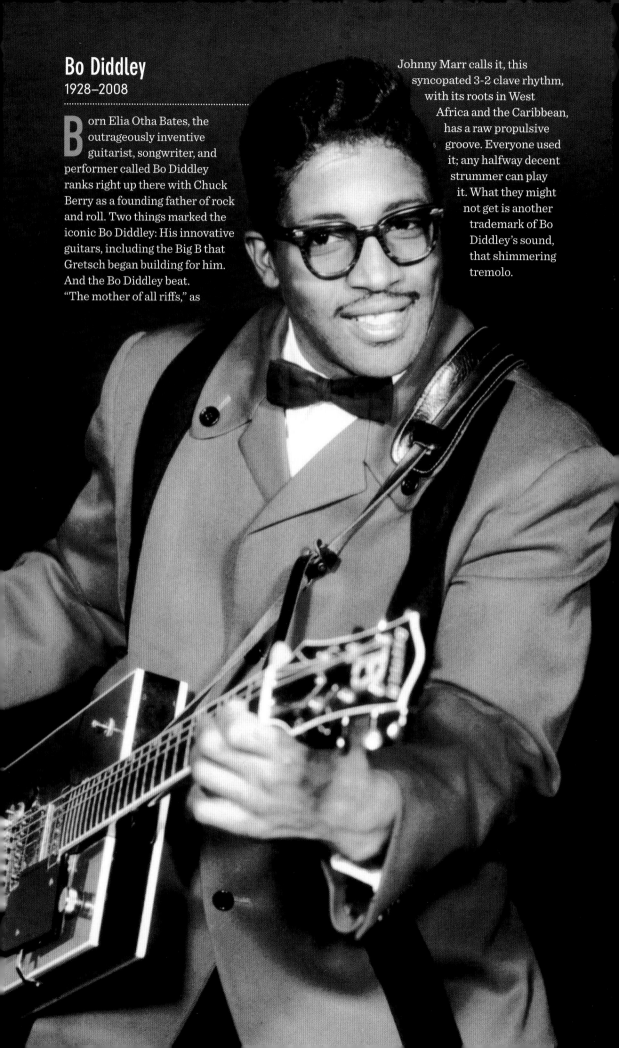

Bo Diddley
1928–2008

Born Elia Otha Bates, the outrageously inventive guitarist, songwriter, and performer called Bo Diddley ranks right up there with Chuck Berry as a founding father of rock and roll. Two things marked the iconic Bo Diddley: His innovative guitars, including the Big B that Gretsch began building for him. And the Bo Diddley beat. "The mother of all riffs," as Johnny Marr calls it, this syncopated 3-2 clave rhythm, with its roots in West Africa and the Caribbean, has a raw propulsive groove. Everyone used it; any halfway decent strummer can play it. What they might not get is another trademark of Bo Diddley's sound, that shimmering tremolo.

Twang Machine

MODEL: **"BO DIDDLEY" BIG B**
BUILDER: **GRETSCH, 1960**
TYPE: **SOLID-BODY ELECTRIC**

OF NOTE: Iconic body and iconic color •
A pair of DeArmond DynaSonic pickups
• What to make of that tiny, brick-shaped
pickguard?

I t's hard to imagine a guitar less elegant than this red rectangular plank, but it's an instantly recognizable icon designed and played by the legendary Bo Diddley. According to one story, Diddley fashioned a rectangular guitar because he constructed cigar-box guitars when he was a kid, a folk craft that continues to this day. Another story claims that he created it to avoid an embarrassing injury that he once suffered—he whacked himself in the groin with the wide upper bout of a Gibson L-5 while jumping around onstage. Whatever the reason, Gretsch built this first Big B, and it became his trademark as much as the "Bo Diddley beat."

That Bluesy
Old Hound Dog

MODEL: **DOBRO**
BUILDER: **DOBRO, 1970s**
TYPE: **RESONATOR ACOUSTIC**

OF NOTE: Wooden body, which harkens back to the first Dobros when the company couldn't afford the tooling to make steel-body instruments • The resonating dish, just visible through the grill

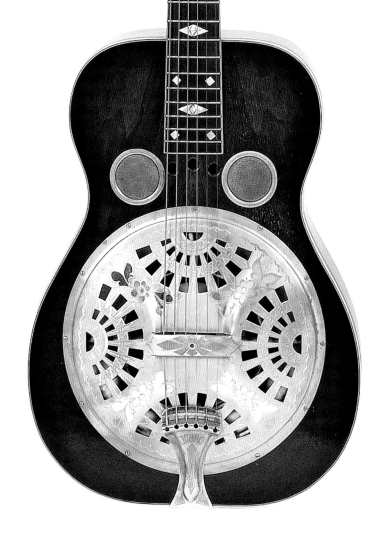

The name Dopyera travels like a vine through twentieth-century guitar history. John Dopyera invented the original resonator guitar and founded the National String Instrument Corporation. Then, after a fight with his partners, John and his brothers founded the Dobro company in 1928—the name derives from DOpyera BROthers, and also means "good" in their native Slovak. What makes an original Dobro a Dobro is the innovation of a single forward-facing resonating cone supported by an eight-legged spider bridge that conducts the strings' vibrations. After riding the Hawaiian music crest in the early '30s, Dobros all but disappeared until a few country pickers kept the instruments alive, and then they were adopted in the 1970s by players like Dickey Betts and Adrian Belew. Today, Gibson owns the Dobro brand and name.

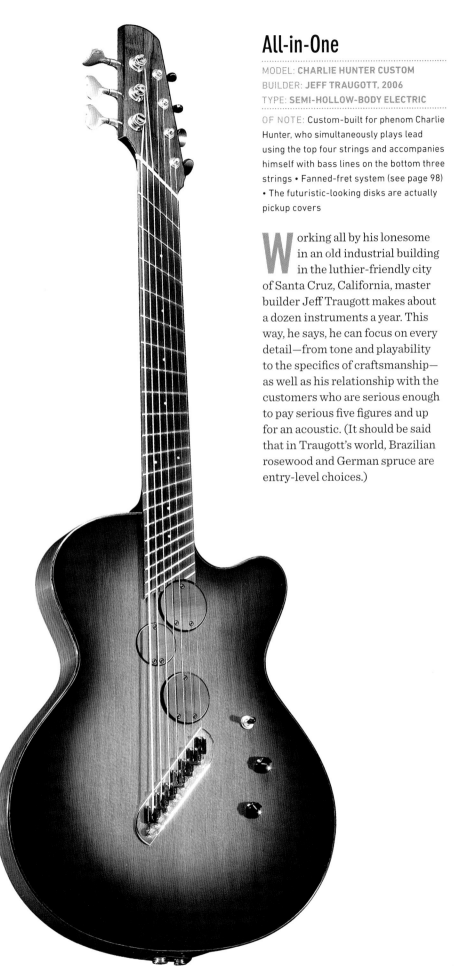

All-in-One

MODEL: **CHARLIE HUNTER CUSTOM**
BUILDER: **JEFF TRAUGOTT, 2006**
TYPE: **SEMI-HOLLOW-BODY ELECTRIC**

OF NOTE: Custom-built for phenom Charlie Hunter, who simultaneously plays lead using the top four strings and accompanies himself with bass lines on the bottom three strings • Fanned-fret system (see page 98) • The futuristic-looking disks are actually pickup covers

Working all by his lonesome in an old industrial building in the luthier-friendly city of Santa Cruz, California, master builder Jeff Traugott makes about a dozen instruments a year. This way, he says, he can focus on every detail—from tone and playability to the specifics of craftsmanship—as well as his relationship with the customers who are serious enough to pay serious five figures and up for an acoustic. (It should be said that in Traugott's world, Brazilian rosewood and German spruce are entry-level choices.)

"Weissenborns Eat Dobros for Lunch"

MODEL: **STYLE 4**
BUILDER: **WEISSENBORN, 1920s**
TYPE: **HAWAIIAN ACOUSTIC**

OF NOTE: Curvy, slender body tapering right into the hollow neck • The wood is koa from Hawaii, historically used to build the islands' oceangoing canoes, as well as the occasional surfboard

In another chapter of the story of German immigrants coming to America in the nineteenth and early twentieth centuries and getting into the musical instrument business, Hermann C. Weissenborn brought his piano- and violin-making skills first to New York City and then to Los Angeles. There, he transitioned into building a line of outstanding guitars designed specifically for Hawaiian lap-steel playing, then all the rage. With a body that extends all the way to the peghead and very light build using Hawaiian koa, it produces an exceptionally warm, sweet, loud tone, and has been enjoying a renaissance among slide guitarists like David Lindley, who sized the Weissenborn up memorably next to the Dobro.

"The World's Greatest Musical Instrument Manufacturer"

MODEL: **BOHMANN**
BUILDER: **JOSEPH BOHMANN, C. 1910**
TYPE: **ARCHTOP ACOUSTIC**

OF NOTE: Double-cutaway, domed—bent, not carved—body • Patented bridge and device that is an adjustable palm rest • Not visible: internal metal rods that vibrate sympathetically with the strings, like a harp guitar—that tiny button on the rosette is used to dampen them

When Joseph Bohmann emigrated from Bohemia to Chicago in 1873, he unabashedly declared himself the "World's Greatest Musical Instrument Manufacturer." He built harp guitars, violins, parlor guitars, and what some credit as the first mandolin made in America. An eager innovator as well as a skilled craftsman and natural marketer, his instruments—like this little beauty—are full of patented innovations, including the bridge and tuners. At 12⅛ inches across and with its domed body, it has been described as sounding like a "parlor archtop."

Eight Miles High

MODEL: **331, "LIGHT SHOW"**
BUILDER: **RICKENBACKER, 1964**
TYPE: **SEMI-HOLLOW-BODY ELECTRIC**

OF NOTE: Lights behind a translucent plastic body flash in different colors according to the frequencies being played • Powered by a separate transformer that was prone to overheating, the 331 was called a "toaster with strings"

Trippy as it looks, the Rickenbacker 331 "Light Show" arrived too late for the Summer of Love. Rickenbacker introduced the guitar in 1970, inspired by stereo speakers and organs outfitted with lights that blinked and flashed in response to the music's pitch. Though it was designed for the psychedelic movement, one of the most celebrated players who used a 331 was, ironically, Buck Owens, who loved to show his off on the program *Hee Haw*. Rickenbacker discontinued the guitar in 1975. If you're curious, YouTube has a few videos of the Light Show in action.

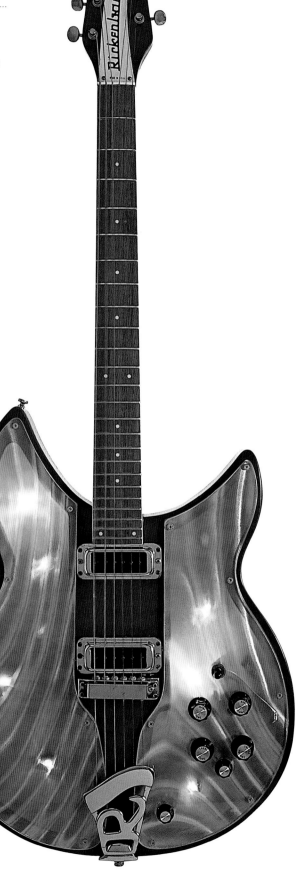

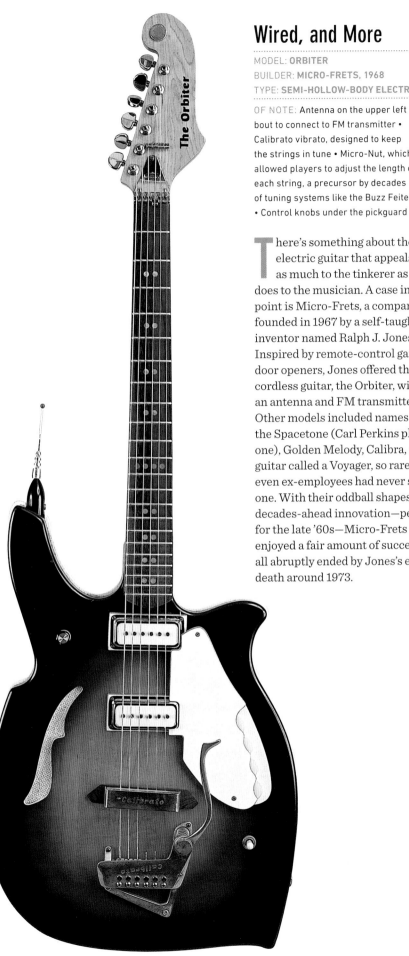

Wired, and More

MODEL: **ORBITER**
BUILDER: **MICRO-FRETS, 1968**
TYPE: **SEMI-HOLLOW-BODY ELECTRIC**

OF NOTE: Antenna on the upper left bout to connect to FM transmitter • Calibrato vibrato, designed to keep the strings in tune • Micro-Nut, which allowed players to adjust the length of each string, a precursor by decades of tuning systems like the Buzz Feiten • Control knobs under the pickguard

There's something about the electric guitar that appeals as much to the tinkerer as it does to the musician. A case in point is Micro-Frets, a company founded in 1967 by a self-taught inventor named Ralph J. Jones. Inspired by remote-control garage door openers, Jones offered the first cordless guitar, the Orbiter, with an antenna and FM transmitter. Other models included names like the Spacetone (Carl Perkins played one), Golden Melody, Calibra, and a guitar called a Voyager, so rare that even ex-employees had never seen one. With their oddball shapes and decades-ahead innovation—perfect for the late '60s—Micro-Frets enjoyed a fair amount of success, all abruptly ended by Jones's early death around 1973.

The Lloyd Loar Masterpiece

MODEL: **L-5**
BUILDER: **GIBSON, 1924**
TYPE: **ARCHTOP ACOUSTIC**

OF NOTE: All the firsts: the first f-hole archtop guitar • The first modern orchestra guitar • The first guitar with a 14-fret neck to the body that had an adjustable truss rod • Gibson knew it had something special on its hands, and gave it this befitting name: "The Master Line Guitar L-5 Professional Special Concert Grand Model"

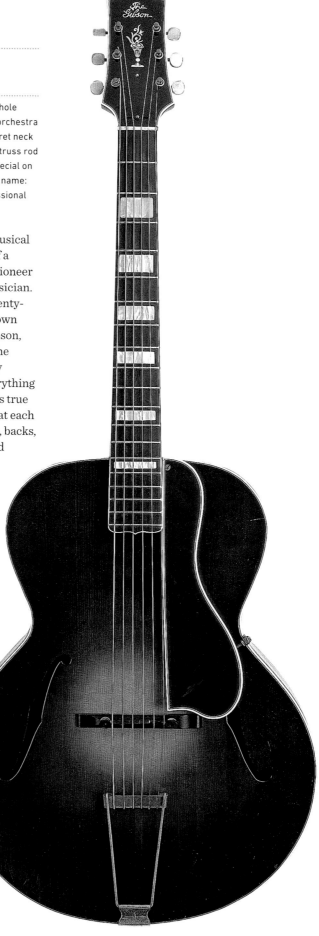

Lloyd Loar was either a musical prodigy with the mind of a scientist or a scientific pioneer with the ears of a master musician. Probably both. When the twenty-year-old, internationally known mandolinist approached Gibson, he had ideas for improving the mandolin, and Gibson wisely signed him on. For Loar, everything revolved around tone, and his true contribution was the idea that each part of the instrument—tops, backs, tonebars, even f-holes—could be "tuned" to create a more dynamic whole. With the L-5's debut in 1922, he really broke new ground, and its uncommon marriage of aesthetics and acoustics kept it as Gibson's top-of-the-line model for more than a decade.

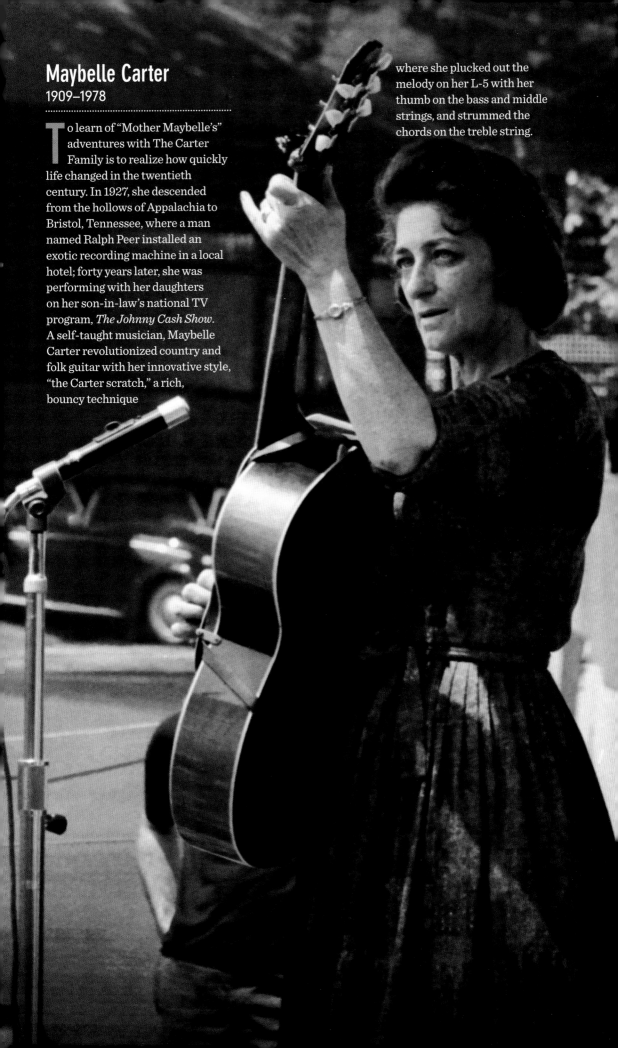

Maybelle Carter
1909–1978

To learn of "Mother Maybelle's" adventures with The Carter Family is to realize how quickly life changed in the twentieth century. In 1927, she descended from the hollows of Appalachia to Bristol, Tennessee, where a man named Ralph Peer installed an exotic recording machine in a local hotel; forty years later, she was performing with her daughters on her son-in-law's national TV program, *The Johnny Cash Show*. A self-taught musician, Maybelle Carter revolutionized country and folk guitar with her innovative style, "the Carter scratch," a rich, bouncy technique where she plucked out the melody on her L-5 with her thumb on the bass and middle strings, and strummed the chords on the treble string.

Following Suit

MODEL: **R-17**
BUILDER: **MARTIN, C. 1934**
TYPE: **ARCHTOP ACOUSTIC**

OF NOTE: Martin introduced two small archtops built on a 00-size body, the R-18 with a spruce top and this funky all-mahogany R-17 • The top is pressed, not carved

Martin is world-famous as the foremost maker of flattop guitars, but that's not to say the company didn't try other things. In 1931, Martin followed Gibson into the archtop world. Sort of. Though its C and R models helped the company survive the Depression, the Martin archtop, as a concept, is more or less a footnote in the company's history. One significant problem: Martin put an arched top on a flattop's back and sides, which caused enormous problems in how the neck was set, mitigating one of an archtop's key selling points, its power.

"My Favorite Guitar in the World"

MODEL: **D'AQUISTO SOLO**
BUILDER: **JAMES D'AQUISTO, 1992**
TYPE: **ARCHTOP ACOUSTIC**

OF NOTE: Gone is the heaviness, the art deco bling, the classic detailing of mid-century archtop—replaced by an elegant wooden tailpiece and pickguard, unadorned sound hole shapes, and open headstock • The quote is from collector Scott Chinery, who also said: "People play it . . . and then look inside, because what they're hearing doesn't make sense."

One day a fledgling guitarist named Jimmy D'Aquisto walked into John D'Angelico's Manhattan workshop and never wanted to leave. Little by little, D'Angelico tolerated this apprentice, giving him basic instruction: "This is how I want it done and this is how I do it. You do it any way you like, but it must turn out as good or better than what I did." And it did: In one of those almost-too-good-to-be-true coincidences, it turns out that the apprentice who wandered into the shop was as innately talented as the master. After following in the D'Angelico vein, D'Aquisto gradually found his own voice as a builder and literally changed the course of archtop design. Then, a much darker coincidence: D'Angelico died young, at fifty-nine—and so did D'Aquisto.

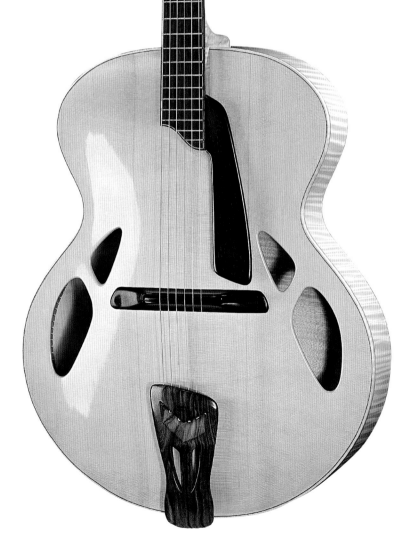

Starter Kit

MODEL: **SILVERTONE 1457**
BUILDER: **DANELECTRO, 1963**
TYPE: **SOLID-BODY ELECTRIC**

OF NOTE: All-in-one ingenuity: a solid-body guitar and a case that doubles as the instrument's amp—in this case, a surprisingly loud five-watt tube amp with an 8-inch speaker and lots of tremolo • Devilish double-cutaway guitar body, swooping white pickguard

How many future rock and rollers woke up on Christmas morning and found this plug-and-play instant music kit under their tree? Built by Danelectro for Silvertone, the private label sold exclusively through Sears, Roebuck & Company, the short-lived 1457 became an icon of the early 1960s—presaging, in its own way, the larger cultural shift that was happening in music, in movies, and in teenagedom in general.

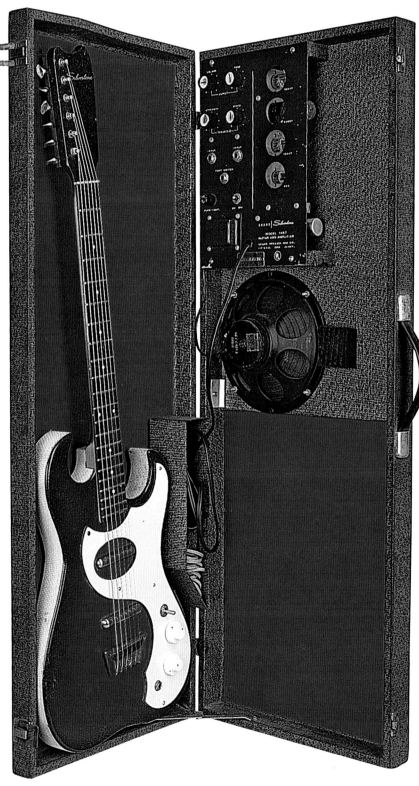

Electrics, Italian-Style

MODEL: **BIKINI**
BUILDER: **KRUNDAAL, 1965**
TYPE: **SOLID-BODY ELECTRIC**

OF NOTE: Attached speaker and amplifier, the look of which is inspired by the designer's love of motorcycles • Davoli pickups with fancily engraved metal pickup covers • Push-button controls • The fancy "W" for "Wandre" on the bridge plate

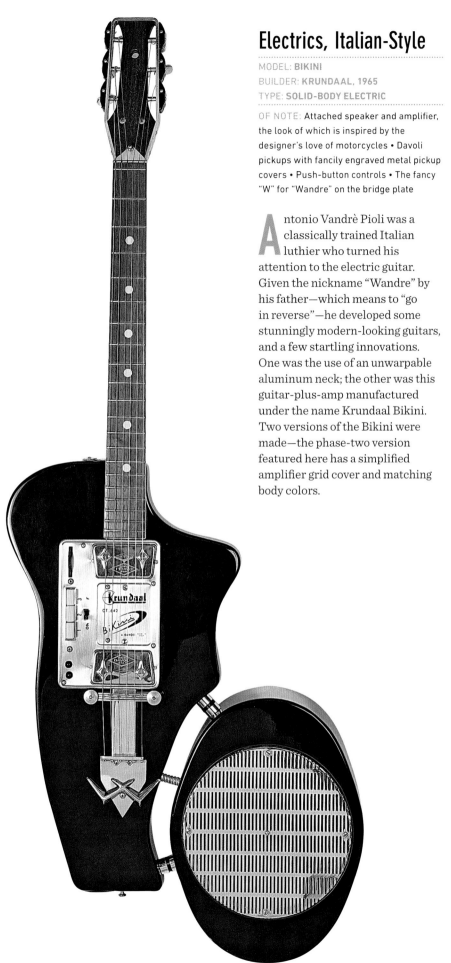

Antonio Vandrè Pioli was a classically trained Italian luthier who turned his attention to the electric guitar. Given the nickname "Wandre" by his father—which means to "go in reverse"—he developed some stunningly modern-looking guitars, and a few startling innovations. One was the use of an unwarpable aluminum neck; the other was this guitar-plus-amp manufactured under the name Krundaal Bikini. Two versions of the Bikini were made—the phase-two version featured here has a simplified amplifier grid cover and matching body colors.

Jumbo Beauty

MODEL: **EUPHONON**
BUILDER: **LARSON BROTHERS, 1940**
TYPE: **FLATTOP ACOUSTIC**

OF NOTE: Those unmissable symmetrical, see-through, engraved pickguards, screwed in on the top and clipped on along the sides • Flowers on the headstock, and what appear to be decorative brass rivets along the top edge, a motif repeated on the bridge

For centuries, guitarists were content to strum and pluck their mild-mannered instruments, usually, alone, like the composer Hector Berlioz who would take a guitar on a stroll with him through the Alpine meadows. But the fact is, virtually every other instrument drowned it out. By the 1920s, it was time for the guitar to evolve and make some noise! One strategy: Make it bigger. Lawson Brothers, a high-end builder in Chicago, got into the game. This one, released through their "Euphonon" brand, is an 18⅞-inch-wide jumbo.

Cowboy Crooner

MODEL: **RANCHER**
BUILDER: **GRETSCH, 1955**
TYPE: **FLATTOP ACOUSTIC**

OF NOTE: Triangular sound hole, swooping pickguard, large rosewood bridge, and sunset-red finish that's now called Western Orange • The Gretsch "G" brand on the lower bout • Cactus and longhorn-inlay fret markers to complete the cowboy theme

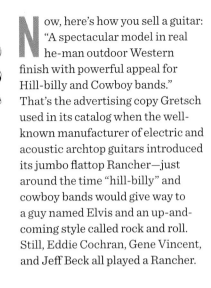

Now, here's how you sell a guitar: "A spectacular model in real he-man outdoor Western finish with powerful appeal for Hill-billy and Cowboy bands." That's the advertising copy Gretsch used in its catalog when the well-known manufacturer of electric and acoustic archtop guitars introduced its jumbo flattop Rancher—just around the time "hill-billy" and cowboy bands would give way to a guy named Elvis and an up-and-coming style called rock and roll. Still, Eddie Cochran, Gene Vincent, and Jeff Beck all played a Rancher.

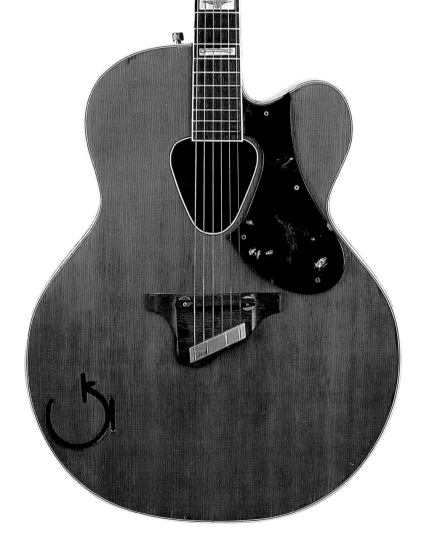

Magical Mystery Guitar

MODEL: **STRATOCASTER, "ROCKY"**
BUILDER: **FENDER, 1961**
TYPE: **SOLID-BODY ELECTRIC**

OF NOTE: An off-the-shelf 1961 Stratocaster decorated by its famous owner, George Harrison, with gloppy Day-Glo paints and some of (then-wife) Pattie Boyd's nail polish • The name "Rocky" and the words "Bebopalula" and "Go Cat Go" added a few years later in honor of guitar heroes Gene Vincent and Carl Perkins

It seems almost inconceivable to guitar obsessives who shop and swap and A/B every instrument, but this is how they used to do it: One day Lennon and Harrison sent a guy to pick up a couple of Strats because Brian Epstein was footing the bill. Said guy (Mal Evans) returned with two 1961 Sonic Blue Fender Stratocasters, first heard on "Nowhere Man." Then in April 1967, when, as George said, "we were painting everything"—ever see a photo of John Lennon's psychedelic Rolls-Royce?—Harrison took the plunge and customized "Rocky." You'll hear this famous guitar on many recordings starting with *Rubber Soul,* and see it in the *Magical Mystery Tour* TV special. Post-Beatles, Harrison set it up for slide work.

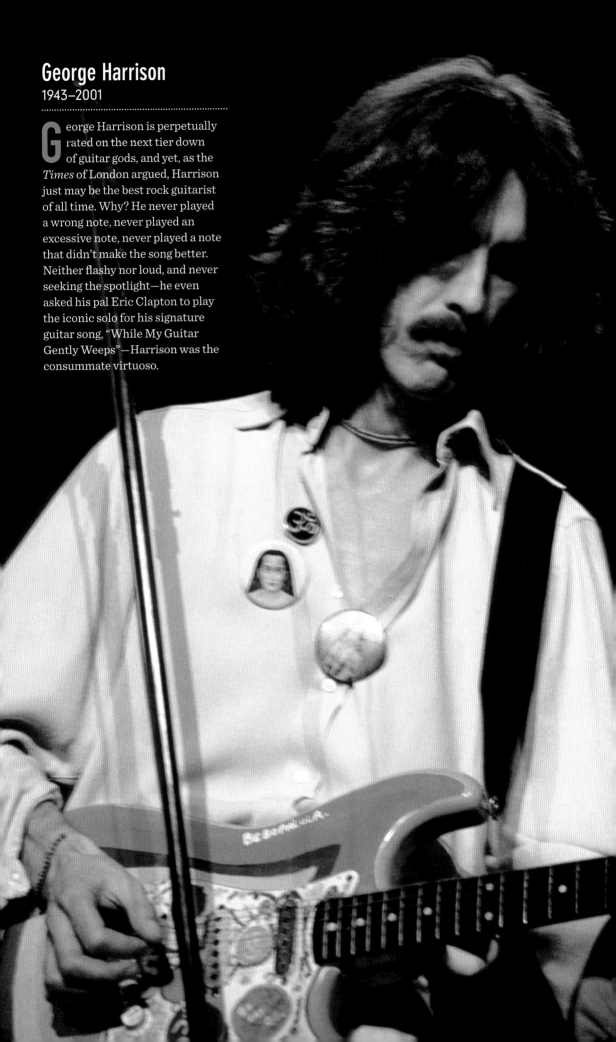

George Harrison
1943–2001

George Harrison is perpetually rated on the next tier down of guitar gods, and yet, as the *Times* of London argued, Harrison just may be the best rock guitarist of all time. Why? He never played a wrong note, never played an excessive note, never played a note that didn't make the song better. Neither flashy nor loud, and never seeking the spotlight—he even asked his pal Eric Clapton to play the iconic solo for his signature guitar song, "While My Guitar Gently Weeps"—Harrison was the consummate virtuoso.

"Broomstick with Pickups"

MODEL: **THE LOG**
BUILDER: **LES PAUL, 1939–1941**
TYPE: **SOLID-BODY ELECTRIC**

OF NOTE: Solid pine core • Sides cut from an Epiphone to make the log look more like a real guitar • Larson neck, Gibson headstock • Handmade pickups • Handmade vibrato added after 1942

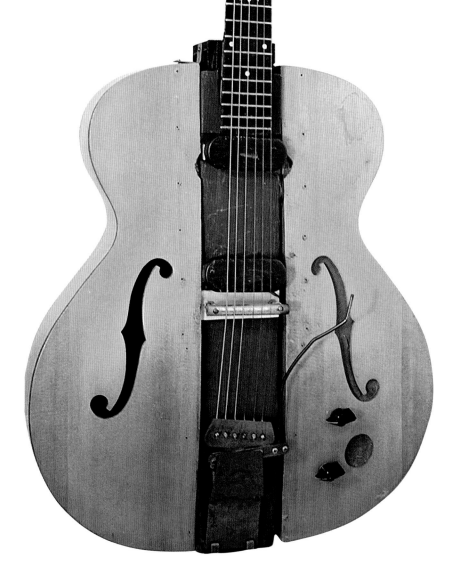

By 1941, after spending years daydreaming about a solid-body electric guitar that would "sustain for days," then tweaking, experimenting, prototyping, and even performing with a DIY version of it, the guitarist and inventor Les Paul brought his "Log" to the folks at Gibson. They laughed, of course, calling it a "broomstick with pickups on it." But Paul had done it. Named for the core of the instrument—a 4″ × 4″ solid block of pine—this twenty-pound assemblage of parts would change the course of guitar history. Gibson would change its tune, too, when Fender introduced its Broadcaster and showed that the world was ready for a solid-body electric guitar. Two years later, Gibson would launch its iconic Les Paul.

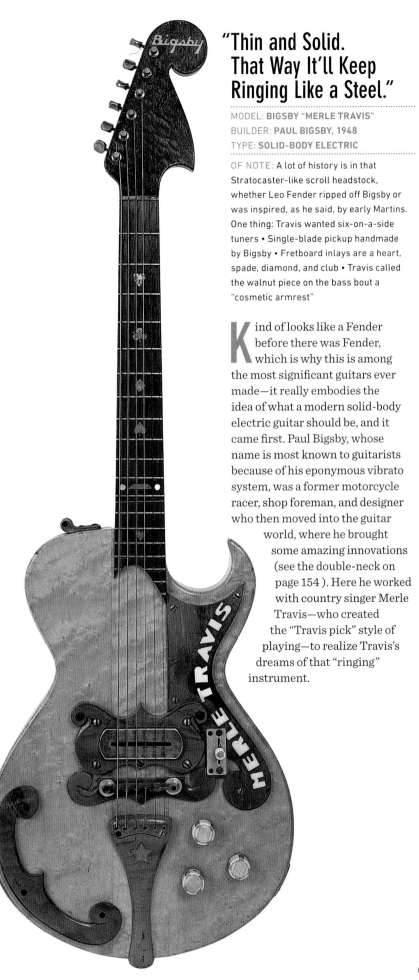

"Thin and Solid. That Way It'll Keep Ringing Like a Steel."

MODEL: **BIGSBY "MERLE TRAVIS"**
BUILDER: **PAUL BIGSBY, 1948**
TYPE: **SOLID-BODY ELECTRIC**

OF NOTE: A lot of history is in that Stratocaster-like scroll headstock, whether Leo Fender ripped off Bigsby or was inspired, as he said, by early Martins. One thing: Travis wanted six-on-a-side tuners • Single-blade pickup handmade by Bigsby • Fretboard inlays are a heart, spade, diamond, and club • Travis called the walnut piece on the bass bout a "cosmetic armrest"

Kind of looks like a Fender before there was Fender, which is why this is among the most significant guitars ever made—it really embodies the idea of what a modern solid-body electric guitar should be, and it came first. Paul Bigsby, whose name is most known to guitarists because of his eponymous vibrato system, was a former motorcycle racer, shop foreman, and designer who then moved into the guitar world, where he brought some amazing innovations (see the double-neck on page 154). Here he worked with country singer Merle Travis—who created the "Travis pick" style of playing—to realize Travis's dreams of that "ringing" instrument.

Old-School American Beauty

MODEL: **DYER STYLE 8 SYMPHONY HARP GUITAR**

BUILDER: **LARSON BROTHERS, C. 1920**

TYPE: **HARP GUITAR**

OF NOTE: Hollow arm with a second sound hole and elaborately designed "headstock" holding six bass strings

The American harp guitar found its true form beginning in the 1890s, when Chris Knutsen, a Norwegian immigrant, designed an instrument with a hollow arm extending out from the body to hold the bass strings. This not only gave the harp guitar its great look, but also contributed to its superior tone. In 1912, his patent expired, and by 1917, Chicago's prolifically talented Larson Brothers began making harp guitars for a Minnesota instrument dealer named W. J. Dyer.

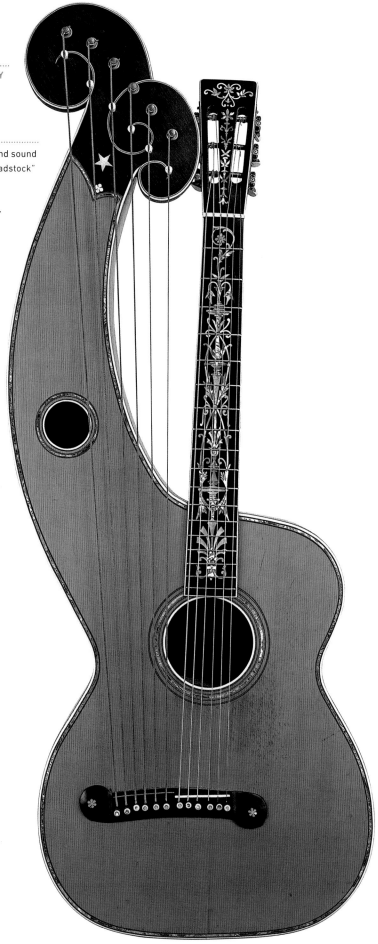

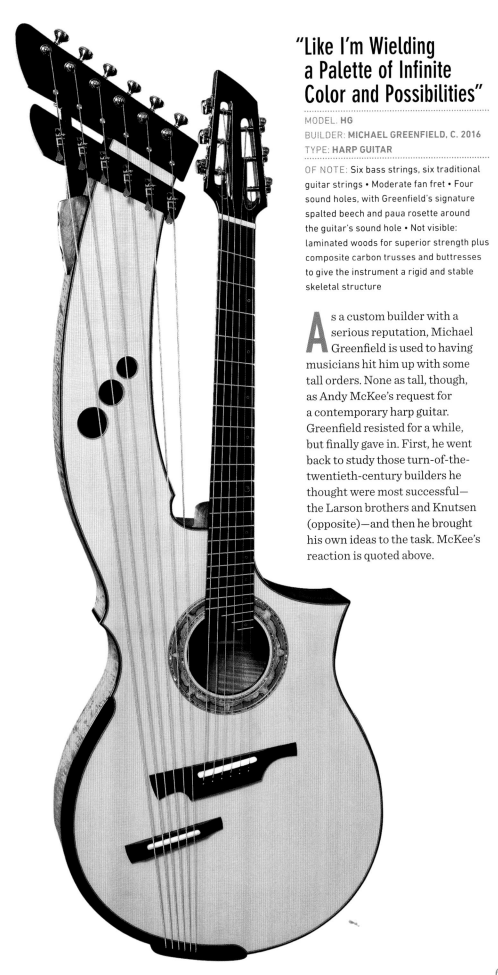

"Like I'm Wielding a Palette of Infinite Color and Possibilities"

MODEL. **HG**

BUILDER: **MICHAEL GREENFIELD, C. 2016**

TYPE: **HARP GUITAR**

OF NOTE: Six bass strings, six traditional guitar strings • Moderate fan fret • Four sound holes, with Greenfield's signature spalted beech and paua rosette around the guitar's sound hole • Not visible: laminated woods for superior strength plus composite carbon trusses and buttresses to give the instrument a rigid and stable skeletal structure

As a custom builder with a serious reputation, Michael Greenfield is used to having musicians hit him up with some tall orders. None as tall, though, as Andy McKee's request for a contemporary harp guitar. Greenfield resisted for a while, but finally gave in. First, he went back to study those turn-of-the-twentieth-century builders he thought were most successful—the Larson brothers and Knutsen (opposite)—and then he brought his own ideas to the task. McKee's reaction is quoted above.

CRAZY SHAPES

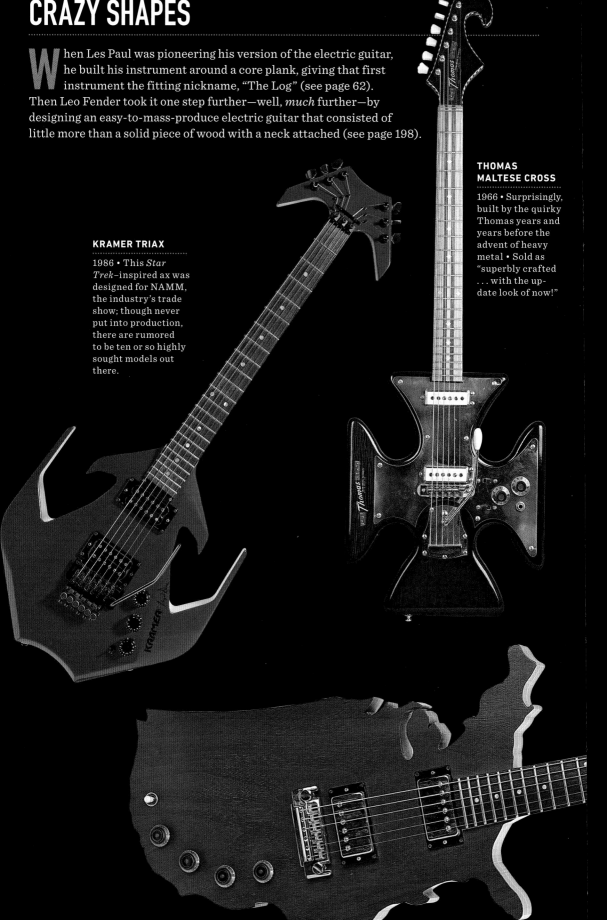

When Les Paul was pioneering his version of the electric guitar, he built his instrument around a core plank, giving that first instrument the fitting nickname, "The Log" (see page 62). Then Leo Fender took it one step further—well, *much* further—by designing an easy-to-mass-produce electric guitar that consisted of little more than a solid piece of wood with a neck attached (see page 198).

THOMAS MALTESE CROSS

1966 • Surprisingly, built by the quirky Thomas years and years before the advent of heavy metal • Sold as "superbly crafted . . . with the up-date look of now!"

KRAMER TRIAX

1986 • This *Star Trek*–inspired ax was designed for NAMM, the industry's trade show; though never put into production, there are rumored to be ten or so highly sought models out there.

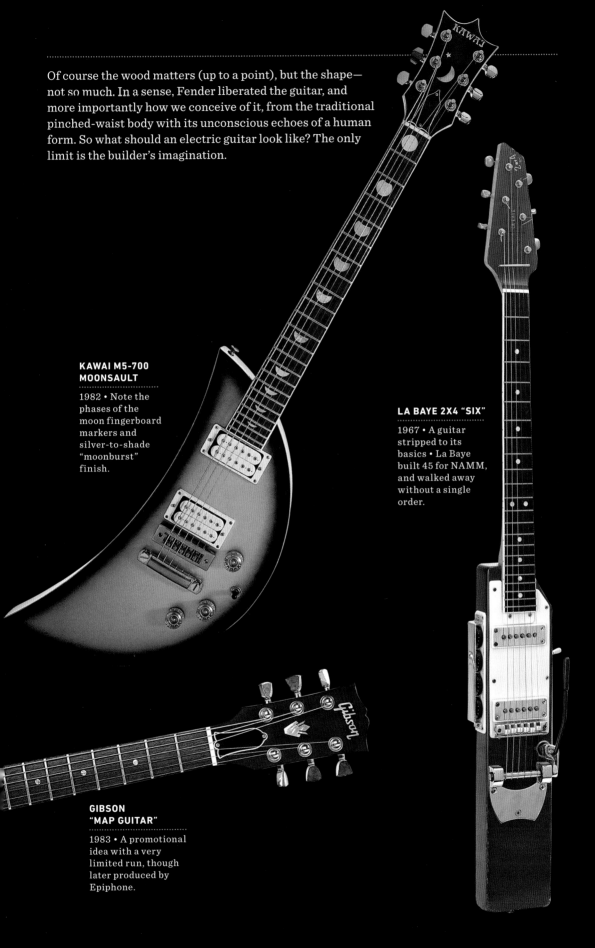

Of course the wood matters (up to a point), but the shape—
not so much. In a sense, Fender liberated the guitar, and
more importantly how we conceive of it, from the traditional
pinched-waist body with its unconscious echoes of a human
form. So what should an electric guitar look like? The only
limit is the builder's imagination.

**KAWAI M5-700
MOONSAULT**

1982 • Note the
phases of the
moon fingerboard
markers and
silver-to-shade
"moonburst"
finish.

LA BAYE 2X4 "SIX"

1967 • A guitar
stripped to its
basics • La Baye
built 45 for NAMM,
and walked away
without a single
order.

**GIBSON
"MAP GUITAR"**

1983 • A promotional
idea with a very
limited run, though
later produced by
Epiphone.

John's
(GEORGE HAD ONE TOO)

MODEL: **J-160E**
BUILDER: **GIBSON, 1964**
TYPE: **AMPLIFIED FLATTOP ACOUSTIC**

OF NOTE: Uncovered P-90 pickup •
Stripped finish • Drawings by John Lennon
made during a 1968 Bed-In for Peace with
Yoko in Montreal

On September 10, 1962, John Lennon and George Harrison each took possession of a brand-new sunburst J-160E. The next day, Lennon used his to record "Love Me Do." The original was stolen during a Christmas show in 1963, but Lennon quickly replaced it, gave it a trippy psychedelic paint job, then later stripped it down to its natural wood. Harrison's, on the other hand, was the one guitar he claimed to have used on every Beatles record from "Please Please Me" through *Abbey Road*. But why? In trying to amplify a dreadnought, Gibson made a series of design choices—laminated (i.e., plywood) top, ladder bracing to fight feedback, an adjustable bridge—that made it an acoustically inferior instrument.

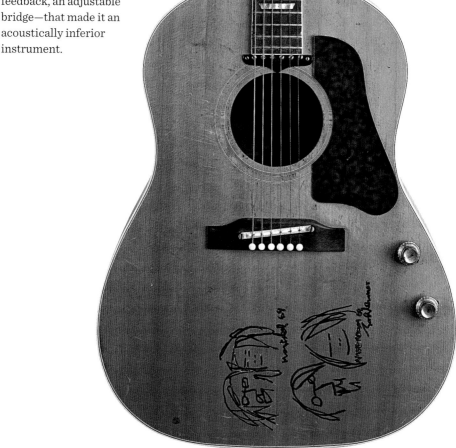

Drive My Guitar

MODEL: **CASINO**
BUILDER: **EPIPHONE, 1962**
TYPE: **THINLINE HOLLOW-BODY ELECTRIC**

OF NOTE: Chrome-plated "dog-ear" P-90 pickups • Though a middling model, McCartney put it on the map—"If I had to choose one electric guitar, it would be this"—and the roster of Casino players is impressive, from the Beatles to the Edge, Keith Richards to Thom Yorke

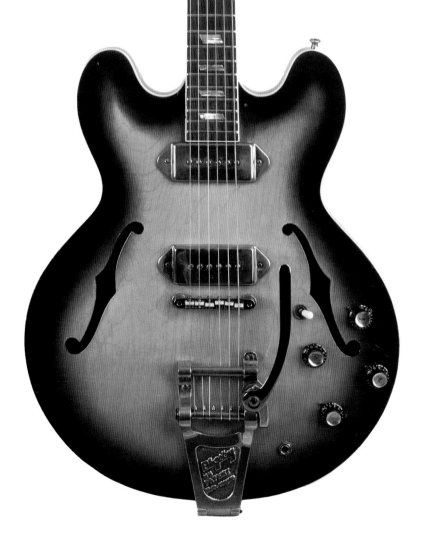

Think of Beatles-era Paul, and the instrument that comes to mind is the famous Hofner violin bass. (It was £70 cheaper than a Fender and, with its symmetrical body, he thought it wouldn't look "daft" played left-handed.) But McCartney did lots of guitar work in the studio, primarily on this Epiphone Casino that he acquired in 1964. A true hollow-body, with two P-90 pickups, it has the real "Beatles sound," not only heard on Paul's solos on "Ticket to Ride," "Drive My Car," and "Taxman," but throughout—because by 1966, John and George decided to pick up their own Casinos. For John, in fact, it became his main guitar with the Beatles, though it looked very different with its natural wood body—while the band and friends were in India studying with the maharishi, Donovan convinced John and George to strip the finish for a better sound.

The Originator

MODEL: **TORRES**

BUILDER: **ANTONIO DE TORRES JURADO,
1883/1888**

TYPE: **FLATTOP CLASSICAL**

OF NOTE: The great care in selecting and shaving the soundboard, the internal fan bracing, the 650-mm scale length • One wistful thought—guitars, unlike violins, do not continue to "play" at the height of their powers for centuries; unlike a violinist picking up a Stradivarius, a guitarist playing a Torres can only imagine how the instrument sounded in its prime

Most every straight male of a certain age understands intuitively one of the guitar's primal appeals: its feminine curves. How perfect, then, to learn that according to stories told by his descendants, Antonio de Torres Jurado based his *plantilla*—the guitar body's template—on the figure of a young woman he saw in Seville. Perfect, because it's Torres's *plantilla* that gives form to virtually every classic guitar made since. In fact, this genius of a luthier *created* the modern classical guitar. He took all the best basic elements that existed and refined them, rethought them, and married them in a way that made something completely new and infinitely better. In so doing, he essentially changed the idea of what a guitar could do, giving it new life with a new range of dynamics and color, of feeling, power, and expressiveness.

"Everything in Music"

MODEL: **WASHBURN 108**
BUILDER: **LYON & HEALY, 1892**
TYPE: **FLATTOP ACOUSTIC**

OF NOTE: That pearl! That purfling! But though it may be hard to believe, a Style "9" has even more decoration than this one • Dimple of pearl on the lower bout—what do you see in the silhouette?

Not a manufacturer per se, but a brand name, the first Washburn guitars were made in Chicago by the company founded by George Washburn Lyon and Patrick J. Healy in 1864. When Lyon retired at the end of the century, Healy guided the company for the next twenty-five years, during which it made "everything in music" at every kind of price range. This Style 108—the "1" stands for its body size, the "8" for the level of decoration—is an outstanding example of their turn-of-the-century work. Oddly enough, Washburn guitars would also be made by J. R. Stewart, Gibson, and Regal, before resurfacing as a contemporary brand unrelated to the original.

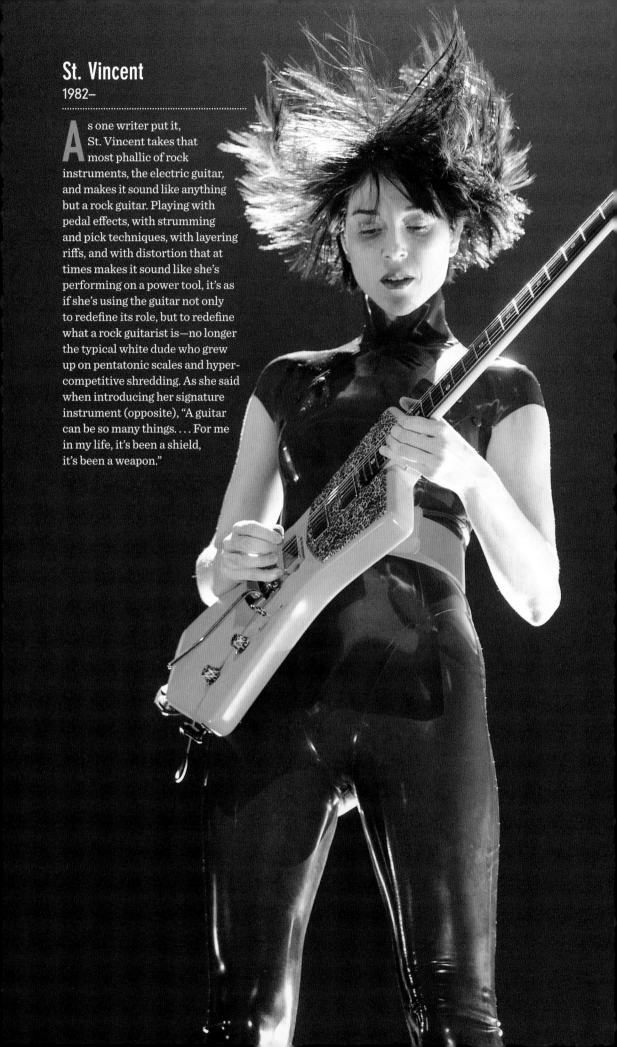

St. Vincent
1982–

A s one writer put it, St. Vincent takes that most phallic of rock instruments, the electric guitar, and makes it sound like anything but a rock guitar. Playing with pedal effects, with strumming and pick techniques, with layering riffs, and with distortion that at times makes it sound like she's performing on a power tool, it's as if she's using the guitar not only to redefine its role, but to redefine what a rock guitarist is—no longer the typical white dude who grew up on pentatonic scales and hyper-competitive shredding. As she said when introducing her signature instrument (opposite), "A guitar can be so many things. . . . For me in my life, it's been a shield, it's been a weapon."

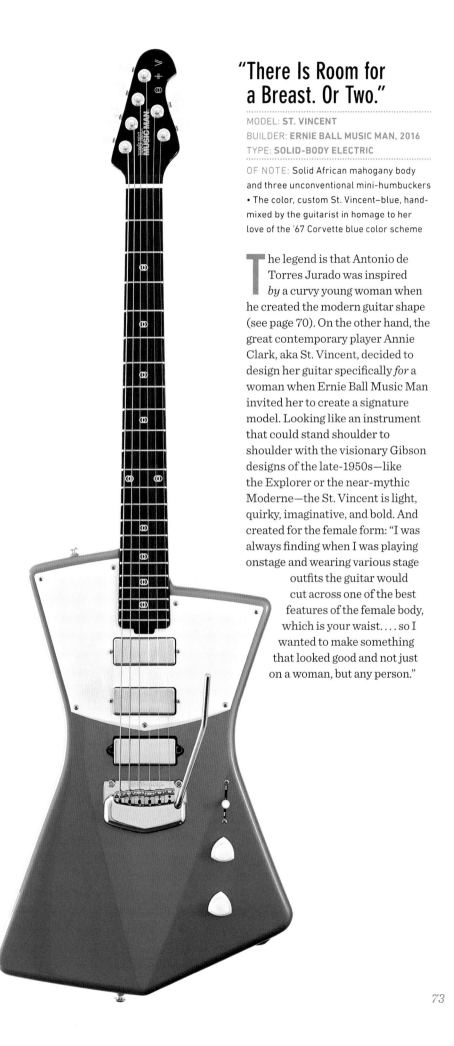

"There Is Room for a Breast. Or Two."

MODEL: **ST. VINCENT**
BUILDER: **ERNIE BALL MUSIC MAN, 2016**
TYPE: **SOLID-BODY ELECTRIC**

OF NOTE: Solid African mahogany body and three unconventional mini-humbuckers • The color, custom St. Vincent–blue, hand-mixed by the guitarist in homage to her love of the '67 Corvette blue color scheme

The legend is that Antonio de Torres Jurado was inspired *by* a curvy young woman when he created the modern guitar shape (see page 70). On the other hand, the great contemporary player Annie Clark, aka St. Vincent, decided to design her guitar specifically *for* a woman when Ernie Ball Music Man invited her to create a signature model. Looking like an instrument that could stand shoulder to shoulder with the visionary Gibson designs of the late-1950s—like the Explorer or the near-mythic Moderne—the St. Vincent is light, quirky, imaginative, and bold. And created for the female form: "I was always finding when I was playing onstage and wearing various stage outfits the guitar would cut across one of the best features of the female body, which is your waist.... so I wanted to make something that looked good and not just on a woman, but any person."

Factory Craftsman

MODEL: **KALAMAZOO AWARD**
BUILDER: **GIBSON, 1978**
TYPE: **ARCHTOP ACOUSTIC**

OF NOTE: A 17-inch, full-bodied archtop, with maple back and sides • Woodgrain pickguard with tree and eagle inlay, which repeats on the headstock—the eagle also appears on the wood tailpiece • Only eighty-five of these were made

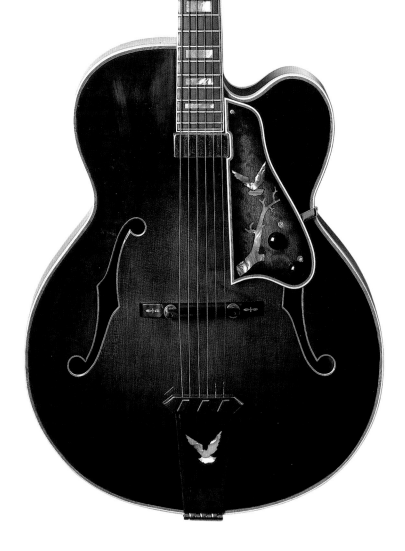

The name on the headstock says "Gibson," but it should really say Wilbur Fuller. The top Gibson craftsman, he finally convinced the powers-that-be to allow him to build—truly build—the first hand-carved, tuned-by-ear guitar in Gibson's history. And he did it, painstakingly carving, gluing, tapping, listening, and ungluing, recarving, retuning, and regluing, until the back, braces, and top were just in tune—all by ear. When launched in 1978, the Kalamazoo Award was Gibson's most expensive guitar ever.

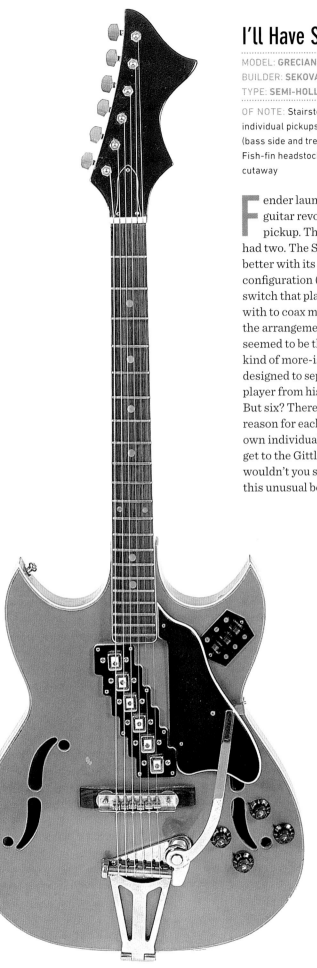

I'll Have Six

MODEL: **GRECIAN**
BUILDER: **SEKOVA, C. 1968**
TYPE: **SEMI-HOLLOW-BODY ELECTRIC**

OF NOTE: Stairstep configuration of six individual pickups, with stereo output (bass side and treble side) • Gold finish • Fish-fin headstock and double Florentine cutaway

Fender launched the solid-body guitar revolution with one pickup. The original Les Paul had two. The Stratocaster did one better with its iconic three-pickup configuration (and a selector switch that players loved to fiddle with to coax more sounds out of the arrangement). Four pickups seemed to be the tipping point, a kind of more-is-less engineering designed to separate an aspiring player from his hard-earned cash. But six? There's no good acoustic reason for each string to have its own individual pickup (until you get to the Gittler, see page 83), but wouldn't you stop twice to admire this unusual beauty?

Fanciful, Practical

MODEL: **LYRE-GUITAR**
BUILDER: **LUIGI MOZZANI, C. 1915**
TYPE: **ACOUSTIC HARP GUITAR**

OF NOTE: The whole instrument is hollow, including the arms • Three extra bass strings on the lyre side • An early—and patented—bolt-on neck: six adjustable bolts (three at the heel, three at the headstock) hold the neck in place

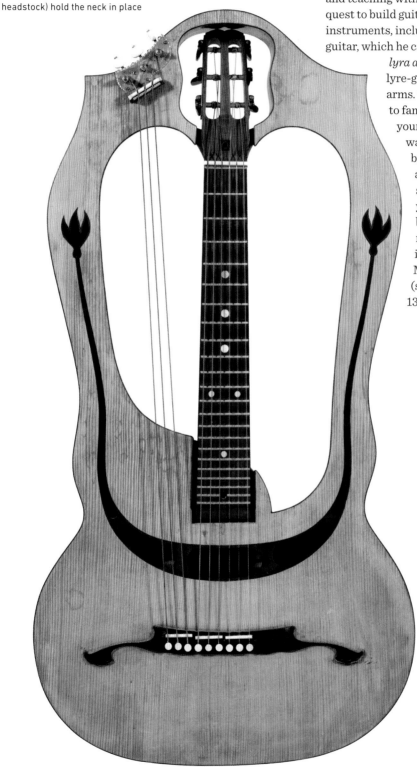

There comes that moment in every prodigy's young life when he or she encounters *it*. In Mozzani's case, he was a dirt-poor musician (at that time, a clarinetist) who lived with his family in Faenza when he heard a guitar one evening. Thus began a lifelong journey that balanced performing, composing, and teaching with an innovative quest to build guitars and guitarlike instruments, including this lyre-guitar, which he called a *chitarra lyra a due bracci*—a lyre-guitar with two arms. One other claim to fame: An eager young Italian who was accepted by Mozzani as an apprentice, stayed twelve years, and would become even more significant in guitar history: Mario Maccaferri (see pages 134, 137).

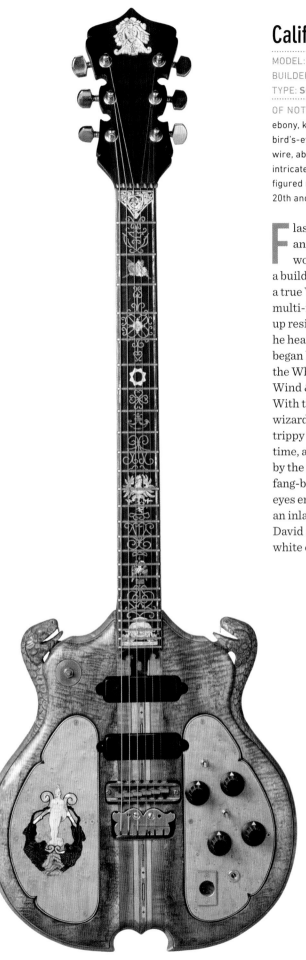

California Dreaming

MODEL: **BECVAR**
BUILDER: **BRUCE BECVAR, 1973–1974**
TYPE: **SOLID-BODY ELECTRIC**

OF NOTE: A smorgasbord of woods—ebony, koa, mahogany, rosewood, bird's-eye maple—and materials—bone, wire, abalone, mother-of-pearl • Massive, intricately carved headstock • Highly figured neck joins the body between the 20th and 21st frets

Flash-forward six decades and here is another unique work of guitar art created by a builder/musician—in this case, a true Windham Hill, New Age multi-instrumentalist who took up residence in Sonoma when he heard the call of lutherie and began building custom guitars for the Who, Carlos Santana, Earth Wind & Fire, and other major acts. With that '60s psychedelia-meets-wizard-craftsman look, it feels trippy and substantial at the same time, and you can be mesmerized by the details, including the pair of fang-bearing snakes with turquoise eyes emerging from the upper bouts, an inlaid scene from the story of David and Goliath, and the Polish white eagle on the twelfth fret.

Groovy

MODEL: **BIANKA**
BUILDER: **HOYER, 1961**
TYPE: **SEMI-HOLLOW-BODY ELECTRIC**

OF NOTE: Lightning-bolt f-holes • Unique parallelogram pickups • Engraved buttons on the tuners • And of course the unusually grooved top, which carries over to the back and is emphasized by the use of the German carve (where the edges of the guitar's top are lower than the actual top—also visible on the Mosrite Ventures, on page 145)

t was only natural that rock and roll accompanied the American GIs who were stationed in Germany in the 1950s and 1960s—including the king himself, Elvis Presley. Plus, as every music fan knows, British bands like the Beatles cut their teeth performing live in German clubs. Unfortunately, the instruments those rockers played—the Gibsons and Fenders—were priced too high for the average aspiring German musician. So, German manufacturers stepped into the market, including Hoyer, a musical instrument maker founded in 1874. At the top of the line was this striking Bianka, a wide, semi-hollow-body electric guitar with extraordinary design choices. Collectors swear by how well it plays. Another famous Hoyer was the inexpensive steel-string acoustic given to Eric Clapton for his thirteenth birthday—the guitar god's first guitar.

Fit for a Royal
(CATALOG SHOPPER)

MODEL: **OLD KRAFTSMAN "CROWN"**
BUILDER: **KAY, 1941**
TYPE: **FLATTOP ACOUSTIC**

OF NOTE: The elaborate crown-shaped sound hole • Equally eye-catching, the series of martial medieval fretboard inlays—another crown, a horse, a pennant, a saber, an ax, the point of a lance • Blank scroll on the headstock, perhaps waiting for the owner's name to be engraved

Before the internet, and before the rise of the megastore, there was the mail-order house. One such was Spiegel, among one of America's longest-running direct-marketing and catalog companies. It thrived during the Depression by offering "no charge for credit," and in the years just before World War II, it shifted to some higher-end offerings, like this top-of-the-line Old Kraftsman guitar made by Kay. (Old Kraftsman was Spiegel's brand, and Kay was just one of their vendors.) Very short-lived, though—the war effectively shifted production away from most nonessential items, so they had to stop making this one in 1942.

Rockabilly Twang from the Heart of Brooklyn

MODEL: **CHET ATKINS COUNTRY GENTLEMAN**

BUILDER: **GRETSCH, 1960s**

TYPE: **HOLLOW-BODY ELECTRIC**

OF NOTE: Filter'Tron pickups, Gretsch's answer to the humbucker and source of "that great Gretsch sound" • Thumbprint fret markers, the fake f-holes, Bigsby vibrato, mute knobs, standby switch, and master volume knob

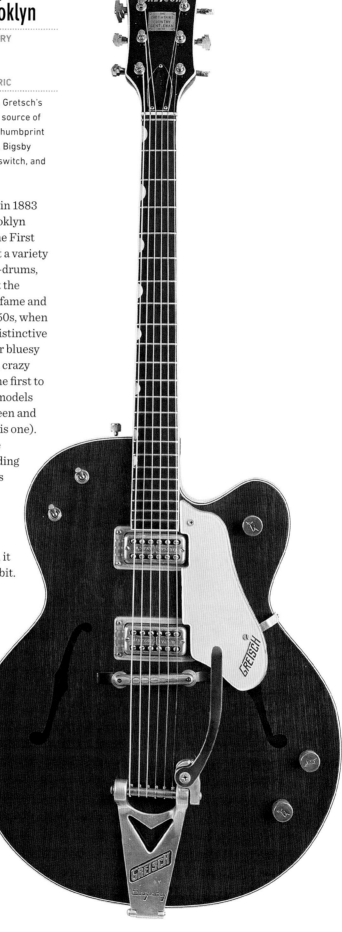

Founded in New York in 1883 and relocated to Brooklyn around the time of the First World War, Gretsch built a variety of musical instruments—drums, banjos, tambourines. But the company didn't find real fame and fortune until the mid-1950s, when it introduced its highly distinctive electric guitars with their bluesy twang, flashy design, and crazy wild colors—they were the first to amp up the palette with models that came in Cadillac Green and Flagstaff Sunset (as in this one). They also attracted some serious musicians, including Chet Atkins, who gave his name to several models that he helped design. When George Harrison played a Country Gentleman on television, it sent the company into orbit.

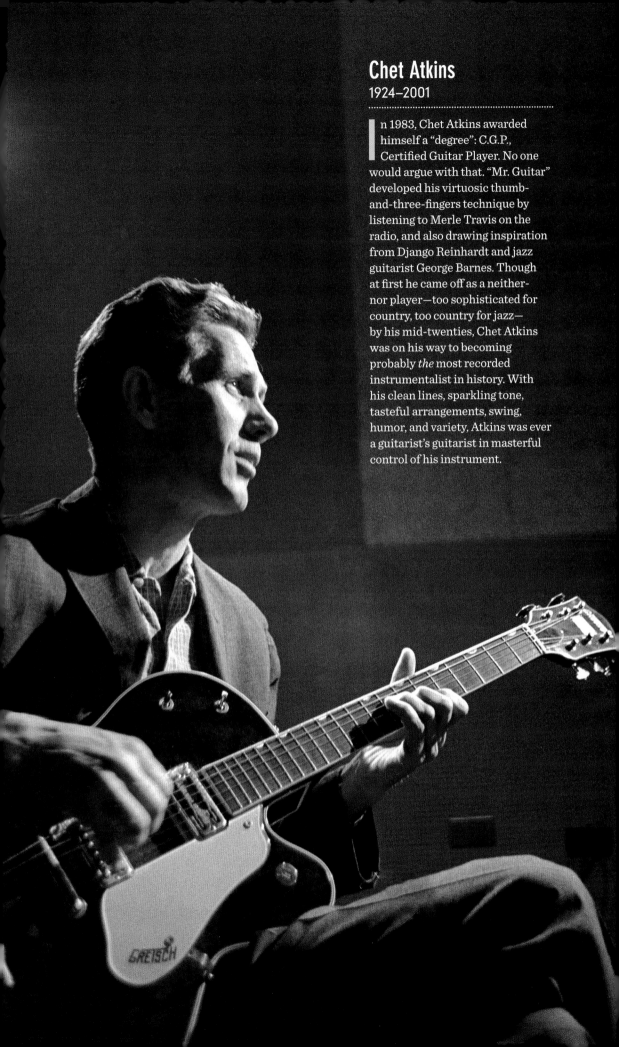

Chet Atkins
1924–2001

In 1983, Chet Atkins awarded himself a "degree": C.G.P., Certified Guitar Player. No one would argue with that. "Mr. Guitar" developed his virtuosic thumb-and-three-fingers technique by listening to Merle Travis on the radio, and also drawing inspiration from Django Reinhardt and jazz guitarist George Barnes. Though at first he came off as a neither-nor player—too sophisticated for country, too country for jazz— by his mid-twenties, Chet Atkins was on his way to becoming probably *the* most recorded instrumentalist in history. With his clean lines, sparkling tone, tasteful arrangements, swing, humor, and variety, Atkins was ever a guitarist's guitarist in masterful control of his instrument.

His Master's Voice

MODEL: **STROVIOLS**
BUILDER: **GEORGE EVANS & CO., 1920s**
TYPE: **ACOUSTIC**

OF NOTE: Metal cone with a diaphragm sits behind the strings, delivering tone to the attached metal megaphone • Cone swivels away, allowing the guitar to be played either in Spanish or Hawaiian style

Tackling the problem of how to amplify a violin, an English watchmaker named John Matthias Augustus Stroh replaced the instrument's body with a vibrating "diaphragm" attached to a megaphone. The result was a kind of early phonograph, the large cone focusing the sound waves in such a way that they were able to cut more easily into the wax of a wax recording. He patented the invention in 1899, and his son Charles began building instruments—violins, violas, cellos, mandolins, and guitars—under the name Stroviols. Later, George Evans & Co. in London took over the manufacture of these unusual instruments, making them until 1942. Only three of these guitars are known to exist today.

Where'd Everything Go?

MODEL: **GITTLER**
BUILDER: **GITTLER, 1987**
TYPE: **BODILESS ELECTRIC**

OF NOTE: No body, no head, and frets fanning out from the stainless-steel spine like ribs, giving the guitar the nickname "Fishbone Gittler" • Each string has its own pickup and output, allowing them to be amplified and modified separately or together

Who needs a headstock? Who needs a body? Through and through, the Gittler is the logical conclusion of what's left when everything inessential is removed from the electric guitar. Or, in the words of its creator, Allan Gittler, "The fundamental beauty of a stringed instrument . . . is that your flesh—your 'vibes'—are in direct contact with its linear motor, the string. . . . So I prefer to be holding as little as possible when I'm searching for the nuances of my sound through the vastness of the electronic sea." You can see Andy Summers of the Police playing a Gittler on the "Synchronicity II" video.

Guitar-Making Prodigy

MODEL: **TAYLOR**
BUILDER: **BOB TAYLOR, C. 1972**
TYPE: **FLATTOP ACOUSTIC**

OF NOTE: Built by a kid in high school, on his own, from plans he read about in Irving Sloane's 1966 book, *Classic Guitar Construction* • The abalone inlay comes from shells that Taylor, who grew up in Southern California, harvested himself from the nearby Pacific

A surprising number of great players got their start on homemade stringed instruments that they themselves built. As a child, Bob Taylor was bitten by the same bug—but as a builder, not a player. Soon after making this guitar, he joined a collective where he stood out as the kid who'd rather actually build guitars than get stoned and talk about them. He then partnered with Kurt Listug, as gifted in selling as Taylor was in making. The rest as they say, is history—for almost half a century, Taylor the company has been known for making some of the most popular, playable, environmentally sustainable, and innovatively designed acoustic and acoustic-electric guitars ever.

"King of the Flattop Guitars"

MODEL: **SJ-200**
BUILDER: **GIBSON, 1959**
TYPE: **FLATTOP ACOUSTIC**

OF NOTE: Everything is bigger and fancier, including the oversize decorated pickguard and pearl markers on the fretboard • Distinctive mustache bridge shaped like cattle horns • Narrower waist than Gibson's traditional jumbos

Martin had Gene Autry. Gibson had country-western singer and future cowboy star Ray Whitley. While at a rodeo show in Madison Square Garden in the late 1930s, Whitley got together with a Gibson man named Guy Hart and suggested the company build a real country music guitar. So Gibson invited Whitley to the Kalamazoo plant, and he gave Gibson designers some ideas—enlarge the body, make it deeper, increase the scale length. They liked what they heard so much that they got to work that very day creating a big, flamboyant showpiece that became known as the Super Jumbo 200. With its stage-worthy looks and deep, powerful, balanced tone, the SJ-200 has attracted an impressive lineup of players including Mance Lipscomb, Bob Dylan, Reverend Gary Davis, Emmylou Harris, Keith Richards, and the Edge.

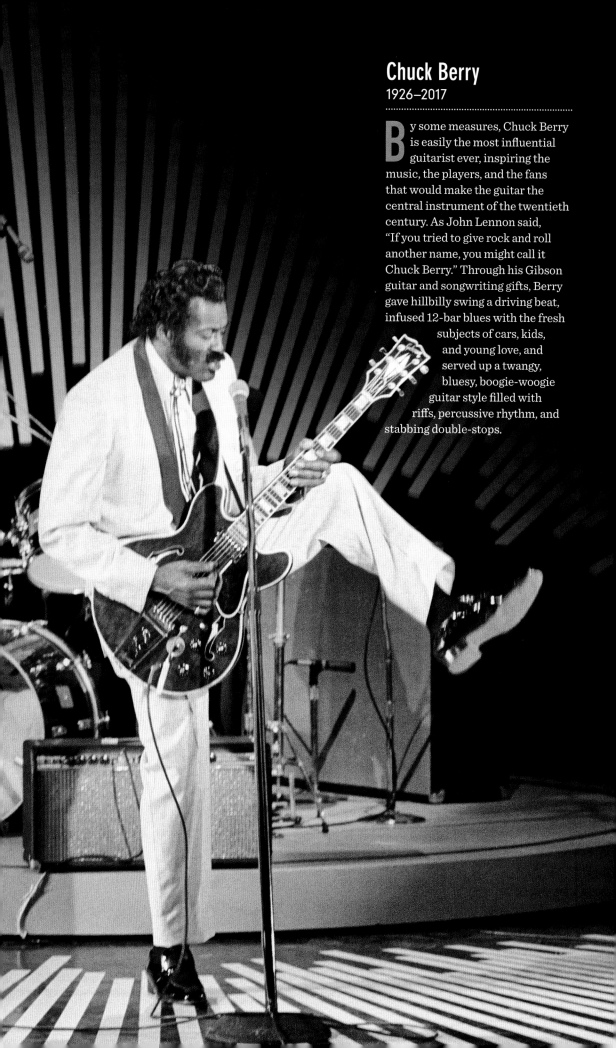

Chuck Berry
1926–2017

By some measures, Chuck Berry is easily the most influential guitarist ever, inspiring the music, the players, and the fans that would make the guitar the central instrument of the twentieth century. As John Lennon said, "If you tried to give rock and roll another name, you might call it Chuck Berry." Through his Gibson guitar and songwriting gifts, Berry gave hillbilly swing a driving beat, infused 12-bar blues with the fresh subjects of cars, kids, and young love, and served up a twangy, bluesy, boogie-woogie guitar style filled with riffs, percussive rhythm, and stabbing double-stops.

Thinline Masterpiece

MODEL: **ES-355TD**
BUILDER: **GIBSON, 1959**
TYPE: **SEMI-HOLLOW ELECTRIC**

OF NOTE: Gold hardware, including the Bigsby vibrato tailpiece • Pearly block markers on an ebony fretboard • Split diamond headstock inlay (used on high-end Gibsons, like the Super 400) and serious binding

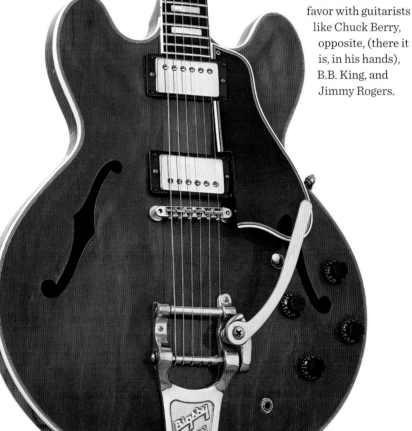

Fast on the heels of 1958's groundbreaking ES-335, the thinline masterpiece (see page 114), Gibson, ever the savviest of marketers, introduced the ES-355TD, a slightly fancier version with all the trimmings. The "T" stood for "thinline," and the "D" for "double pickups"—yes, you very well might ask why. You might also wonder if it had an identity crisis—other than the Bigsby, and its inaugural cherry red finish, nothing essential differentiated it from the 335. So later that year (1959), Gibson gave it stereo wiring—"stereophonic" was just coming into its own, and this split the pickups so that players would feed into two amps (not going to happen)—and something called a Vari-tone selector with additional six tone options that, when added to the pickup selector, resulted in eighteen variations of tonal output. Too much? Sales tell the story, as 335s far outpaced the 355. Still, this deluxe model found much favor with guitarists like Chuck Berry, opposite, (there it is, in his hands), B.B. King, and Jimmy Rogers.

"It Looks Like Something You Found on the Beach"

MODEL: **FLY ARTIST**
BUILDER: **KEN PARKER, 2000**
TYPE: **SOLID-BODY ELECTRIC**

OF NOTE: Lightweight, resonant, solid Sitka-spruce body strengthened with composite materials • A pair of DiMarzio magnetic humbuckers and a Fishman piezo pickup • Sperzel locking tuners • Ergonomic body

Ken Parker is an esteemed luthier who begins his work by asking "why," as in the case of solid-body electric guitars: Why are they so heavy? Why are they still made the same way they were fifty years ago? Why, when you put one on your lap and let go, does the body tip to the floor while the headstock smacks you in the face? Working with Larry Fishman, of pickup fame, Parker reinvented and radically changed the electric guitar with the Fly, one of the lightest and most versatile guitars ever made—though it's interesting to get Joni Mitchell's opinion about its appearance (see headline)!

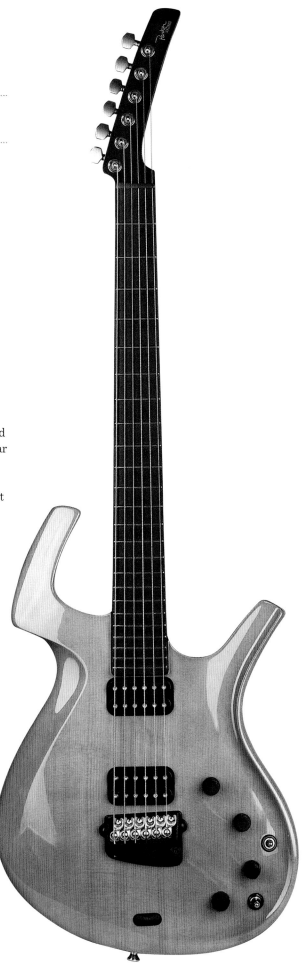

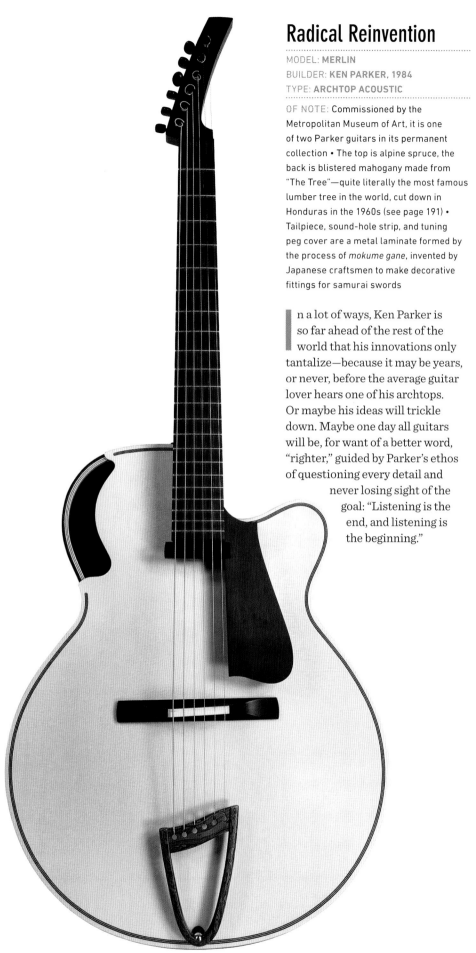

Radical Reinvention

MODEL: **MERLIN**
BUILDER: **KEN PARKER, 1984**
TYPE: **ARCHTOP ACOUSTIC**

OF NOTE: Commissioned by the
Metropolitan Museum of Art, it is one
of two Parker guitars in its permanent
collection • The top is alpine spruce, the
back is blistered mahogany made from
"The Tree"—quite literally the most famous
lumber tree in the world, cut down in
Honduras in the 1960s (see page 191) •
Tailpiece, sound-hole strip, and tuning
peg cover are a metal laminate formed by
the process of *mokume gane*, invented by
Japanese craftsmen to make decorative
fittings for samurai swords

In a lot of ways, Ken Parker is
so far ahead of the rest of the
world that his innovations only
tantalize—because it may be years,
or never, before the average guitar
lover hears one of his archtops.
Or maybe his ideas will trickle
down. Maybe one day all guitars
will be, for want of a better word,
"righter," guided by Parker's ethos
of questioning every detail and
never losing sight of the
goal: "Listening is the
end, and listening is
the beginning."

Summer of Love

MODEL: **MOSRITE CUSTOM 6-
AND 12-STRING**
BUILDER: **SEMIE MOSELEY, 1967**
TYPE: **SOLID-BODY ELECTRIC**

OF NOTE: The classic trappings of a Mosrite guitar, including the signature "M" headstock, in a completely original body shape • Beautiful ornamentation including flowers on the 12-string

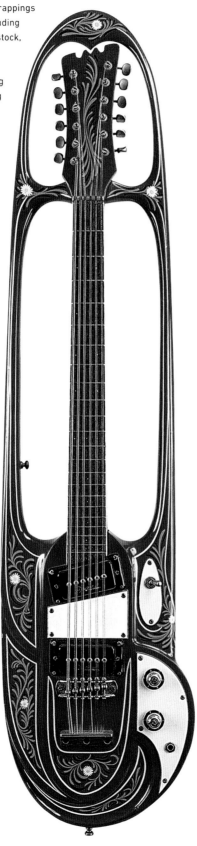

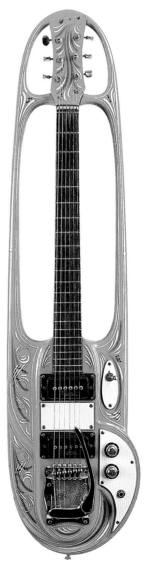

Readers of a certain age will encounter the next three words—"Incense and Peppermints"—and not be able to get the song out of their heads for quite a while. Sorry! But it was that hit that propelled the psychedelic band, the Strawberry Alarm Clock, to great but short-lived fame and fortune. It also inspired the quirky California guitar maker Semie Moseley to make this suite of custom instruments for the band. After creating the bodies, Moseley sent the guitars to the California artist Von Dutch, famous for pin-striping cars and surfboards, which gave these instruments the nickname "the surfboard guitars." The band, however, referred to them as giant safety pins, and because of difficulties keeping them in tune, never actually used them.

Napkin Dreams

MODEL: **MK-80 CUSTOM**
BUILDER: **PENSA, 2007**
TYPE: **SOLID-BODY ELECTRIC**

OF NOTE: The essence of an MK—easy-playing Strat body with exquisite woods and workmanship • Custom painted by Marie Pensa • The MK designation might stand for Mark Knopfler, but he doesn't have a monopoly on playing a Pensa—other guitarists include Peter Frampton, Eric Clapton, Lou Reed, Lenny Kravitz, and more

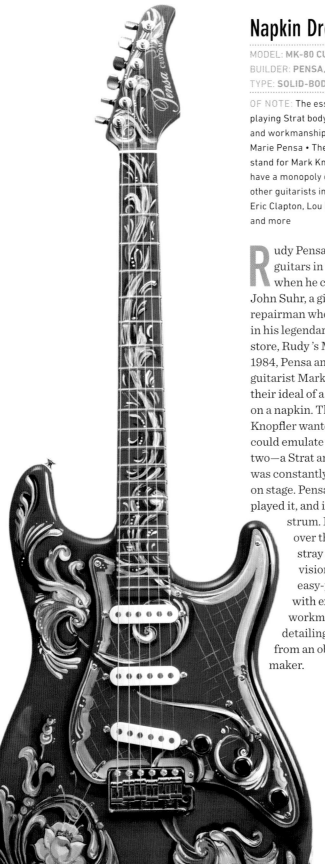

Rudy Pensa got his start building guitars in the early 1980s when he collaborated with John Suhr, a gifted builder and repairman whom he employed in his legendary New York guitar store, Rudy's Music. Then, in 1984, Pensa and his friend, the guitarist Mark Knopfler, sketched their ideal of a solid-body electric on a napkin. The story goes that Knopfler wanted just one guitar that could emulate the sounds of the two—a Strat and a Les Paul—that he was constantly switching between on stage. Pensa made it, Knopfler played it, and it was love at first strum. MKs have evolved over the years, but never stray from the original vision of marrying the easy-playing Strat body with exquisite woods, workmanship, and custom detailing that can come only from an obsessive boutique maker.

Freedom of Experimentation

MODEL: **MILLENNIUM**
BUILDER: **THOMAS HUMPHREY, 1987**
TYPE: **FLATTOP CLASSICAL**

OF NOTE: Distinctive scroll carved into the headstock • F-holes on the upper bout—uncharacteristic not only for their use on a classical guitar, but also for how wide they are

Thomas Humphrey had been building acclaimed nylon-string guitars for almost fifteen years when the innovations that led to his famous Millennium model came to him in a dream. He'd been searching for a way to overcome the classical guitar's limited projection and sustain. Then he woke up with answers—set the neck and strings at an oblique angle to the top, using an elevated fretboard, and taper the body, from thinner at the neck to deeper at the bottom. The result is a visually striking instrument with a large, rich, resonant tone. He also tinkered with other parts of the guitar's design vocabulary. Later on, Humphrey collaborated with the artist Tamara Codor, who painted the backs and sides of select Millennium guitars, giving them a secret, romantic identity invisible from the front. Sadly, in 2008 Humphrey died of a heart attack at the age of fifty-nine.

Sharon Isbin

1956–

A guitar in Sharon Isbin's hands, a reviewer once wrote, takes on the precision of a diamond, every note a facet that is clear, polished, and shining. Isbin gets right to the heart of the guitar's intimate nature: "There are no keys, no bow . . . you literally caress the instrument and the strings," she says. She studied with Segovia, founded the classical guitar department at Juilliard, and won back-to-back Grammys. She also works hard on the issue facing every classical musician: how to keep relevant. Her solution—expand the repertoire, which means you might have heard her on the soundtrack of *The Departed*, or performing with Steve Vai.

Guitars! Teenagers! TV!

MODEL: **LES PAUL TV SPECIAL**
BUILDER: **GIBSON, 1957**
TYPE: **SOLID-BODY ELECTRIC**

OF NOTE: A Les Paul in design, but flat "slab" mahogany body • Two P-90 pickups • That signature mustard color

I
t's the great confluence of postwar cultural trends: teens playing electric guitars on TV! And Gibson, the savviest and most protean of American guitar makers, sensed an opportunity to broadcast to a wide audience. They lightened the weight (and price tag) of their flagship solid-body Les Paul and colored it a translucent mustard yellow with the intention that it would show up well on black-and-white television while getting around the glare problem. They applied this same color to the Les Paul Juniors, merging the Junior and TV idea in a few more models, including a single pickup double-cutaway, with improved access to the upper frets, and then a 1961 Junior TV with the newly formed SG body.

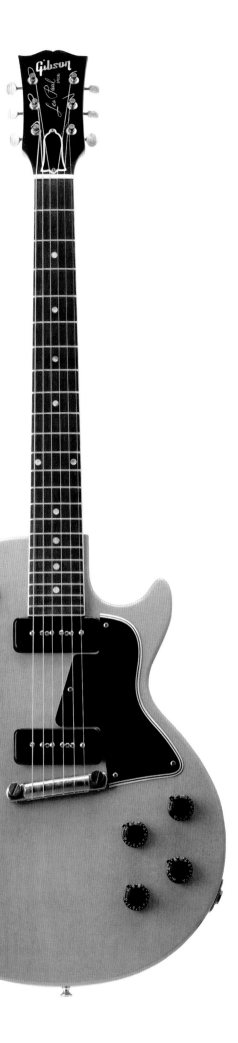

Silver Tones

MODEL: **SILVERTONE 1415**
BUILDER: **DANELECTRO, 1960**
TYPE: **SEMI-HOLLOW-BODY ELECTRIC**

OF NOTE: Iconic "lipstick" tube pickup—
which started, literally, when Danelectro
used empty lipstick tubes from a cosmetics
company as pickup covers • Headstock that
gives this model its "bottlenose dolphin"
nickname • It retailed in the Sears catalog
for $37.95

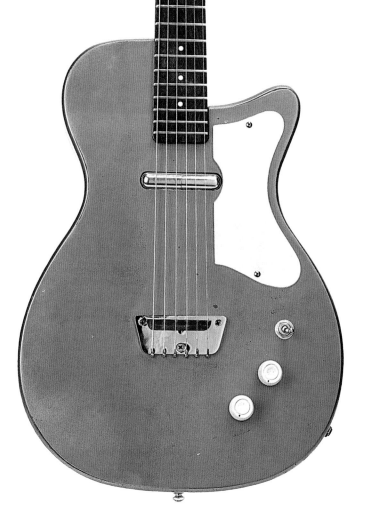

In his excellent history, *American Guitars*, Tom Wheeler compares Danelectros of the 1950s and 1960s to the Volkswagen Beetles of the same era—good, cheap, and reliable, and a great first guitar for a roster of players stretching from Jerry Garcia to Chet Atkins, Joan Jett to Jack White, Mark Knopfler to Brad Paisley. Founded by an electronics guy named Nathan I. Daniel who started with amplifiers, the Danelectro company moved into guitar making in the mid-'50s with a little push from Sears. For the next ten years plus, Danelectro rode the guitar boom, producing as many as two hundred guitars a day, sold through Sears under the Silvertone label.

The Mythical Burst

MODEL: **LES PAUL**
BUILDER: **GIBSON, 1959**
TYPE: **SOLID-BODY ELECTRIC**

OF NOTE: Yes, those are PAF (patent applied-for) humbuckers • The maple "cap" is book-matched to create symmetrical patterns under the cherry sunburst finish • Retro treble/rhythm switch with the poker chip cover

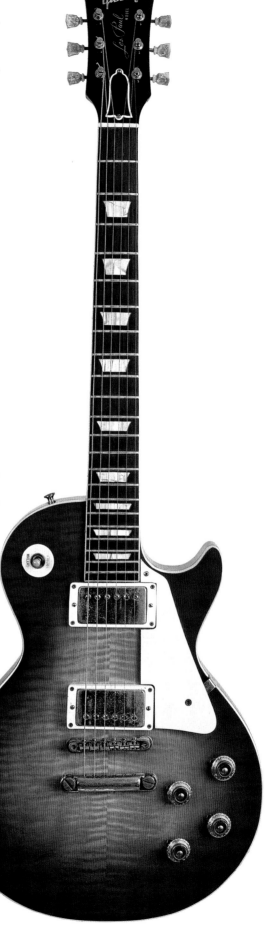

A mong the most coveted of all production guitars is a Les Paul from the late 1950s. These original "bursts," made from 1958 to 1960, have a legendary quality, a musicality, a soul that's never been duplicated. But it was rocky going. Competing with Fender and its success with the Telecaster, Gibson teamed up with the famous guitarist Les Paul to launch its own solid-body line, and the first Les Pauls shipped in 1952 with a striking gold finish. Yet by the late '50s sales were diminishing, so Gibson changed the look to the sunburst. Even then, it wasn't until the mid-1960s, when rockers such as Keith Richards, Eric Clapton, Jimmy Page, and Mike Bloomfield featured the guitar and its unmatched deep, throaty sound, that the model started to attain iconic status.

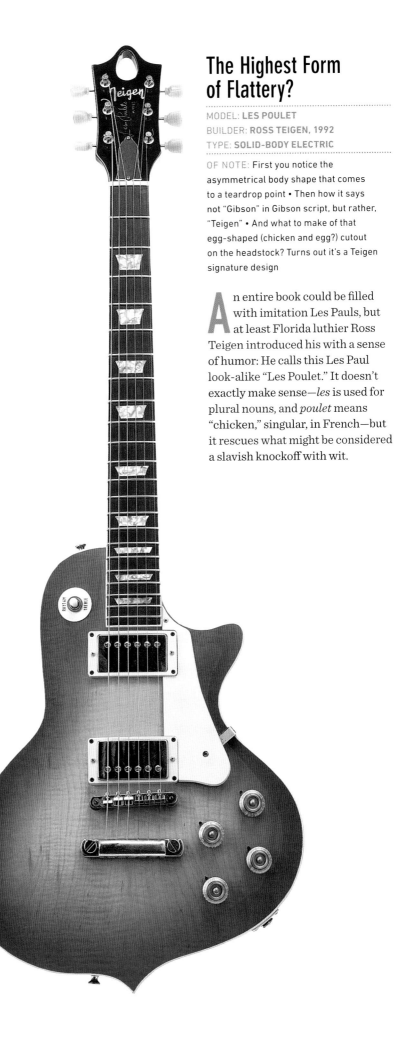

The Highest Form of Flattery?

MODEL: **LES POULET**
BUILDER: **ROSS TEIGEN, 1992**
TYPE: **SOLID-BODY ELECTRIC**

OF NOTE: First you notice the asymmetrical body shape that comes to a teardrop point • Then how it says not "Gibson" in Gibson script, but rather, "Teigen" • And what to make of that egg-shaped (chicken and egg?) cutout on the headstock? Turns out it's a Teigen signature design

An entire book could be filled with imitation Les Pauls, but at least Florida luthier Ross Teigen introduced his with a sense of humor: He calls this Les Paul look-alike "Les Poulet." It doesn't exactly make sense—*les* is used for plural nouns, and *poulet* means "chicken," singular, in French—but it rescues what might be considered a slavish knockoff with wit.

Neoclassical

MODEL: **CHANGUI**
BUILDER: **MICHAEL GREENFIELD, 2005**
TYPE: **FLATTOP ACOUSTIC**

OF NOTE: A radical, deep-voiced nylon string instrument with an extra bass string and, with the fanned frets, an unusual 29-inch to 25-inch scale length • Comfort bevel on the lower bout • Spalted beech and paua rosette • Sound port on the upper bout along with another bevel

Montreal-based luthier Michael Greenfield may use the hot, animal-hide glue that's been the choice of makers for centuries, but he's using it to create some fairly radical instruments (see page 65). He's also very comfortable building with the Novax Fanned-Fret system, which is designed to improve intonation by giving each string its own scale length while also matching the fretboard angle with the natural arc of the player's hand. Michael's passion is tone— "Great tone. FAT tone. I believe in squeezing every last molecule of tone out of my guitars"—and he puts every tool at his disposal toward achieving it.

Not So Classical

MODEL: **CARLEVARO**
BUILDER: **MANUEL CONTRERAS, 1983**
TYPE: **CLASSICAL ACOUSTIC**

OF NOTE: The obvious lack of a waist on the bass side, and the lack of a real sound hole • A second set of back and sides to help isolate the guitar from the player's body, and what looks like thick binding in the photograph is actually a gap between the guitar's top and the extra sides and back; it is from here that the sound is projected

Manuel Contreras was a sought-after cabinet maker in Madrid who joined the famous Ramirez guitar workshop at the invitation of José Ramirez III. Contreras soon became one of the great Spanish innovators, developing a "double top" guitar in the early 1970s— a second top was suspended beneath the first, to improve tone and volume. Then, in 1983, he unveiled the "Carlevaro," inspired by a Uruguayan guitarist Abel Carlevaro. All of its unconventional ideas are intended to increase the instrument's projection and tone, volume and resonance. Not many Carlevaros were made, and all are cherished.

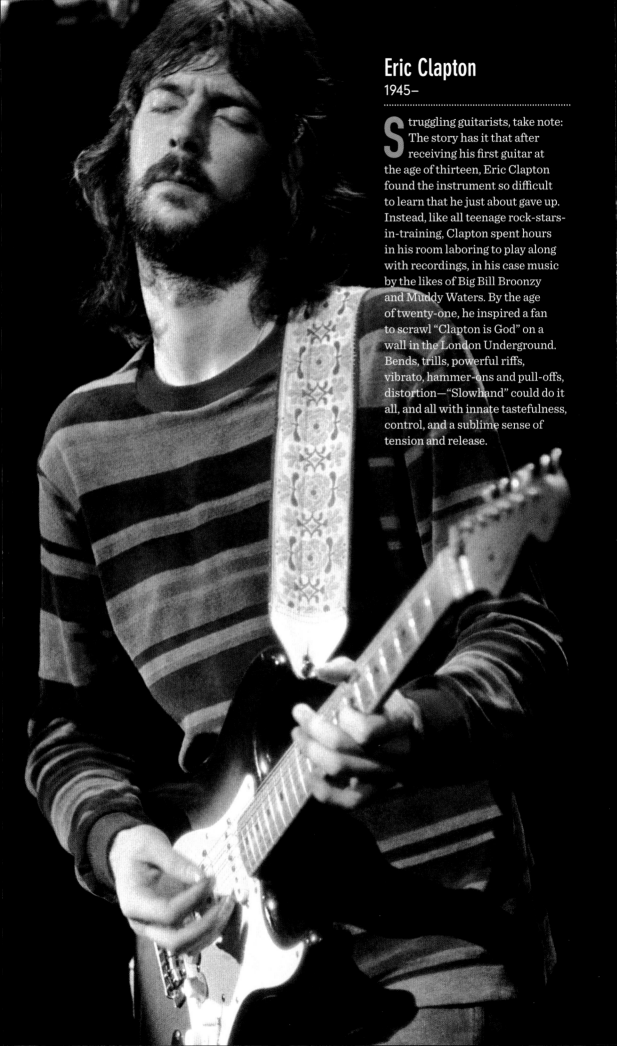

Eric Clapton
1945–

Struggling guitarists, take note: The story has it that after receiving his first guitar at the age of thirteen, Eric Clapton found the instrument so difficult to learn that he just about gave up. Instead, like all teenage rock-stars-in-training, Clapton spent hours in his room laboring to play along with recordings, in his case music by the likes of Big Bill Broonzy and Muddy Waters. By the age of twenty-one, he inspired a fan to scrawl "Clapton is God" on a wall in the London Underground. Bends, trills, powerful riffs, vibrato, hammer-ons and pull-offs, distortion—"Slowhand" could do it all, and all with innate tastefulness, control, and a sublime sense of tension and release.

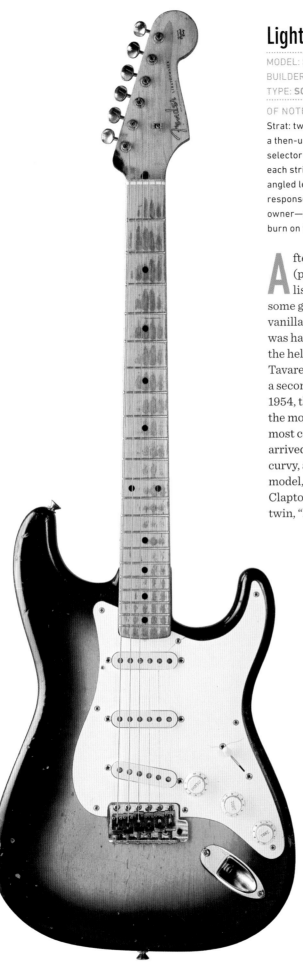

Lightning Strikes Twice

MODEL: **STRATOCASTER, "BROWNIE"**
BUILDER: **FENDER, 1956**
TYPE: **SOLID-BODY ELECTRIC**

OF NOTE: Everything is new on the Strat: two cutaways, the beveled body, a then-unheard-of three pickups with selector switch, adjustable bridge for each string, protected output jack, and angled lead pickup for better treble response • On this model, signs of its owner—scuffs, scratches, and cigarette burn on the headstock

After launching the Telecaster (page 198), Leo Fender listened to the reservations some guitarists had—too plain vanilla, and the heavy, blocky body was hard on the ribs—so with the help of two players, Freddie Tavares and Bill Carson, he created a second masterpiece. Unveiled in 1954, the Stratocaster is probably the most played, most popular, and most copied electric guitar ever. It arrived as if out of the future: sleek, curvy, and contoured. This sunburst model, from 1956, belonged to Eric Clapton—it also had a fraternal twin, "Blackie."

La Dolce Chitarra

MODEL: **"THE ARTIST" 700/4AV**
BUILDER: **EKO, 1964**
TYPE: **SOLID-BODY ELECTRIC**

OF NOTE: Multi-cutaway body • Six "press-button automatic tone selectors" to give players multiple options for dealing with the four pickups, plus a rhythm-solo switch • "Hockey-stick" headstock

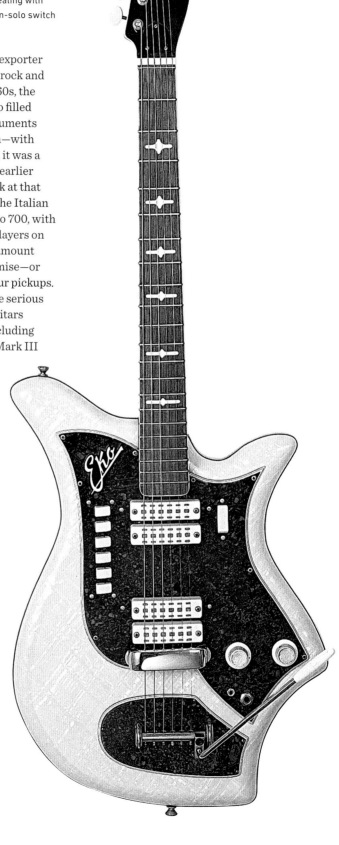

The largest European exporter of guitars during the rock and roll heyday of the 1960s, the Italian manufacturer Eko filled a niche—affordable instruments for the aspiring musician—with panache. Partly, perhaps, it was a vestige of the company's earlier focus on accordions: Look at that pearl! Or maybe it's just the Italian way with design. This Eko 700, with the triple-cutaway body, layers on not only a stage-worthy amount of eye candy, but the promise—or perhaps challenge—of four pickups. But the company did have serious cred—it produced Vox guitars during the same time, including popular models like the Mark III and the Vox Phantom.

The British Leo Fender

MODEL: **BLACK BISON**
BUILDER: **BURNS, 1961**
TYPE: **SOLID-BODY ELECTRIC**

OF NOTE: Deep "bison horn" cutaways •
Four Ormston Burns low-impedance Ultra
Sonic pickups • Curious metal cover over
the tuning posts—the metal parts were
originally gold-plated, providing even more
of a rich contrast with the deep black body

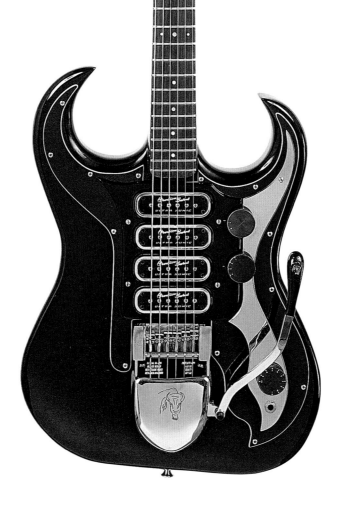

A legendary English guitar maker, Jim Burns created desirable, technically sophisticated, and undeniably cool electrics—and yet somehow managed to lose money during the greatest electric guitar boom in twentieth-century history. Regardless, the models Burns put out during the Ormston Burns company's first brief run, from 1960 to 1965 (often labeled Burns London), are classics, particularly the first Burns Bison, with its vaguely threatening horns and four pickups. Only fifty were built before Burns went to a revised three-pickup model—though with the three-pickup model came a knob that switched between these four factory settings: Split Sound, Bass, Treble, and Wild Dog. Forget cranking it up to eleven—who wouldn't want to bang out a tune in "Wild Dog"?

The Aristocrat
of Archtops

MODEL: **SUPER 400**
BUILDER: **GIBSON, 1935**
TYPE: **ARCHTOP ACOUSTIC**

OF NOTE: From gold plating on all the metal parts to the tiniest touches—note the parenthesis point at the end of the fretboard—the signs of luxury are everywhere • Unique layering technique used to achieve the marbleized-tortoise look of the pickguard

A decade after the milestone L-5, Gibson achieved the pinnacle of its archtop offerings with the Super 400, debuting in 1934. Here was an instrument that was simply bigger, bolder, richer—a massive 18-inch jazz masterpiece that exuded luxury from peghead to tailpiece. It was also quite an act of confidence on Gibson's part, introducing a $400 instrument during the very depths of the Great Depression, but they justified it by announcing: "Its price is a criterion of its quality." (Gibson's next priciest guitar was the $302 L-5). Musicians agreed, the gamble worked, and Gibson's competitors were quickly launching their own imitations.

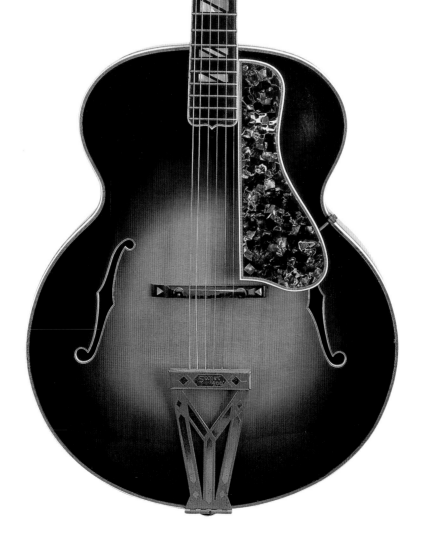

People's Instrument

MODEL: **ESQUIRE**
BUILDER: **REGAL, 1939**
TYPE: **ACOUSTIC ARCHTOP**

OF NOTE: "Coliseum" size • Brightly bound f-holes really pop against the sunburst carved spruce top • The headstock inlay: that figure of the guitarist confidently playing his instrument while walking away—who wouldn't want to see himself in that moment of pure freedom?

A number of guitar makers decided to keep Gibson company in the area of 18-inch acoustic archtops, including Regal, another Chicago powerhouse of musical-instrument manufacturing. Founded originally in Indiana, picked up by Lyon & Healy at the turn of the century, Regal produced an amazing number of instruments until World War II reversed its fortunes. At the height of the big-bodied archtop war in the late 1930s, Regal offered four different models, including this penultimate top-of-the-line Esquire. At $125, it was a bargain compared to the Gibson 400.

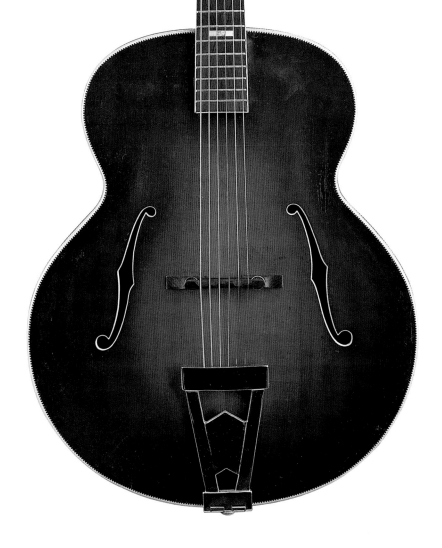

THE BLUES

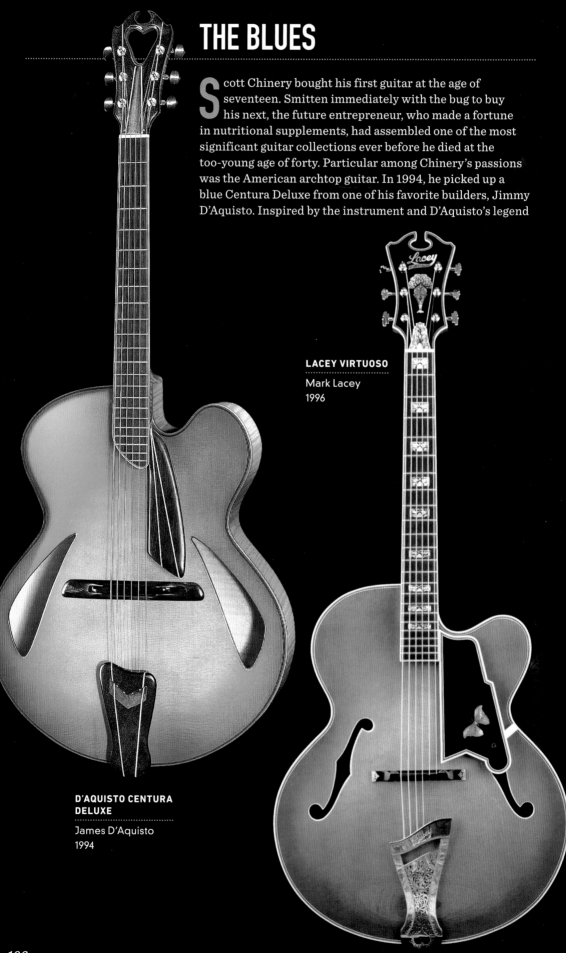

Scott Chinery bought his first guitar at the age of seventeen. Smitten immediately with the bug to buy his next, the future entrepreneur, who made a fortune in nutritional supplements, had assembled one of the most significant guitar collections ever before he died at the too-young age of forty. Particular among Chinery's passions was the American archtop guitar. In 1994, he picked up a blue Centura Deluxe from one of his favorite builders, Jimmy D'Aquisto. Inspired by the instrument and D'Aquisto's legend

LACEY VIRTUOSO

Mark Lacey
1996

**D'AQUISTO CENTURA
DELUXE**

James D'Aquisto
1994

(the luthier died soon after building it), Chinery reached out to twenty-one other archtop makers with an unusual commission: Build an 18-inch cutaway archtop, like the Centura, and finish it in Mohawk's Ultra Blue Penetrating Stain M520. The result is an astonishing survey of the contemporary archtop guitar. And oh, that BLUE.

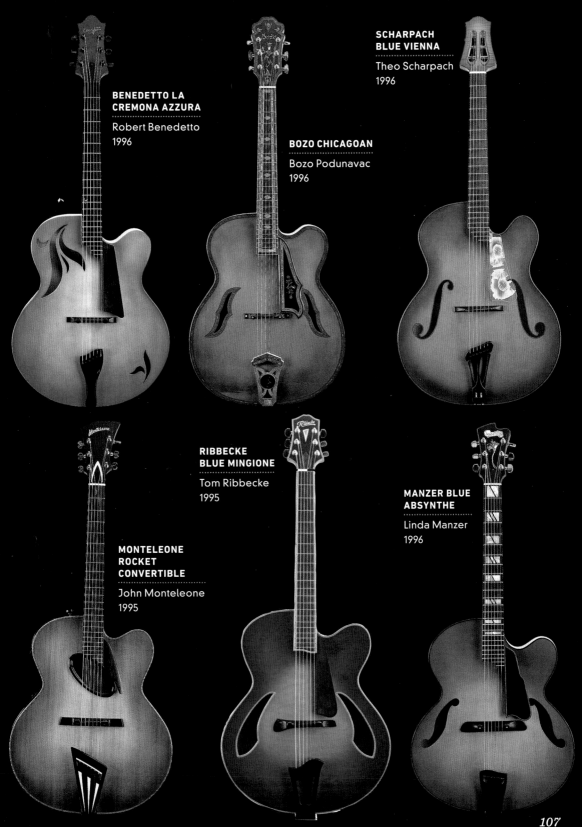

BENEDETTO LA CREMONA AZZURA

Robert Benedetto
1996

BOZO CHICAGOAN

Bozo Podunavac
1996

SCHARPACH BLUE VIENNA

Theo Scharpach
1996

MONTELEONE ROCKET CONVERTIBLE

John Monteleone
1995

RIBBECKE BLUE MINGIONE

Tom Ribbecke
1995

MANZER BLUE ABSYNTHE

Linda Manzer
1996

The One?

MODEL: **OM-28**
BUILDER: **MARTIN GUITAR, 1930**
TYPE: **FLATTOP ACOUSTIC**

OF NOTE: This early OM used banjo tuners, though they did not hold up well under the string pressure • No name on the headstock

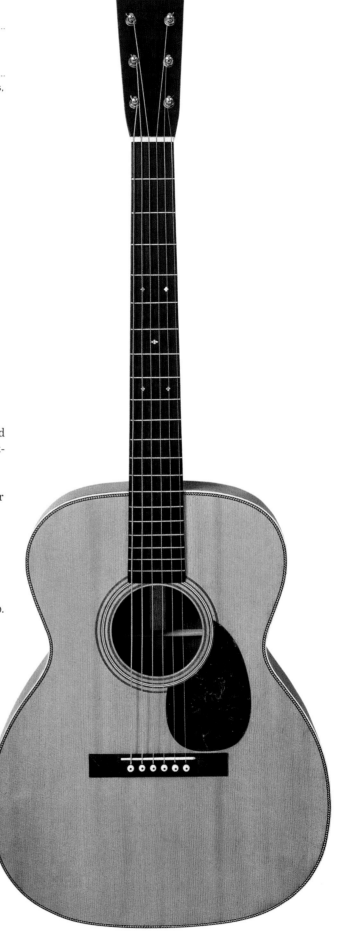

Time and again in the guitar's history, innovation is nudged along by a musician. The celebrated OM came about when a bandleader named Perry Bechtel approached Frank Henry Martin about building a guitar that was easier for a banjo player to use, suggesting an instrument with a longer, narrower 14-fret neck. Martin called it the OM for Orchestra Model. It didn't immediately cast the spell that it has today. Within a few years Martin started making 14-fret necks the de facto choice, and so decided they should follow their traditional naming conventions and call the OM a OOO. Confusing. Fast-forward to today, and two things happened: Those original OMs are among the most highly sought-after Martins ever made. And the OM is heralded as perhaps the most versatile and well-balanced steel-string acoustic design, handling all the basics like fingerpicking, flat-picking, strumming, and vocal accompaniment with equal aplomb.

The Gibson That's Always Good Enough

MODEL: **J-45**
BUILDER: **GIBSON, 1966**
TYPE: **FLATTOP ACOUSTIC**

OF NOTE: Standard sunburst finish, originally critical to the World War II–era J-45 because it could hide flaws in the wood available during wartime (a J-45 with a natural finish is designated a J-50)

Martin had the square-shouldered dreadnought, which for many epitomized the idea of a big acoustic guitar. And Gibson countered forever with their slope-shouldered jumbo. Multiple jumbos: the mythical Advanced Jumbo, the round-bottomed and often pinch-waisted Super Jumbos, the prewar J-35, and the rare, short-lived J-55 with its mustache bridge and stairstep peghead. Then, in 1942, Gibson introduced one of those special models where everything comes together: the workaday J-45. With its warm, sweet mahogany-body tone, superb playability, and outstanding value—listed originally at $45, hence the designation— the J-45 is among Gibson's most popular and successful guitars, appealing to a range of players from folk-blues artists like Mississippi John Hurt and Lightnin' Hopkins to Jeff Tweedy, Aimee Mann, and Bruce Springsteen.

Melt in Your Hands

MODEL: **EMMA MARIA**
BUILDER: **JUHA RUOKANGAS, 2018**
TYPE: **ARCHTOP ACOUSTIC**

OF NOTE: The back, sides, and neck are made from arctic birch, a wild and notoriously difficult local wood to work with • All the woods except for the ebony neck have been thermally treated through a process called torrefaction, developed in Finland in the 1990s to replicate the cellular change that occurs in aging • Princess inlay on the fretboard inspired by the work of Swedish artist John Bauer, whose illustrations for fairy tales are beloved by Juha's wife, Emma Maria

Juha Ruokangas builds guitars in Finland that, in looks and tone, rival anything made anywhere. When the guitar is good enough, he believes, it will melt in your hands. And those are just his standard models. Then come the instruments where he pushes his and his team's boundaries. Emma Maria, named after the love of his life, is the first Ruokangas acoustic archtop. In setting out to build such an instrument, the team set the bar really high, and delivered a guitar that captures all the passion and obsession that have driven Juha throughout his extraordinary career.

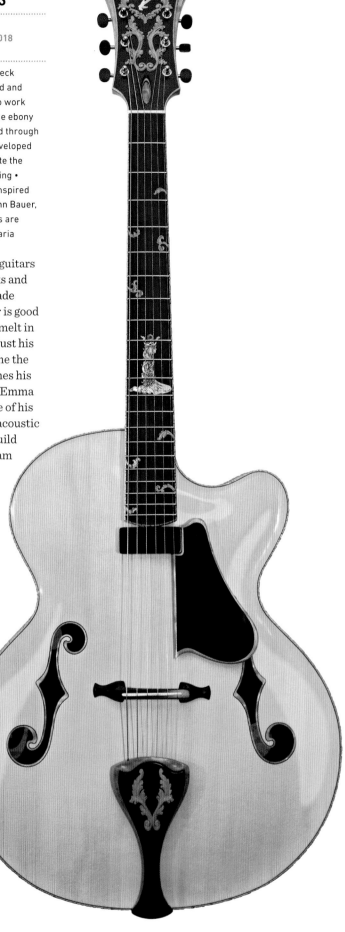

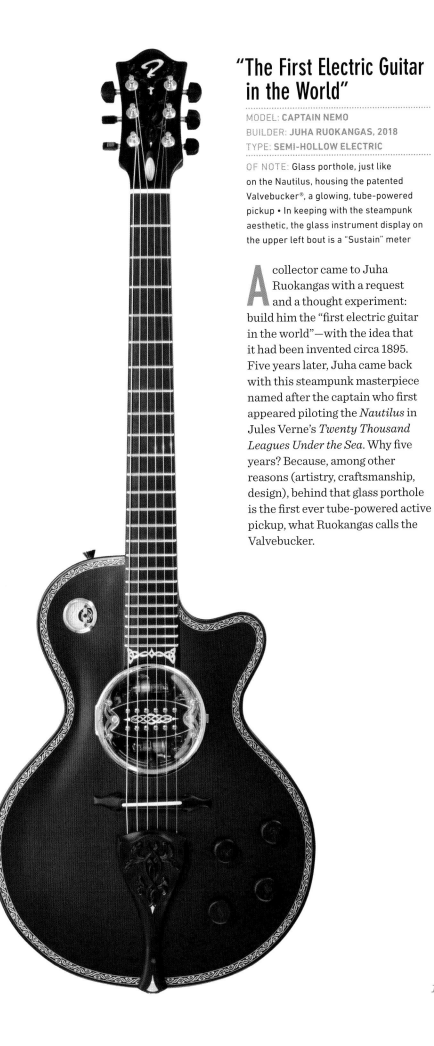

"The First Electric Guitar in the World"

MODEL: **CAPTAIN NEMO**
BUILDER: **JUHA RUOKANGAS, 2018**
TYPE: **SEMI-HOLLOW ELECTRIC**

OF NOTE: Glass porthole, just like on the Nautilus, housing the patented Valvebucker®, a glowing, tube-powered pickup • In keeping with the steampunk aesthetic, the glass instrument display on the upper left bout is a "Sustain" meter

A collector came to Juha Ruokangas with a request and a thought experiment: build him the "first electric guitar in the world"—with the idea that it had been invented circa 1895. Five years later, Juha came back with this steampunk masterpiece named after the captain who first appeared piloting the *Nautilus* in Jules Verne's *Twenty Thousand Leagues Under the Sea.* Why five years? Because, among other reasons (artistry, craftsmanship, design), behind that glass porthole is the first ever tube-powered active pickup, what Ruokangas calls the Valvebucker.

Space Age

MODEL: **SATURN 63**
BUILDER: **HOPF, C. 1965**
TYPE: **SEMI-HOLLOW ELECTRIC**

OF NOTE: Carved spruce top with teardrop sound holes on the bass side, bound in inlaid metal beading • Space-age control panel with a three-pin socket • Neck made of dozens of strips of 1-mm beech glued together to prevent warping

Hamburg's legendary Star-Club opened in 1962 and for the next seven years hosted some of the most important rock bands of the day, starting with the Beatles and including Jimi Hendrix, Cream, Little Richard, and many, many more. And this was the guitar they featured in their advertising, the Hopf Saturn 63, with a name and a look that has one foot in the world of earthy rock and roll and the other on an imaginary spaceship heading to Saturn.

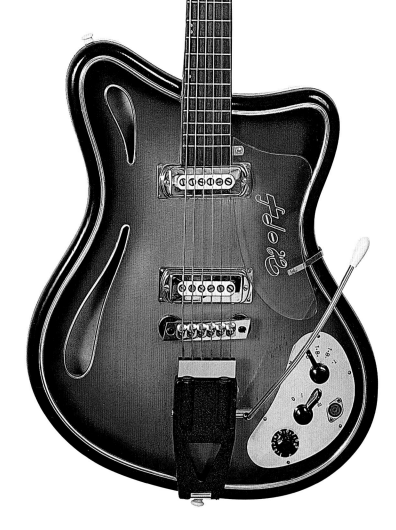

Flying Samurai

MODEL: **SG-5A**
BUILDER: **YAMAHA, 1967**
TYPE: **SOLID-BODY ELECTRIC**

OF NOTE: Asymmetrical reverse body shape—like the guitar is leaping forward—inspired the "flying samurai" nickname given to these 1960s Yamaha electrics • Crossed tuning fork logo on the narrow paddle headstock

Yamaha, who seems to make everything, including a lot of guitarists' first motorcycles, started manufacturing acoustic guitars after World War II and came out with its first solid-body electrics in the mid-1960s. And like this popular SG-5A, they were strong instruments in their own right—appearing before Japanese makers picked up a reputation, starting in the early 1970s, as low-quality copiers of Strats and Les Pauls. Ten years later, Yamaha would achieve real success when Carlos Santana started playing its double-cutaway SG-200.

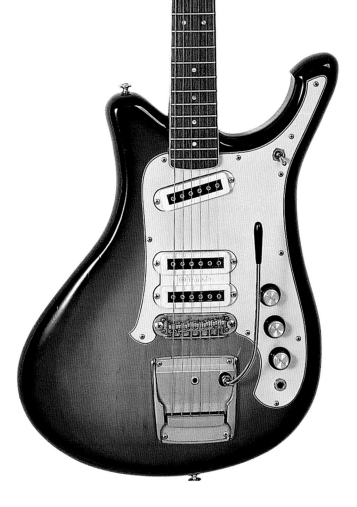

"Wonder-Thin" Wunderkind

MODEL: **ES-335**
BUILDER: **GIBSON, 1959**
TYPE: **SEMI-SOLID ELECTRIC**

OF NOTE: Aficionados call this one a "dot neck" because of the style of fret markers that were used until 1962 • Tune-O-Matic bridge and stop tailpiece • Sunburst finish—cherry red, which was the color of Eric Clapton's famous ES-335, wasn't available until 1960 (P.S., *that* particular instrument sold for $847,500 at Clapton's Crossroads Guitar Auction)

The year 1958 was a busy one for Gibson, which saw not only the introduction of the flamboyant but faltering "Modernistic" series of guitars (see pages 188–189), but also the thin-line design heralded by the ES-335. Considered one of the greatest milestones in electric guitar design, the 335 is a double-cutaway that marries the warmth of a hollow-body jazz guitar with the sustain of a solid-body electric. The innovation lies in the use of a maple block that runs down the middle of the "wonder-thin" body and eliminates the feedback problem endemic to hollow-body guitars played at high volume. A few variations followed almost instantly, including the fancy ES-355TD (see page 87), also launched in 1958, known to blues fans around the world as the Lucille guitar played by B.B. King.

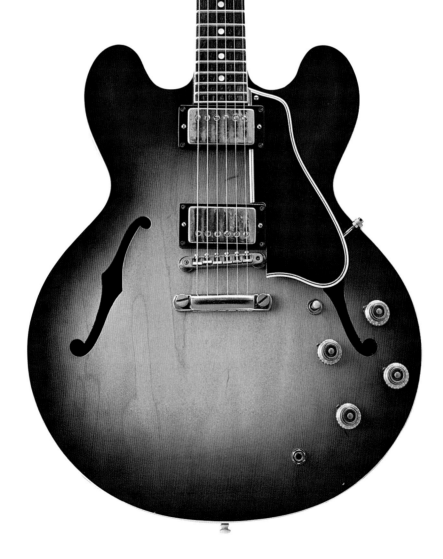

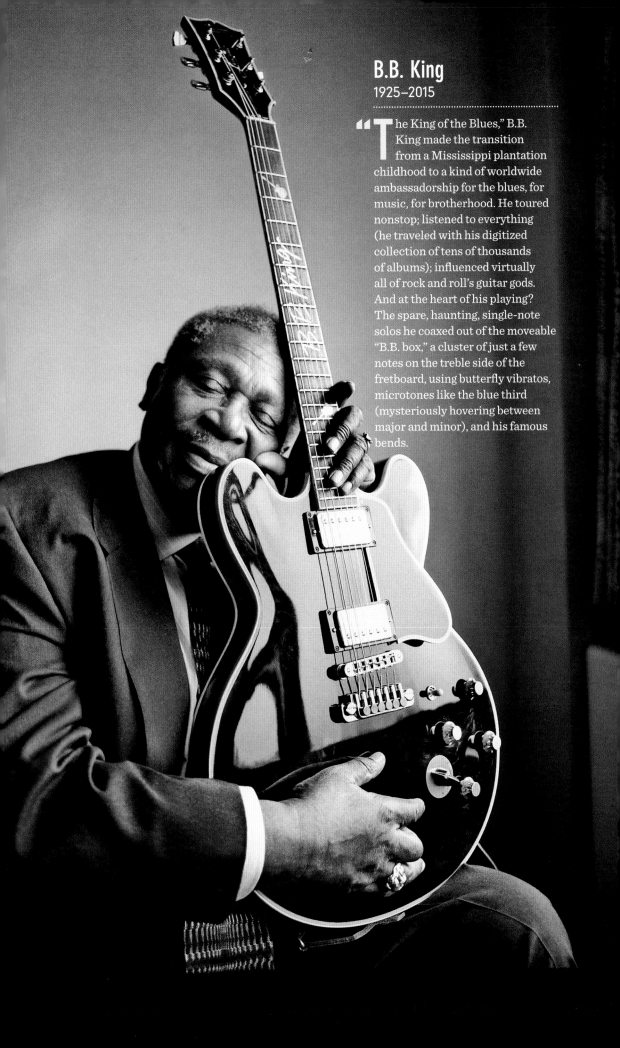

B.B. King
1925–2015

"The King of the Blues," B.B. King made the transition from a Mississippi plantation childhood to a kind of worldwide ambassadorship for the blues, for music, for brotherhood. He toured nonstop; listened to everything (he traveled with his digitized collection of tens of thousands of albums); influenced virtually all of rock and roll's guitar gods. And at the heart of his playing? The spare, haunting, single-note solos he coaxed out of the moveable "B.B. box," a cluster of just a few notes on the treble side of the fretboard, using butterfly vibratos, microtones like the blue third (mysteriously hovering between major and minor), and his famous bends.

It's Pronounced *Bo-zho*

MODEL: **BOZO REQUINTO/REQUINTO**
BUILDER: **BOZO PODUNAVAC, C. 1996**
TYPE: **FLATTOP ACOUSTIC**

OF NOTE: The extraordinary amount of decorative inlay • Neck joins the body at the 16th fret • That head on the headstock

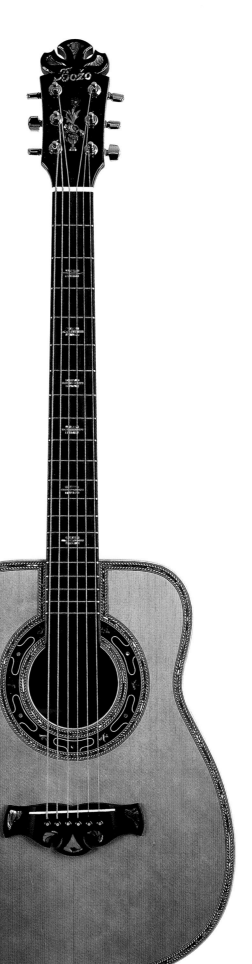

A Serbian master luthier, Bozo Podunavac emigrated to the US and started building his own guitars in Chicago in 1964. His instruments shimmer with pearl and abalone and are known for their rich tone and sustain, attracting players like Leo Kottke, who played 6- and 12-string Bozos in the early 1970s. When Bozo started building flattops, he first followed the traditional dreadnought design, but within a few years created a shape he called the Bell Western, which features a much larger lower bout topped by a much smaller lower bout. This Requinto shows Podunavac's unique Bell Western template, and also the Serbian's love for the ornate. By the way, a "Requinto guitar" is a small-bodied acoustic lead guitar in a mariachi band.

Flagship of the Martin Line

MODEL: **D-45**
BUILDER: **MARTIN, 1938**
TYPE: **FLATTOP ACOUSTIC**

OF NOTE: With its unique sunburst finish, this may be one of the rarest of the rare • Also unusual are the hexagon fretboard inlays, taken from Martin's ill-fated F-9 archtop • D-45s glitter with abalone, a shellfish whose mother-of-pearl interior gives us the name "pearl"

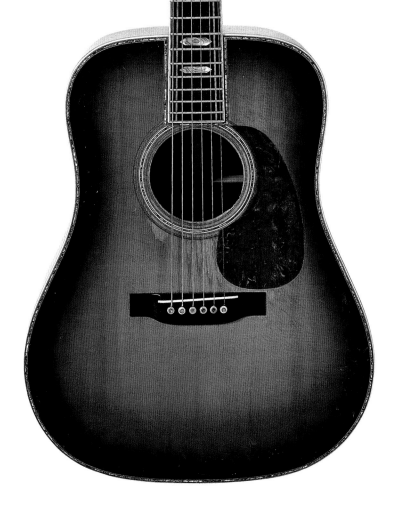

I n 1933, at the height of his popularity, the singing cowboy movie star Gene Autry contacted Martin and requested a custom guitar, a 12-fret dreadnought with style-45 trim and his name writ large in abalone along the fretboard. Martin then put the guitar into production as a 14-fret model, the D-45. Only ninety-one were built between 1933 and 1941, and they possessed extraordinary tone, quality, looks, and sheer presence. Neil Young, hearing that magic in old guitars—and who often shared the stage with Stephen Stills, whose D-45 hails from 1939—bought his own D-45 in 1967. Today, one of these prewar beauties carries an astronomical price tag.

The First Artist Model

MODEL: **NICK LUCAS**
BUILDER: **GIBSON, 1928**
TYPE: **FLATTOP ACOUSTIC**

OF NOTE: Though it is among the finest flattops Gibson ever made, the Nick Lucas saw a lot of tweaking in its original decade-long run—different woods, changes in the body shape. The main design constant was the significantly deeper (4½-inch) body • Banjo tuners

These days, artists' models and endorsements are a common strategy to connect customers with their favorite musicians—and builders with new customers. It all started when Gibson approached the most popular guitarist of the 1920s, the "Crooning Troubadour," Nick Lucas, who played a Gibson L-1 and who sold more than eighty million records, including hits like "Tiptoe Through the Tulips" and instrumental tracks such as "Teasing the Frets." Gibson may also have invented GAS (Guitar Acquisition Syndrome) with this bit of catalog description: "Here is an instrument with a big, harp-like tone, responsive to the lightest touch, balanced in every register. Crisp, sparkling treble and solid, resonant bass that makes your whole being sway to its rhythmic pulsations . . . an instrument by an artist, for an artist."

Plain as Poetry

MODEL: **00-17**
BUILDER: **MARTIN, 1949**
TYPE: **FLATTOP ACOUSTIC**

OF NOTE: Bob Dylan has used countless guitars in his never-ending life as a performer—this particular guitar he played almost exclusively during his earliest years in New York • The predecessor to this model, Martin's 2-17, has an even greater claim to guitar history—it was the first Martin braced for steel strings

Mahogany has always been considered a lesser tone wood, not just for the body of a guitar—rosewood is traditionally the preferred choice—but especially the top: "brown" guitars exude a Depression-era homeliness. On the other hand, an all-mahogany guitar, in the words of Taylor Guitars' Bob Taylor, "creates a warm, full tone with a sound all its own." So, occasionally even contemporary luthiers, who admire mahogany for its quick response and punchiness, will offer an updated version of this plain old Martin. Whether because of price or tone, blues and country players were the first to adopt mahogany guitars, and later folk singers, also looking for quality and plain authenticity at a low price, followed suit.

Jimmy Page
1944–

At the top of the pantheon of rock guitar gods stands the triumvirate—Hendrix, Clapton, and Jimmy Page. And of them, Page has perhaps the most varied career. He started, as a teenager, as a nonstop session musician, "Lil' Jim Pea," appearing on a ton of hits like Lulu's "Shout," Tom Jones's "It's Not Unusual," and Petula Clark's "Downtown." From there he went to the Yardbirds as the third brilliant English blues guitarist after Clapton and Jeff Beck, and then, of course, came his masterpiece, Led Zeppelin, which *Rolling Stone* called "the heaviest band of all time." Not only was he Zeppelin's guitarist, churning out one massively cool riff after another, followed by his breathtaking solos, but he essentially created the whole "light and shade" Led Zeppelin sound as its principle songwriter and producer. Humble may be the last word to describe Jimmy, but this quote does attest to his self-knowledge as an artist: "There are mistakes in my solos, but it doesn't matter. I will always leave in the mistakes."

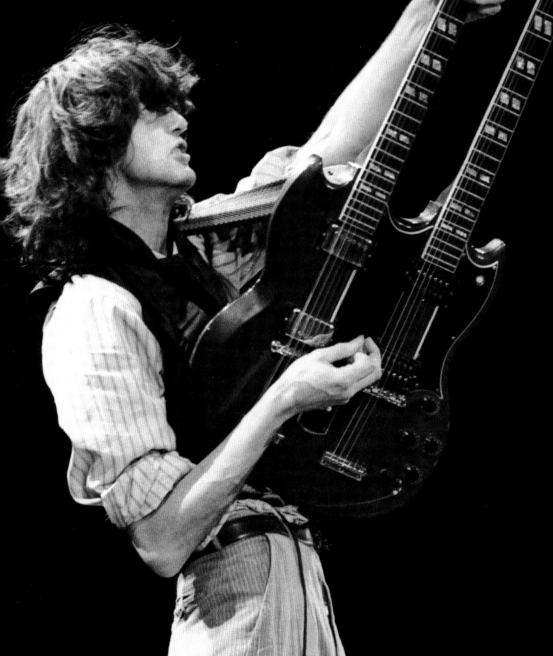

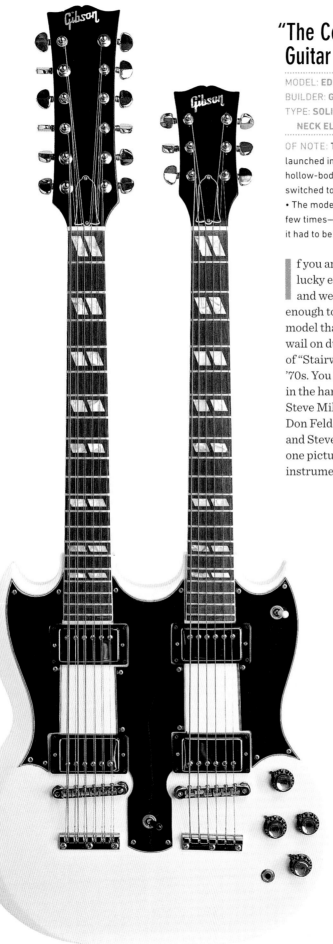

"The Coolest Guitar in Rock"

MODEL: **EDS-1275**
BUILDER: **GIBSON, 1964**
TYPE: **SOLID-BODY DOUBLE-NECK ELECTRIC**

OF NOTE: The original EDS-1275 was launched in 1958 and was actually a semi-hollow-body instrument; in 1962, they switched to this solid-body with SG styling • The model went in and out of production a few times—when Page wanted his in 1971, it had to be custom-made

If you are of a certain age, were lucky enough to score tickets, and were actually clearheaded enough to remember, this is the model that you saw Jimmy Page wail on during live performances of "Stairway to Heaven" in the '70s. You might also have seen it in the hands of John McLaughlin, Steve Miller, Alex Lifeson of Rush, Don Felder for "Hotel California," and Steve Howe—this blond one pictured, in fact, is Howe's instrument.

Guitar, Italian Style

MODEL: **BARTOLINI**
BUILDER: **BARTOLINI, 1960s**
TYPE: **SOLID-BODY ELECTRIC**

OF NOTE: Lots of sparkle and pearl, showing the maker's literal transition from accordions to guitars—that heavy black edging is actually a vinyl strip connecting the front piece to the back • Four pickups, and the accordion-style push-button controls

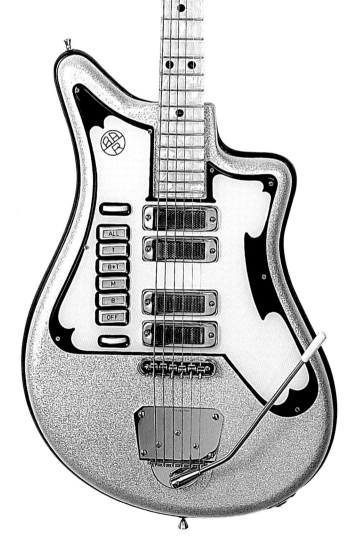

The guitar boom came to Italy in the early 1960s just as it did in America, England, Germany, and elsewhere. But the Italians, like many European builders, had their own singular response, converting the manufacturing of accordions into the manufacturing of guitars. This meant repurposing the materials (the glittery plastic and vinyl covers, the excessive amount of pearl) and the mind-set (push-button controls) through a distinctly Italian design sensibility. Maybe the guitars weren't great instruments, but boy, they looked cool. There's a photo of American blues guitarist Hubert Sumlin holding a Bartolini like this one, probably while on tour with Howlin' Wolf. Did he actually play it? Who knows . . . by the end of the '60s, Japan swept up all the low-end guitar business and these dazzling Italians went away forever.

Mr. November

MODEL: **LES PAUL "BLACK BEAUTY"**
 '57 CENTENNIAL
BUILDER: **GIBSON, 1994**
TYPE: **SOLID-BODY ELECTRIC**

OF NOTE: Elegant ebony-black finish, with gold appointments throughout—in this centennial edition, they are 24K gold-plated • Another touch of classic: the split diamond headstock inlay, used on the Super 400

1994 marked Gibson's centennial, and the company responded with a model-of-the-month reissue of some of its most historic electric guitars. Shipping that November was a limited 100-instrument run of the beloved "Black Beauty," aka the Les Paul Custom that Paul himself requested be an elegant all-black, "like a tuxedo," to show off the guitarist's hand. Why this model is so important: Frank Zappa, Jimmy Page, Keith Richards, Slash, Robert Fripp, the Edge, Lightnin' Hopkins, Trent Reznor, Johnny Marr, Mick Ronson, Peter Frampton, Ace Frehley, Mick Jones, Zakk Wylde, and on and on. Not to mention Les Paul.

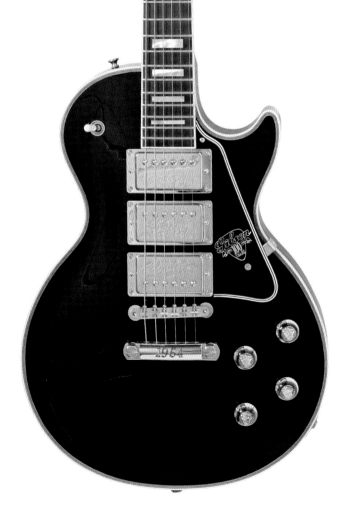

Inspired Hybrid

MODEL: **FTC, 40TH ANNIVERSARY**
BUILDER: **SANTA CRUZ, 2016**
TYPE: **FLATTOP/ARCHTOP ACOUSTIC**

OF NOTE: Hybrid design of a midsize jumbo—the top is flat, the back carved like an archtop—offers the sustain of a flattop with the projection of an archtop • Schaller tuners modeled after old Grover Imperials

Richard Hoover developed the boutique guitar concept when he knew he didn't have the patience to do by himself all he wanted to accomplish as a guitar maker and designer. Since then, he and his small band of skilled craftspeople have created a company and line of instruments that are exceptional. Among Santa Cruz's hallmarks: models that borrow from the American classics, but with innovations, some seen and some not; guitar bodies that are light and slightly rounded, more like naturally strong eggs than rigid boxes; an obsessive attention to detail and quality; and a recognizable, focused sound, rich with sustain, overtones, and a lovely complexity.

Functional Genius

MODEL: **H-12**
BUILDER: **FROGGY BOTTOM, 2016**
TYPE: **ACOUSTIC FLATTOP**

OF NOTE: Adirondack spruce top
and Bastogne walnut back and sides
(see page 191) • Neck meets the body
at the 12th fret, which tends to produce
a warmer, fuller-sounding instrument
• Frog inlay on the slotted headstock,
delicate fret markers

Yes, each guitar is a work of art. Yes, the finish is impeccable, and yes, the embellishments are beautiful. But what sets a Froggy Bottom guitar apart is its distinctive voice, a balance of warm woodiness and shimmering clarity that players describe as "magic" and "heavenly" and "perfection." Working out of a small shop tucked into the Vermont woods, Michael Millard is a singular builder who still assembles his steel-string, acoustic flattop guitars in a free-form dance, and who has an uncanny ability to coax every element in the guitar's build, from its back braces to top, to suit the player's needs. "My satisfaction doesn't come out of making the guitar I want," he says, "[but] when I've made the guitar somebody else wants."

"Enjoy the Wonderful World of Electrodynamics"

MODEL: **BELMONT**
BUILDER: **SUPRO, 1960**
TYPE: **SOLID-BODY ELECTRIC**

OF NOTE: Peanut-shaped body and "rich maroon 'no-mar' finish" • The single pickup looks like a humbucker but is an oversize single coil, more like a P-90

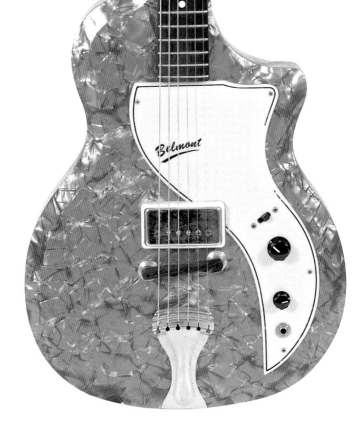

Despite postwar prosperity, not every kid with rock-and-roll dreams could afford a Gibson Les Paul or Fender Stratocaster. Enter the value lines like Supro. One of several brands launched by a company called Valco—named after its founders, who included owners of the National Dobro Corporation—Supro in its early years was making solid-body electrics out of wood, then sheathing them in pearloid plastic. Or, as some guitar geeks whimsically call it, "mother of toilet seat." You can hear them being played on YouTube, and they sound gorgeous—capable of twang and grit, and with the right modulation, even warm jazz tones too. After a few years, Valco/Supro ditched the wood altogether and introduced a line of fiberglass-bodied guitars, best known under the sister brand name, National.

The 2663 Cometh

MODEL: **ARTIST 2663, THE "ICEMAN"**
BUILDER: **IBANEZ, 1975**
TYPE: **SOLID-BODY ELECTRIC**

OF NOTE: Swoopy, curvy, pointy—and that flyaway cutaway on the treble side • The use of one triple-coil pickup—in some models, this was mounted on a slide to take advantage of different positions

After getting into the electric guitar business by producing Fender and Gibson knockoffs, the Japanese company Ibanez launched its first significant original model in 1975 with the Artist 2663, soon to be known as the "Iceman." Then, when KISS was on tour in Japan, the company reached out to rhythm guitarist Paul Stanley to design a signature model, which debuted in 1977 as the Iceman PS10. Stanley loved the edgy, eye-catching look of the 2663, though he recalls saying to the company: "You've got something here, but you don't know what to do with it." Stanley also made the analogy that the PS10 is to the original Iceman what a Rolls-Royce is to a Chevy. But take a good look—this is one sharp-looking Chevy!

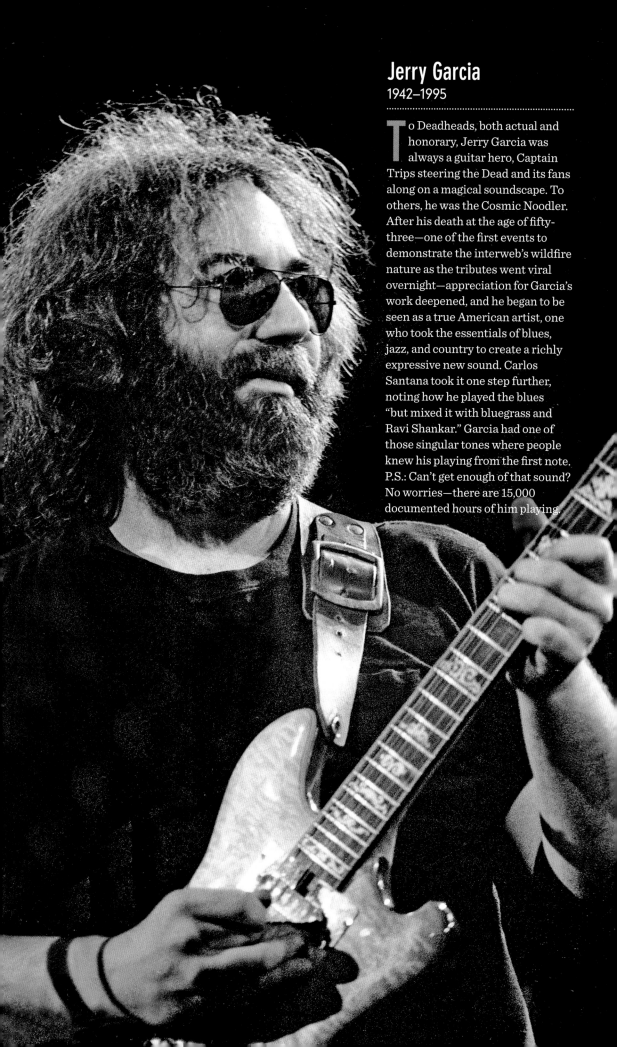

Jerry Garcia
1942–1995

To Deadheads, both actual and honorary, Jerry Garcia was always a guitar hero, Captain Trips steering the Dead and its fans along on a magical soundscape. To others, he was the Cosmic Noodler. After his death at the age of fifty-three—one of the first events to demonstrate the interweb's wildfire nature as the tributes went viral overnight—appreciation for Garcia's work deepened, and he began to be seen as a true American artist, one who took the essentials of blues, jazz, and country to create a richly expressive new sound. Carlos Santana took it one step further, noting how he played the blues "but mixed it with bluegrass and Ravi Shankar." Garcia had one of those singular tones where people knew his playing from the first note. P.S.: Can't get enough of that sound? No worries—there are 15,000 documented hours of him playing.

Musical Alchemy

MODEL: **JERRY GARCIA**
BUILDER: **ALEMBIC, 2006**
TYPE: **SOLID-BODY ELECTRIC**

OF NOTE: Though not fully visible, the stunning use of assorted woods like cocobolo, flame maple, and vermilion
• Three Alembic pickups and cutting-edge electronics

Like partners in high-tech psychedelia, Alembic and the Grateful Dead shared origins in the late 1960s, explored innovations in sound, live recording, and electronics, and exploded the nature of a rock concert through the Dead's massive "Wall of Sound" PA system—all under the guiding spirit of the infamous Owsley "Bear" Stanley, the LSD genius who turned on *The Electric Kool-Aid Acid Test* and the Summer of Love (not to mention the Beatles' Magical Mystery Tour). Alembic, originally a consulting company for the Dead and other bands, moved into building instruments because they realized it was the only way to control the complete signal path between musician and listener during a concert. Its first was the $4,000 "mission-control" bass created for Jack Casady of Jefferson Airplane. This recent Alembic Jerry Garcia is a tribute both to the artist and to the guitars that luthier Doug Irwin built for Garcia, like Tiger, Rosebud, and Lightning Bolt.

Cheaper by the Dozen

MODEL: **1200 STEREO**
BUILDER: **VEGA, 1959**
TYPE: **ARCHTOP ELECTRIC**

OF NOTE: Six individual pickups on the treble six, six on the bass side, each intended to feed a separate channel, resulting in stereo sound • Massive yet asymmetrical sparkly gold pickguards

Readers will get the wrong idea about Vega from this and the Cremona (see page 38), but how to resist an instrument as over-the-top as this jazz guitar from the late 1950s? The underlying guitar, of course, is as familiar as any of the dozens of amplified archtops made in the postwar era. But *twelve* pickups? And flanked by those pickguards?

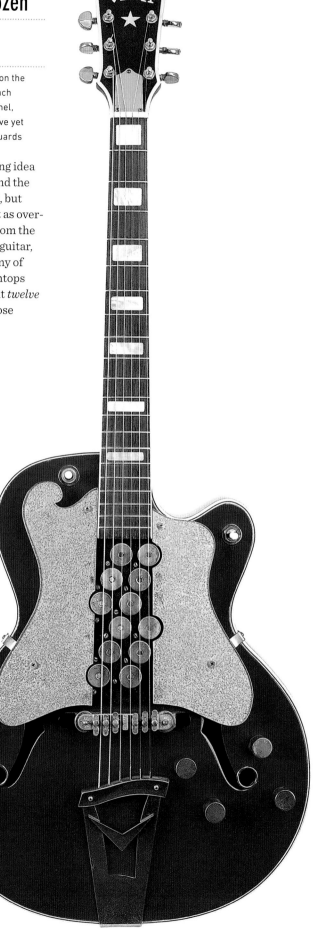

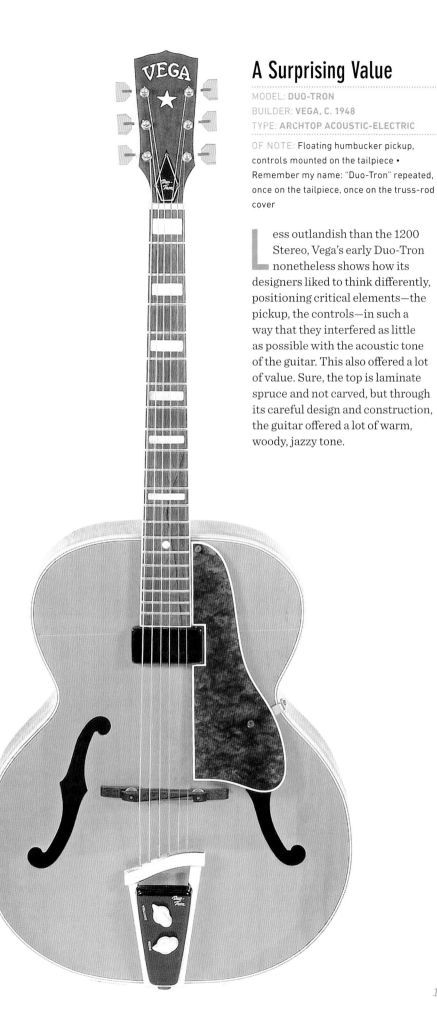

A Surprising Value

MODEL: **DUO-TRON**
BUILDER: **VEGA, C. 1948**
TYPE: **ARCHTOP ACOUSTIC-ELECTRIC**

OF NOTE: Floating humbucker pickup, controls mounted on the tailpiece • Remember my name: "Duo-Tron" repeated, once on the tailpiece, once on the truss-rod cover

Less outlandish than the 1200 Stereo, Vega's early Duo-Tron nonetheless shows how its designers liked to think differently, positioning critical elements—the pickup, the controls—in such a way that they interfered as little as possible with the acoustic tone of the guitar. This also offered a lot of value. Sure, the top is laminate spruce and not carved, but through its careful design and construction, the guitar offered a lot of warm, woody, jazzy tone.

Birth of the Superstrat

MODEL: **RANDY RHOADS**
BUILDER: **JACKSON/CHARVEL, 1983**
TYPE: **SOLID-BODY ELECTRIC**

OF NOTE: A 22-fret neck and cutaways so deep that you can easily reach every last note • Floyd Rose tremolo system • The signature drooped pointy headstock

Which comes first, the guitar or the music? In the case of some radical designs, like the Gibson L-5, it took years for the music to catch up. But here the nascent partnership of guitarist and tinkerer Grover Jackson with Wayne Charvel of Charvel's Guitar Repair was about hurrying to fulfill the needs of hotshot guitarists who had outgrown their Gibsons and Fenders. Working with supershredders like Eddie Van Halen, they created stripped-down, speeded-up "super-Strats," perfect machine-gun-like guitars with aggressive looks and the fast, fat tone that served the needs of 1980s heavy-duty rock. This first "Jackson" came out in 1983 and was designed in collaboration with Randy Rhoads, who wanted a Flying V but "more shark-fin-y."

The People's Instrument

MODEL: **SUNDALE**
BUILDER: **STELLA/HARMONY, 1955**
TYPE: **FLATTOP ACOUSTIC**

OF NOTE: The angular, highly graphic blue-and-white design with pink binding—other Sundales are equally bizarre, including one with a reverse avocado-green sunburst and another with a sculpted mountain silhouette against a gray-green sky

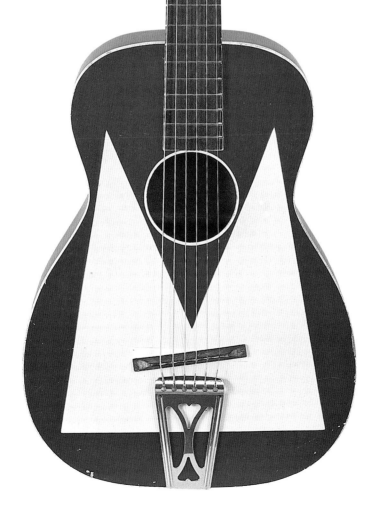

Even going back centuries, the guitar had a split personality—at home in both the king's private salon and the corner tavern. In America, almost anyone who wanted a guitar could afford one—a page from the 1908 Sears catalog lists guitars starting at $1.89. Or maybe someone would come around and sell you one—that's how the Oscar Schmidt Company got its inexpensive, easily available Stella guitars into the hands of some pretty significant blues players like Blind Willie McTell, Charlie Patton, Blind Blake, and, most famously, Huddie "Leadbelly" Ledbetter, who made legendary music on a Stella 12-string. Later, Harmony would pick up these brands and keep the same idea—affordable, playable guitars, often made of birch, with eye-catching finishes.

Django's Ax

MODEL: **ORCHESTRE**
BUILDER: **SELMER-MACCAFERRI, 1932**
TYPE: **FLATTOP ACOUSTIC**

OF NOTE: The "D"-shape sound hole, the *"grande bouche,"* built to accommodate an internal resonator • Floating mustache bridge, slotted headstock, a mandolin-style tailpiece • Fretboard extension over the sound hole, giving the treble two full octaves

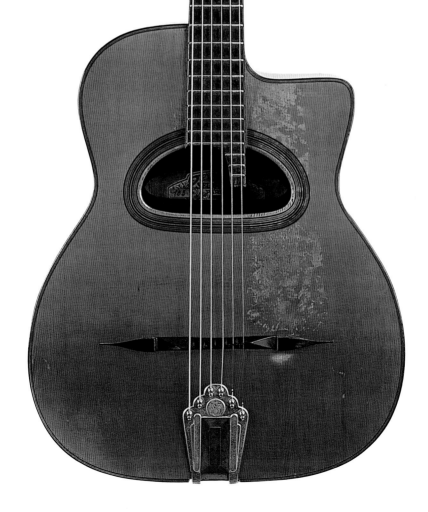

A luthier, a gifted classical guitarist, and a pioneer in the use of plastics, Mario Maccaferri may be best known for the guitars that he designed during a brief two-year partnership with the French saxophone company Selmer. The Selmer-Maccaferri models achieved lasting fame because of one player—gypsy jazz guitarist Django Reinhardt. Large-bodied and square-shouldered, many with single cutaways—the first production guitar to offer such—these Selmers incorporated elements of both the flattop and archtop styles, with a gentle dome on the top created by bending, rather than carving, the wood. In addition, Maccaferri patented an internal resonator that came as an option—though many players would remove it as it tended to loosen with use, then rattle and buzz.

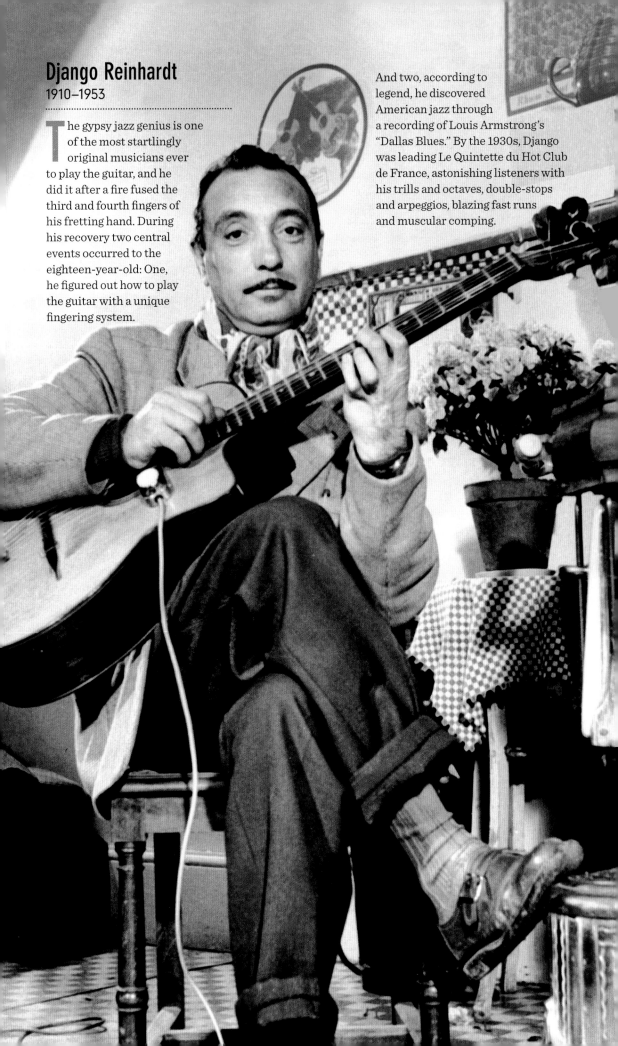

Django Reinhardt
1910–1953

The gypsy jazz genius is one of the most startlingly original musicians ever to play the guitar, and he did it after a fire fused the third and fourth fingers of his fretting hand. During his recovery two central events occurred to the eighteen-year-old: One, he figured out how to play the guitar with a unique fingering system.

And two, according to legend, he discovered American jazz through a recording of Louis Armstrong's "Dallas Blues." By the 1930s, Django was leading Le Quintette du Hot Club de France, astonishing listeners with his trills and octaves, double-stops and arpeggios, blazing fast runs and muscular comping.

Depression-Era Cool

MODEL: **LE DOMINO 410**
BUILDER: **REGAL, C. 1932**
TYPE: **FLATTOP ACOUSTIC**

OF NOTE: The domino fret markers actually give the position—i.e., a one and four on the 5th fret, boxcars on the 12th! • Decals on the body and around the sound hole are in remarkably fine condition

s it a toy? Is it a masterpiece? Neither, really. Built by the Chicago-based powerhouse, Regal, after it acquired the Le Domino brand from a smaller shop, this extraordinarily good-looking guitar is just a solidly decent small-bodied flattop with a serious amount of flash to lure buyers who might be tempted by so many other inexpensive birch-bodied guitars.

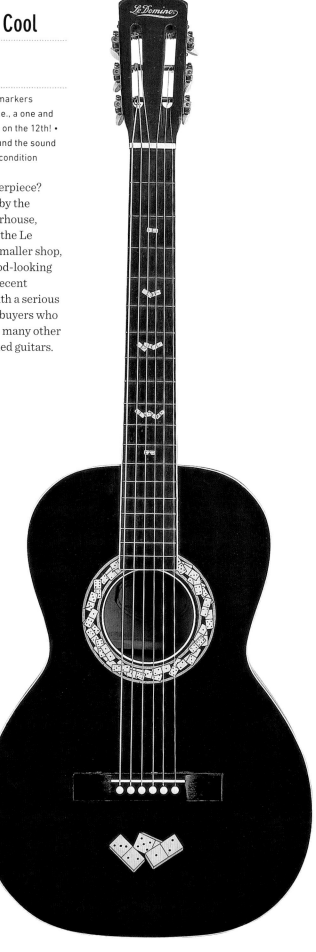

One Word: Plastics

MODEL: **G-40**
BUILDER: **MACCAFERRI, 1950s**
TYPE: **ARCHTOP PLASTIC ACOUSTIC**

OF NOTE: Selmer-style design, especially in the bridge and tailpiece • "Rosewood"-colored plastic neck, cream body • Not visible: wood ladder bracing and a heel-less neck joint with a wooden core that went into the body and could be adjusted to alter the pitch of the neck

After leaving Selmer in 1933, Mario Maccaferri drifted into and out of various businesses until, when World War II cut off the supply of natural materials, he channeled a fascination with plastics into making a fortune manufacturing plastic clothespins. In 1949, he introduced the Islander, a plastic ukulele—and sold nine million of them thanks to an endorsement from Arthur Godfrey. So why not a plastic guitar? Working with Dow Chemical, he developed both a "spruce" and "rosewood" formulation, and in 1953 introduced the very Selmer-like archtop G-40 and its cheaper flattop G-30, both designed to be played, and respected, as legitimate instruments. Compared to other budget, mass-produced guitars, they were actually quite superior. But bottom line, they were thought of as toys and were never really taken seriously.

Cult Status

MODEL: **CORONADO II WILDWOOD**
BUILDER: **FENDER, 1967**
TYPE: **THINLINE ELECTRIC**

OF NOTE: Fender calls this finish Wildwood, referring to a process in which dyes are injected into growing beechwood; when harvested a year later, the grain pops with color and contrast • DeArmond pickups, a Tune-O-Matic bridge, and a suspended tailpiece

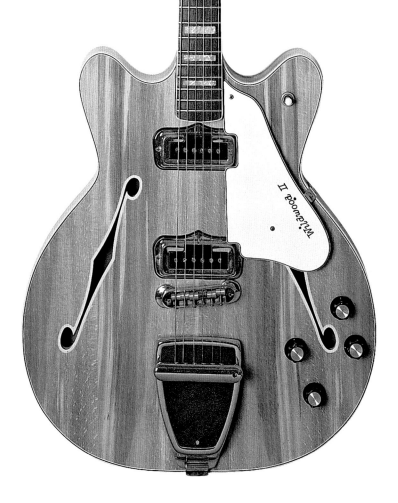

ntroduced in the mid-1960s, the Coronado was a true departure for Fender, which dominated the solid-body market with the Telecaster and Stratocaster. But watching the Beatles elevate the fortunes of Rickenbacker, Gretsch, and Epiphone with Paul's beloved Casino, Fender hired designer Roger Rossmeisl to create a hollow-body thinline to compete. But the Coronado never took off. Unlike the Gibson 335, it had no block under the hood, so it was prone to feedback when played at rock volumes. Meanwhile, the bolt-on neck didn't appeal to jazz players. Flash-forward three decades and the Coronado was rediscovered by some pretty serious musicians, showing up in bands like Radiohead, Blur, and the Red Hot Chili Peppers.

Minimalist Master

MODEL: **SINFONIETTA CUSTOM**

BUILDER: **ROBERT "BOB" BENEDETTO,**
2012

TYPE: **ARCHTOP ACOUSTIC**

OF NOTE: The restrained Benedetto style—all-wood appointments, virtually no inlay, no pickguard, no binding • Simple oval sound hole, unusual on an archtop • Stunning quilted redwood top and, not visible, walnut back and sides

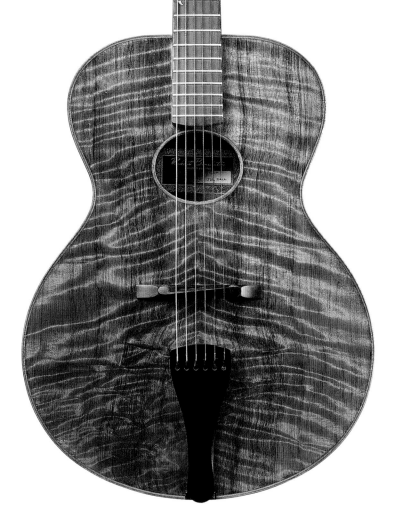

Repeating the essence of an experiment from a century earlier, when Antonio de Torres Jurado created a guitar with a papier-mâché back to prove the importance of the top, Robert Benedetto—one of the premier contemporary builders—once built an archtop out of construction-grade pine to prove that craftsmanship is as important as the quality of the tone woods. This mastery placed him on par with Jimmy D'Aquisto as the premier contemporary builder of jazz guitars. One reason he's achieved this: through listening to what jazz players had to say about what worked and what didn't, with the result that he's built instruments for the leading musicians of the day, including Chuck Wayne, Bucky Pizzarelli, Kenny Burrell, Andy Summers, and Pat Martino.

Too Cool for Words

MODEL: **GLENWOOD 99**
BUILDER: **VALCO, C. 1965**
TYPE: **SEMI-HOLLOW-BODY ELECTRIC**

OF NOTE: Three pickups—there's a piezo under the bridge • That seafoam green— the use of pigment-dyed resin gives these guitars a deep glowing color

In the 1940s, former partners of the National Dobro Company founded a company called Valco and started manufacturing some of the coolest electric guitars ever. Affectionately called "map guitars" for their quirky shape and with bodies made out of molded fiberglass—which the company named Res-O-Glas in classic marketing speak—these guitars burst onto the world in the early '60s . . . and kind of fizzled. Too odd looking? Too expensive? Too confusing? Whatever the reason, they were done by 1968. But today collectors love them.

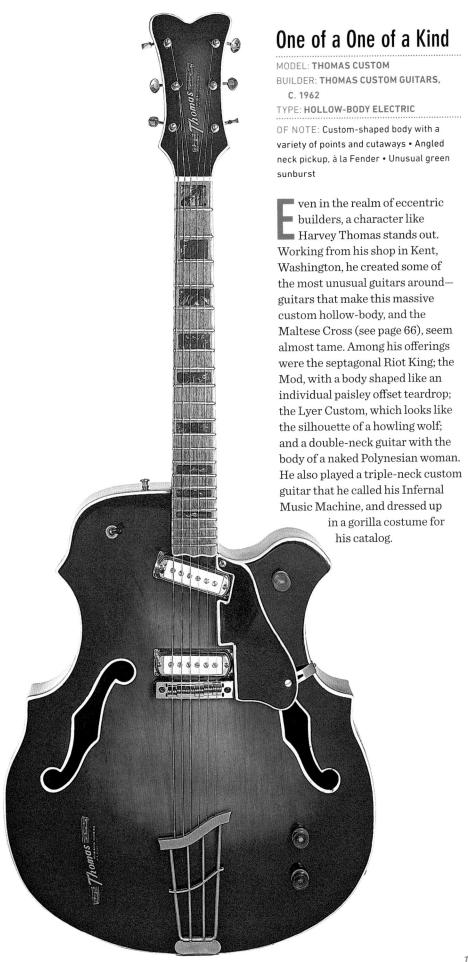

One of a One of a Kind

MODEL: **THOMAS CUSTOM**
BUILDER: **THOMAS CUSTOM GUITARS,**
 C. 1962
TYPE: **HOLLOW-BODY ELECTRIC**

OF NOTE: Custom-shaped body with a variety of points and cutaways • Angled neck pickup, à la Fender • Unusual green sunburst

E ven in the realm of eccentric builders, a character like Harvey Thomas stands out. Working from his shop in Kent, Washington, he created some of the most unusual guitars around— guitars that make this massive custom hollow-body, and the Maltese Cross (see page 66), seem almost tame. Among his offerings were the septagonal Riot King; the Mod, with a body shaped like an individual paisley offset teardrop; the Lyer Custom, which looks like the silhouette of a howling wolf; and a double-neck guitar with the body of a naked Polynesian woman. He also played a triple-neck custom guitar that he called his Infernal Music Machine, and dressed up in a gorilla costume for his catalog.

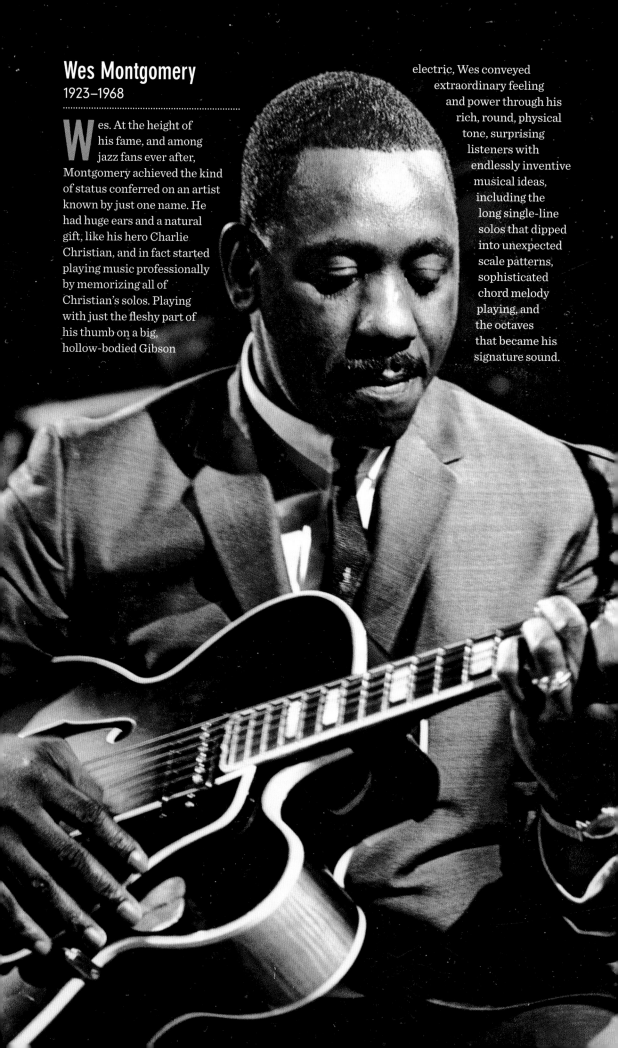

Wes Montgomery
1923–1968

Wes. At the height of his fame, and among jazz fans ever after, Montgomery achieved the kind of status conferred on an artist known by just one name. He had huge ears and a natural gift, like his hero Charlie Christian, and in fact started playing music professionally by memorizing all of Christian's solos. Playing with just the fleshy part of his thumb on a big, hollow-bodied Gibson electric, Wes conveyed extraordinary feeling and power through his rich, round, physical tone, surprising listeners with endlessly inventive musical ideas, including the long single-line solos that dipped into unexpected scale patterns, sophisticated chord melody playing, and the octaves that became his signature sound.

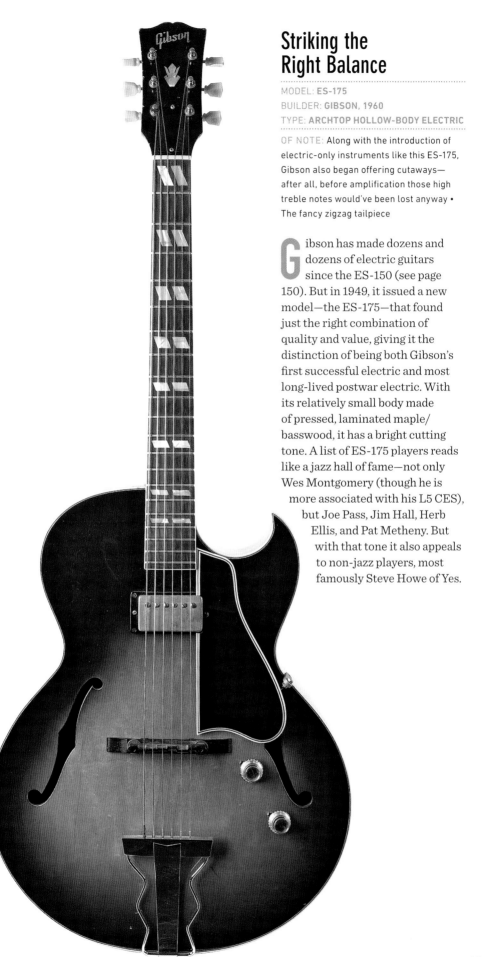

Striking the Right Balance

MODEL: **ES-175**
BUILDER: **GIBSON, 1960**
TYPE: **ARCHTOP HOLLOW-BODY ELECTRIC**

OF NOTE: Along with the introduction of electric-only instruments like this ES-175, Gibson also began offering cutaways—after all, before amplification those high treble notes would've been lost anyway • The fancy zigzag tailpiece

Gibson has made dozens and dozens of electric guitars since the ES-150 (see page 150). But in 1949, it issued a new model—the ES-175—that found just the right combination of quality and value, giving it the distinction of being both Gibson's first successful electric and most long-lived postwar electric. With its relatively small body made of pressed, laminated maple/basswood, it has a bright cutting tone. A list of ES-175 players reads like a jazz hall of fame—not only Wes Montgomery (though he is more associated with his L5 CES), but Joe Pass, Jim Hall, Herb Ellis, and Pat Metheny. But with that tone it also appeals to non-jazz players, most famously Steve Howe of Yes.

143

Parallel Stream

MODEL: **THUNDERBIRD S-200**
BUILDER: **GUILD, 1966**
TYPE: **SOLID-BODY ELECTRIC**

OF NOTE: Distinctive, if not a little off-putting, body, matched by a curiously asymmetrical headstock • Not visible: a truly unique feature—a hinged metal leg in the back billed as the "Guild Built-In Guitar Stand" available "at no extra cost"

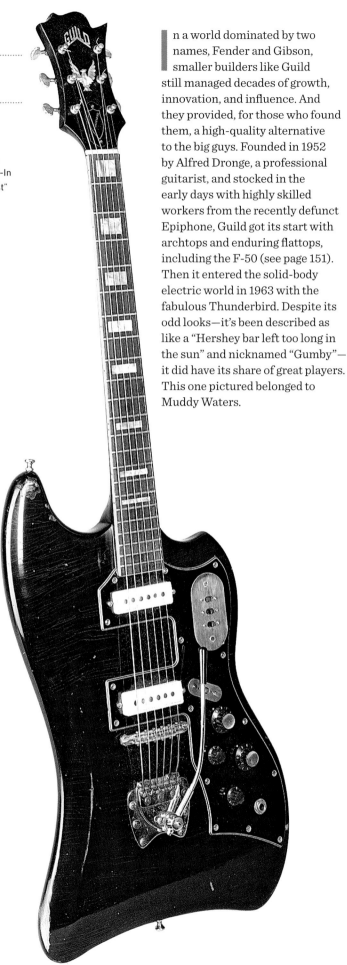

In a world dominated by two names, Fender and Gibson, smaller builders like Guild still managed decades of growth, innovation, and influence. And they provided, for those who found them, a high-quality alternative to the big guys. Founded in 1952 by Alfred Dronge, a professional guitarist, and stocked in the early days with highly skilled workers from the recently defunct Epiphone, Guild got its start with archtops and enduring flattops, including the F-50 (see page 151). Then it entered the solid-body electric world in 1963 with the fabulous Thunderbird. Despite its odd looks—it's been described as like a "Hershey bar left too long in the sun" and nicknamed "Gumby"—it did have its share of great players. This one pictured belonged to Muddy Waters.

Dazzling Iconoclast

MODEL: **MARK I VENTURES**
BUILDER: **MOSRITE, 1960s**
TYPE: **SOLID-BODY ELECTRIC**

OF NOTE: "M"-shaped headstock •
All parts, including pickups and vibrato,
labeled "Mosrite of California" • The name
"Moseley" on the bottom of the bridge

emie Moseley, already playing guitar at age thirteen with a gospel group, created crazy custom models for both individual players (see page 146) and groups (see page 90), and designed one of the most successful solid-bodies of the 1960s, the Mosrite Ventures. He got his start with Rickenbacker but soon headed out on his own, struggling to get by until one of his models was endorsed by Nokie Edwards, a guitarist for the Ventures, the preeminent instrumental group of the early 1960s. The Ventures had started out playing only Strats—the Fender sound was *their* sound—but suddenly a different guitar began appearing on their album covers and, on the back, the words "The Ventures play only the Mosrite guitar." Soon, fans were looking for this mysterious Mosrite, and by 1968 Semie Moseley and his company were manufacturing six hundred guitars a month. Yet by 1969, the company closed its doors; the finances of running a major manufacturing company were beyond the scope of its owner. It was only the first of many ups and downs.

A Little Something

MODEL: **MOSRITE CUSTOM**
BUILDER: **SEMIE MOSELEY, 1980**
TYPE: **SOLID-BODY ELECTRIC**

OF NOTE: The beautifully carved body is made of laminated walnut and maple • Take a close look—all the bronze pieces are individually cast, including the knobs, strap buttons, pickup covers, and bridge with its odd tailpiece engraved with the artist's initials • Free-form pickguard and arrow fret markers

After Mosrite's crash and bankruptcy in 1969 (see page 145), Semie Moseley began a new phase of guitar building. He reclaimed the Mosrite name in the 1970s, and fired up the first of what would be three factories. But the fact is, he was much more a visionary than a businessman, pursuing ideas instead of focusing on the bottom line. A perfect example: this extraordinary custom instrument that he built for a business partner in 1980. There's not much to say except *look*.

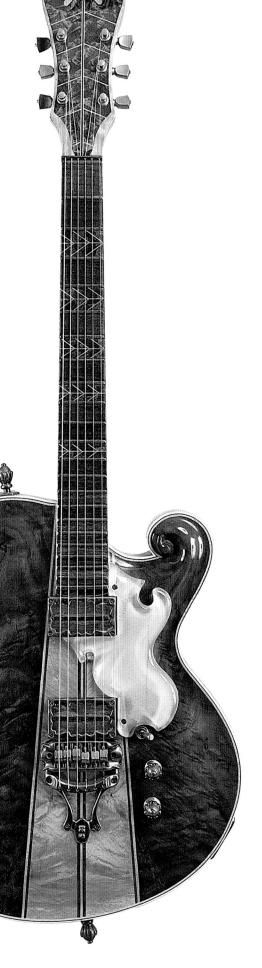

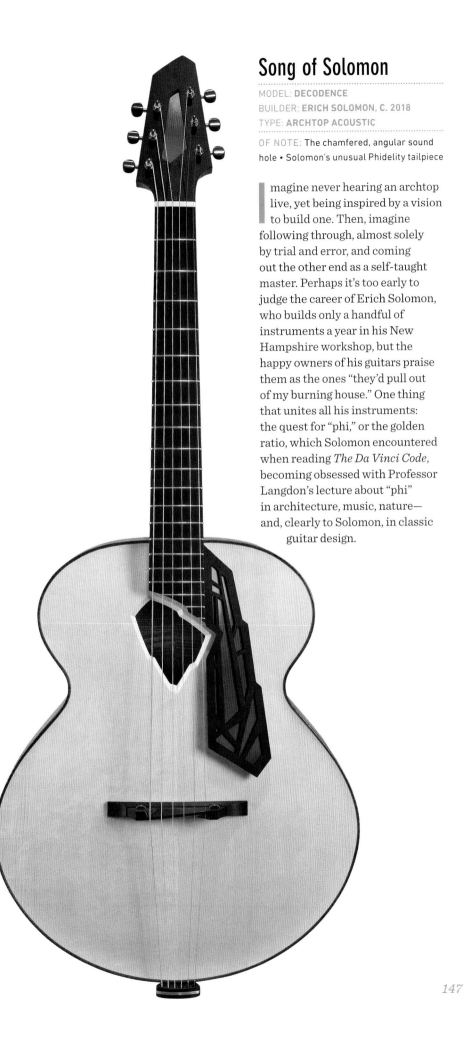

Song of Solomon

MODEL: **DECODENCE**
BUILDER: **ERICH SOLOMON, C. 2018**
TYPE: **ARCHTOP ACOUSTIC**

OF NOTE: The chamfered, angular sound hole • Solomon's unusual Phidelity tailpiece

magine never hearing an archtop live, yet being inspired by a vision to build one. Then, imagine following through, almost solely by trial and error, and coming out the other end as a self-taught master. Perhaps it's too early to judge the career of Erich Solomon, who builds only a handful of instruments a year in his New Hampshire workshop, but the happy owners of his guitars praise them as the ones "they'd pull out of my burning house." One thing that unites all his instruments: the quest for "phi," or the golden ratio, which Solomon encountered when reading *The Da Vinci Code*, becoming obsessed with Professor Langdon's lecture about "phi" in architecture, music, nature— and, clearly to Solomon, in classic guitar design.

Charlie Christian
1916–1942

"**G**uitarmen, Wake Up and Pluck! Wire for Sound; Let 'Em Hear You Play." So proclaimed the jazz pioneer Charlie Christian in a manifesto he published in *DownBeat* magazine in 1939. Nourished on Lester Young, the tenor saxophonist, and Django Reinhardt, Christian revolutionized the guitar's role in jazz, and fundamentally all of pop, by being the first to capitalize on the electric guitar's possibilities as a solo instrument. In Christian's hands, the guitar left the rhythm section and took center stage as he fashioned gorgeous, swinging, single-note lines, full of bluesy riffs and offbeat accents.

"A New Lease on Life"

MODEL: **ES-150**
BUILDER: **GIBSON, 1938**
TYPE: **HOLLOW-BODY ELECTRIC**

OF NOTE: The early Charlie Christian pickup—a "bar" or blade pole piece, and a pair of 5-inch magnets under the top, secured by three visible bolts

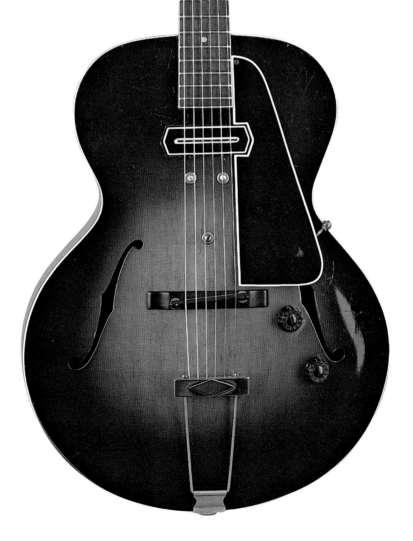

With those words—"a new lease on life"—Charlie Christian praised the use of electric amplification, a sea change that brought the guitarist out from the rhythm shadows and into the spotlight. It was a sea change for Gibson too. Introduced in 1936, the ES-150—the "ES" stands for "Electric-Spanish," with "Spanish" used to differentiate this style of guitar from a Hawaiian lap steel—was the first commercially successful electric guitar. And it's clear from the lack of appointments and bling—plain sunburst, simple dot markers, unadorned headstock, no fancy metal parts or engraving, inexpensive price tag (the guitar, at $77.50, with an amp for around $75, equals the 150 of the name)—that Gibson was hedging its bets. But boy, did it work.

"Do You Love a Deep, Throaty Guitar?"

MODEL: **ADVANCED JUMBO**
BUILDER: **GIBSON, 1938**
TYPE: **FLATTOP ACOUSTIC**

OF NOTE: "Advanced" size—i.e., "big" in Gibson-speak • Only three hundred made between 1936 and 1939 • The first guitar to appear on TV—and, fifteen years later, on color TV—both times in the hands of "Canadian Cowgirl" Helen Diller Hinn

A classic case of competition resulting in excellence that might not have been achieved otherwise: the Advanced Jumbo, released by Gibson in 1936. Maybe the flattop side of Gibson was always playing catch-up to Martin, particularly during the dreadnought era of the 1930s, but this classic round-shouldered Gibson jumbo— the first with a rosewood body— delivered an unsurpassed marriage of power, tone, clarity, and balance. "If you're lucky enough to play one of these prewar creations," write the authors of *Gibson's Fabulous Flat-Top Guitars*, "be prepared for attitude readjustment and brain alteration."

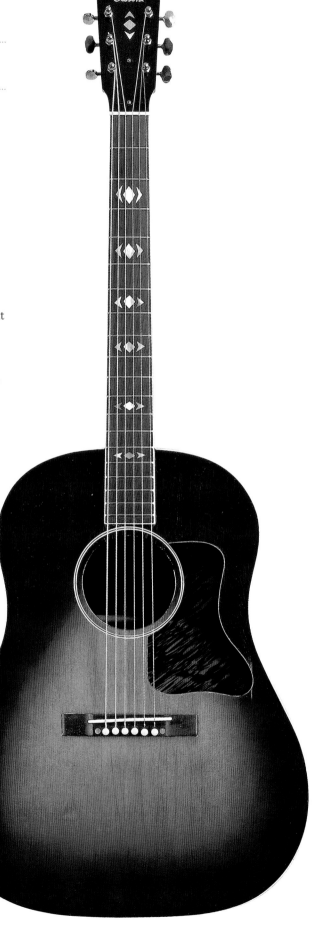

Hootenanny Time

MODEL: **F-50**
BUILDER: **GUILD, EARLY 1960s**
TYPE: **FLATTOP ACOUSTIC**

OF NOTE: As the Guild flattops found greater success, design changes were made—this early model still has the Gibson-like headstock • Guild found no shortage of famous players—one catalog from the '60s has Eric Clapton, George Benson, Richie Havens, and the Smothers Brothers on the cover

aunched in 1958 with the Kingston Trio's unexpected hit "Tom Dooley"—imagine that, a cover of a song from the 1800s sold more than six million copies and topped the charts—America's folk revival turned into a folk boom. And everyone wanted to sing along. "Guitars hit a cashbox crescendo," *Businessweek* reported, and guitar makers of every stripe rushed to put an instrument in people's hands. There's no better guitar for vocal accompaniment than a big, bassy flattop—and the skillful and savvy makers at Guild, led by its founder Alfred Dronge and his son, Mark, created some of the 1960s' finest, including this jumbo F-50.

"Whatever Your Style of Playing, You Will Ultimately Choose a Guild"

MODEL: **STARFIRE II**
BUILDER: **GUILD, 1966**
TYPE: **HOLLOW-BODY ELECTRIC**

OF NOTE: Fresh Guild humbuckers, harp-trapeze tailpiece with the cutout "G" • This particular instrument was used by Mike Mitchell of the Kingsmen to bang out "Louie Louie"

Though it seems unfair to compare Guild to its bigger siblings in the guitar world, it's always a part of the conversation—in the case of the enduring Starfire line, how these hollow-body and thinline models stack up to the Gibson ES-225 and 335s. Which misses the point: Players love the iconic Starfires for their raucous, bluesy sound and easy playability. The Starfire line came in a number of variations—seven guitars and two basses—and were used by some prominent rockers and blues musicians including Jerry Garcia, Buddy Guy, and Lightnin' Hopkins.

"The Guitar of the Future"

MODEL: **WHITE FALCON**
BUILDER: **GRETSCH, 1955**
TYPE: **HOLLOW-BODY ELECTRIC**

OF NOTE: Though subdued by age, when this guitar was new, the metal parts gleamed with gold plate, matched by thick gold sparkle binding from the Gretsch drum department and the shimmery gold pickguard • Engraved feather motifs on the fret markers

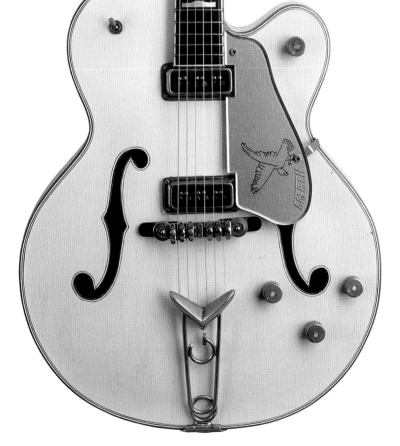

Conceived as a "dream guitar" by Jimmie Webster, Gretsch's guitar guru, and introduced at the 1954 National Association of Music Merchants show as a futuristic promise of what might someday be, the Gretsch White Falcon was such an instant hit that the company needed to put it into production immediately. The following year, well-heeled players got the pleasure of buying "the finest guitar we know how to make" for $600. (With 1955's median family income at $5,000, that was a serious chunk of change.) And Gretsch has been making them ever since. This particular instrument belonged to Stray Cat Brian Setzer, whose only modification is what looks like a shower of diamonds on the headstock. Because, you know, it's otherwise such a shrinking violet of a guitar. . . .

DOUBLE-NECKS. AND MORE!

A double-neck guitar feels like such a radical idea, until it's not. Still, they are pretty rare birds, particularly in the acoustic world. For example, the Gibson L-10 (opposite page) is the only double-neck acoustic archtop that Gibson ever built; though you can't see it here, its owner's name, Art Pruneau, is woven into the design on the left truss cover. Also interesting, the 6-string is on the left, and on the right is a 4-string tenor neck.

A double-neck electric feels like a more obvious idea—why not put two instruments into a guitar god's hands? Typically it's a combination a of 6-string and a 12-string—think of the

STRATOSPHERE TWIN

1955 • First true production model double-neck electric • Tuning system on 12-string using major-minor thirds kept it from popular use • Unusual slot-heads

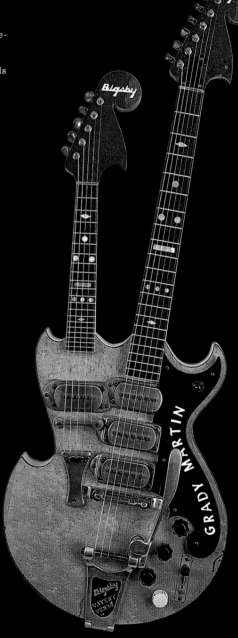

BIGSBY GRADY MARTIN

1952 • Semi-hollow-body electric guitar/mandolin • Previously unheard-of three pickups on the guitar side

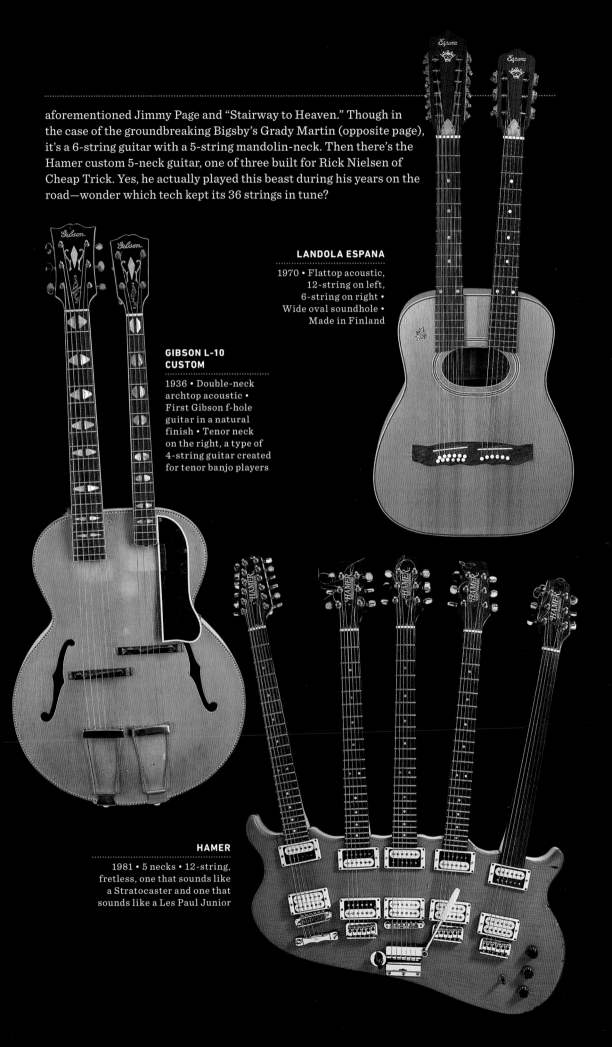

aforementioned Jimmy Page and "Stairway to Heaven." Though in the case of the groundbreaking Bigsby's Grady Martin (opposite page), it's a 6-string guitar with a 5-string mandolin-neck. Then there's the Hamer custom 5-neck guitar, one of three built for Rick Nielsen of Cheap Trick. Yes, he actually played this beast during his years on the road—wonder which tech kept its 36 strings in tune?

LANDOLA ESPANA

1970 • Flattop acoustic, 12-string on left, 6-string on right • Wide oval soundhole • Made in Finland

GIBSON L-10 CUSTOM

1936 • Double-neck archtop acoustic • First Gibson f-hole guitar in a natural finish • Tenor neck on the right, a type of 4-string guitar created for tenor banjo players

HAMER

1981 • 5 necks • 12-string, fretless, one that sounds like a Stratocaster and one that sounds like a Les Paul Junior

Hard-Driving

MODEL: **FIREBIRD III**
BUILDER: **GIBSON, 1964**
TYPE: **SOLID-BODY ELECTRIC**

OF NOTE: Banjo tuners • Mini-humbuckers, which gives the Firebird a little more trebly bite, causing blues-rock legend Johnny Winter to say, "It feels like a Gibson, but sounds closer to a Fender"

In the early 1960s, Gibson hired car designer Ray Dietrich to create a solid-body electric that would take on—or take out! —its archrival, Fender. Behold the Firebird, introduced in 1963 in four flavors: the I, III, V, and VII, depending on the number of pickups and type of bridge. Aggressively Fenderish, the Firebird also featured a flipped Fender headstock, with the curious use of hard-to-reach banjo-style tuners, and came in a Fender-type palette of custom colors. A number of important players used the Firebird—including Eric Clapton, who loved his single-pickup Firebird I that he played in the waning Cream and Blind Faith years—but the instrument never quite took off. Dietrich's body had an unbalanced feel, giving it the collector's nickname, "reverse body." And it truly irritated the folks at Fender, complaining that the Firebird's design seemed like its own Jaguar and Jazzmaster models. Gibson ceased production on the original model in 1969.

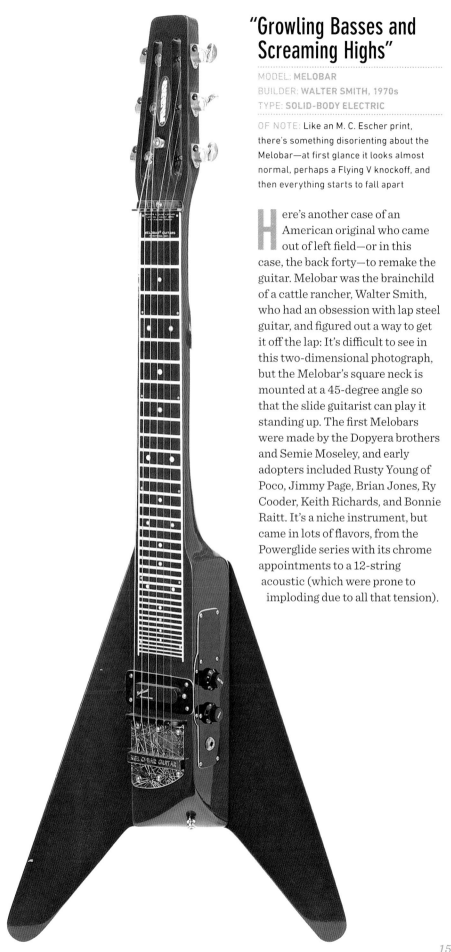

"Growling Basses and Screaming Highs"

MODEL: **MELOBAR**
BUILDER: **WALTER SMITH, 1970s**
TYPE: **SOLID-BODY ELECTRIC**

OF NOTE: Like an M. C. Escher print, there's something disorienting about the Melobar—at first glance it looks almost normal, perhaps a Flying V knockoff, and then everything starts to fall apart

Here's another case of an American original who came out of left field—or in this case, the back forty—to remake the guitar. Melobar was the brainchild of a cattle rancher, Walter Smith, who had an obsession with lap steel guitar, and figured out a way to get it off the lap: It's difficult to see in this two-dimensional photograph, but the Melobar's square neck is mounted at a 45-degree angle so that the slide guitarist can play it standing up. The first Melobars were made by the Dopyera brothers and Semie Moseley, and early adopters included Rusty Young of Poco, Jimmy Page, Brian Jones, Ry Cooder, Keith Richards, and Bonnie Raitt. It's a niche instrument, but came in lots of flavors, from the Powerglide series with its chrome appointments to a 12-string acoustic (which were prone to imploding due to all that tension).

Aloha

MODEL: **HONOLULU MASTER**
BUILDER: **BRONSON, 1938**
TYPE: **FLATTOP ACOUSTIC**

OF NOTE: Bronson made instruments in
different sizes—this one has a deep small
body, similar to a Gibson Nick Lucas •
Beautiful headstock with a pearl or plastic
overlay and contrast of gold-and-black
letters, heavy mother-of-pearl purfling

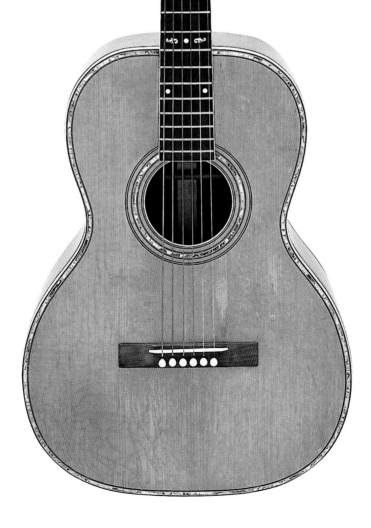

It's difficult to overstate the
importance of Hawaiian (or
"steel") guitar. Even harder,
perhaps, to comprehend how that
corny, swooping sound could have
had such an influence on American
guitar. But it did. Imported from
the islands in the 1920s, Hawaiian
guitar made Americans guitar
crazy. It gave us the solo guitarist—
and the guitar "solo"—along with
slide guitar and pedal steel guitar.
And it pretty much forced the
invention of the electric guitar:
The Rickenbacker "Frying Pan"
was designed to sit on the lap
of a superstar like Sol Hoopii.
Bronson, a well-known publisher
of Hawaiian guitar music, started
introducing its own instruments,
like this impeccable Honolulu
Master. Thing is, it came, of course,
with a square neck for Hawaiian-
style playing, on the lap, with a
slide—but also a round neck for
Spanish style. That's marketing.

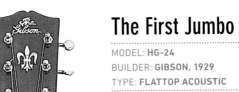

The First Jumbo

MODEL: **HG-24**
BUILDER: **GIBSON, 1929**
TYPE: **FLATTOP ACOUSTIC**

OF NOTE: The peculiar extra f-holes—four, in fact—designed, presumably, to push out more sound • Not visible: a second set of sides, like an internal wall, possibly used to help the body withstand the tension of Hawaiian open tunings

The Hawaiian guitar craze, as noted, had a significant impact on the early history of the American guitar and guitar-playing styles. Perhaps the most fundamental: When you bring the guitar to center stage, you'd better make sure everyone can hear it. Thus, the push for louder instruments. One way to achieve extra volume is to make the guitar bigger. This Gibson HG—the "HG" stands for "Hawaiian guitar"—is historically significant because it's the first guitar with a 16-inch-wide body designed with dreadnought proportions and a neck that joins the body at the 14th fret.

Special K

MODEL: **KOONTZ CUSTOM**
BUILDER: **SAM KOONTZ, C. 1977**
TYPE: **ARCHTOP ACOUSTIC**

OF NOTE: Fancy scroll on the upper left, echoed beautifully by the scrollwork on the pickguard • Exquisitely fine purfling that's repeated around the f-holes and also the pickguard

S am Koontz was one of those obsessive, passionate, ahead-of-his-time personalities that guitar making attracts. He built approximately two hundred instruments in his Linden, New Jersey, shop, including this stunning—even imposing—Koontz Custom with a scroll that hearkens back to the original Gibson O (see page 18). It's a guitar that shows his attention to classic archtop design, the kind of work that attracted players like Pat Martino. But Koontz was also a true innovator, experimenting with a variety of guitar-organ and guitar-synthesizer hybrids, as well as an early guitar that included a built-in amp and tape recorder so that a player could capture his or her performance while it happened.

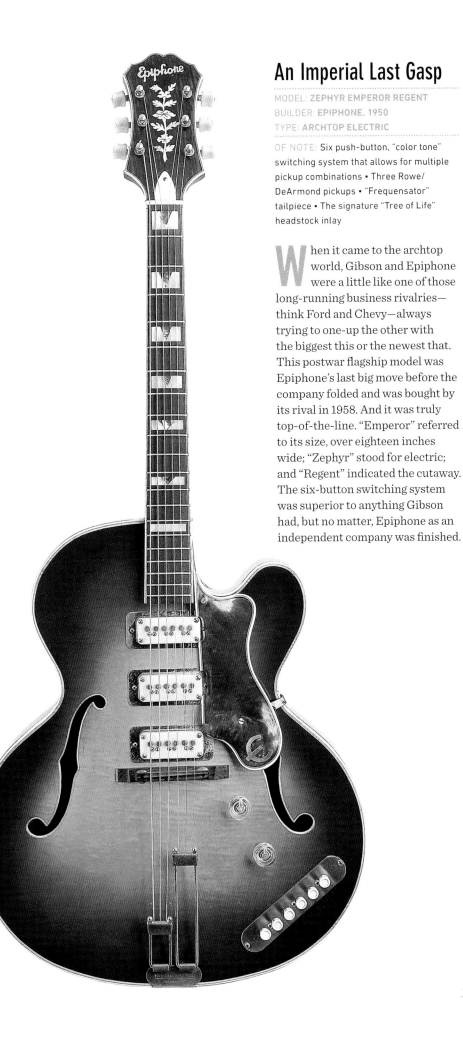

An Imperial Last Gasp

MODEL: **ZEPHYR EMPEROR REGENT**
BUILDER: **EPIPHONE, 1950**
TYPE: **ARCHTOP ELECTRIC**

OF NOTE: Six push-button, "color tone" switching system that allows for multiple pickup combinations • Three Rowe/DeArmond pickups • "Frequensator" tailpiece • The signature "Tree of Life" headstock inlay

When it came to the archtop world, Gibson and Epiphone were a little like one of those long-running business rivalries—think Ford and Chevy—always trying to one-up the other with the biggest this or the newest that. This postwar flagship model was Epiphone's last big move before the company folded and was bought by its rival in 1958. And it was truly top-of-the-line. "Emperor" referred to its size, over eighteen inches wide; "Zephyr" stood for electric; and "Regent" indicated the cutaway. The six-button switching system was superior to anything Gibson had, but no matter, Epiphone as an independent company was finished.

Pure Gold

MODEL: **LES PAUL "GOLD-TOP"**
BUILDER: **GIBSON, 1957**
TYPE: **SOLID-BODY ELECTRIC**

OF NOTE: The new Gibson Tune-O-Matic and stop-tail bridge—the first gold-tops were fitted with a "trapeze" bridge • There's some question about the pickups—Allman traded this gold-top for a 1959 cherry-red sunburst, but supposedly made sure to keep the original pickups

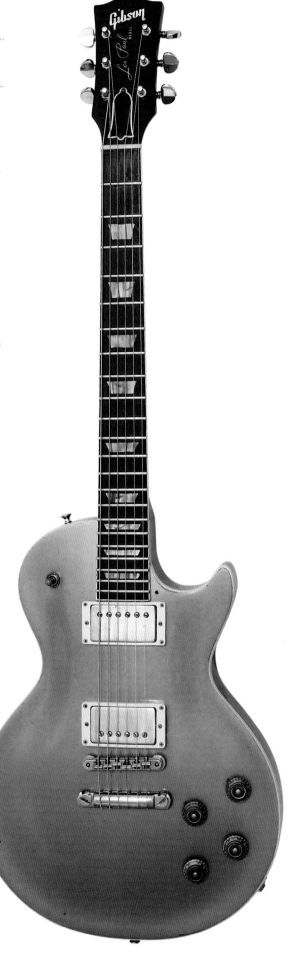

S tory has it that Les Paul himself suggested the gold color of the inaugural Les Paul guitar in 1952 because it looked "expensive," giving greater commercial appeal to an idea—the solid-body electric guitar—that Gibson had no idea how to judge. This model, from 1957 with the first PAF humbuckers, is the apotheosis of the gold-top, just before Gibson ditched the whole gold thing and moved to a sunburst in order to reinvigorate sales. By the way, this is also Duane Allman's guitar—he bought it in 1969 and used it on the first two Allman Brothers albums, as well as during the Derek and the Dominos sessions. Which means that it was on this guitar that Allman gave us the original versions of "Whipping Post," "In Memory of Elizabeth Reed," and "Midnight Rider," as well as the immortal opening seven notes of "Layla."

Duane Allman
1946–1971

Coveting his brother Gregg's
Silvertone guitar, the teenage
Duane "Skydog" Allman traded in
motorcycle parts for his own ax, and
found his calling. He spent hours in
his room controlling a record player
with his foot while his hands were
busy on the guitar, swallowing whole
such musicians as Albert King, T-Bone
Walker, Robert Johnson, Jimi Hendrix,
Miles Davis, and John Coltrane. One day,
suffering from a cold, Duane emptied a
bottle of Coricidin, popped it onto his
third finger, and used it as the slide that
would define his powerful, inventive,
progressive bluesy sound. In
addition to his work with the
Allman Brothers, Duane
was a great session
musician.

What About Us?

MODEL: **COMBO 600**
BUILDER: **RICKENBACKER, 1957**
TYPE: **SOLID-BODY ELECTRIC**

OF NOTE: True understated elegance here, capped off by that single horseshoe pickup • Gold-colored, anodized aluminum pickguard that covers almost the entire treble side, with a matching cover over the bridge

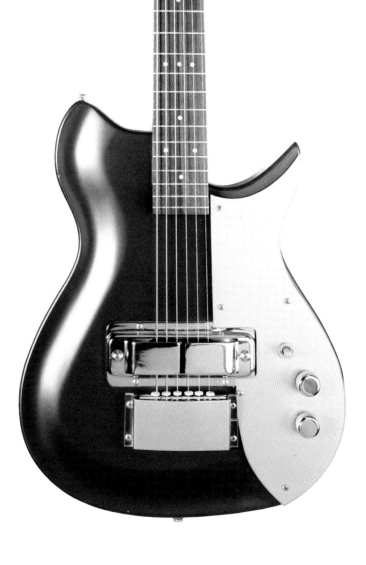

Around 1932, Adolph Rickenbacker introduced one of the very first electric guitars, a lap steel affectionately nicknamed the "Frying Pan" (see page 28). But by the early 1950s, lap steels were on the way out, Rickenbacker sold his company, and Fender and Gibson were taking all the credit for revolutionizing the guitar with electrics like the Telecaster and Les Paul. Knowing they had serious catching up to do, the new Rickenbacker introduced its first solid-body Spanish-style electrics in 1954, the Combo 600 (single pickup) and Combo 800 (double pickup). They didn't set the world on fire, and are now extremely rare. But no matter—in less than a decade, a few British cats named John, George, and Paul would change Rickenbacker's fortunes forever.

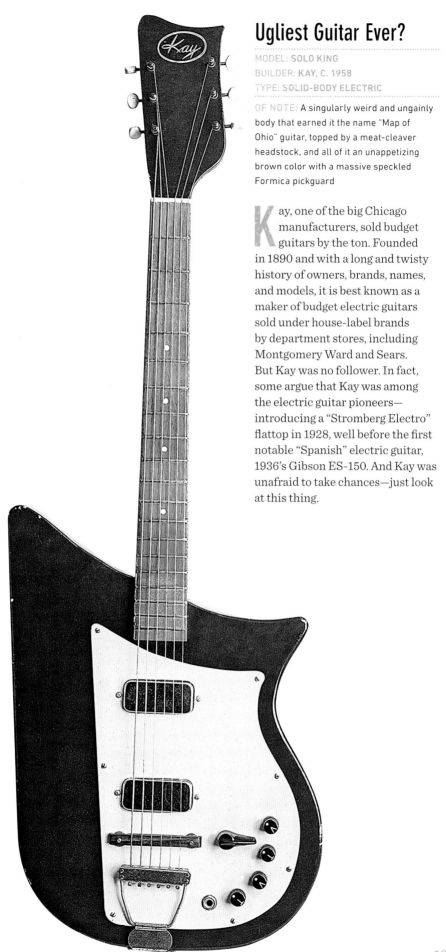

Ugliest Guitar Ever?

MODEL: **SOLO KING**
BUILDER: **KAY, C. 1958**
TYPE: **SOLID-BODY ELECTRIC**

OF NOTE: A singularly weird and ungainly body that earned it the name "Map of Ohio" guitar, topped by a meat-cleaver headstock, and all of it an unappetizing brown color with a massive speckled Formica pickguard

Kay, one of the big Chicago manufacturers, sold budget guitars by the ton. Founded in 1890 and with a long and twisty history of owners, brands, names, and models, it is best known as a maker of budget electric guitars sold under house-label brands by department stores, including Montgomery Ward and Sears. But Kay was no follower. In fact, some argue that Kay was among the electric guitar pioneers—introducing a "Stromberg Electro" flattop in 1928, well before the first notable "Spanish" electric guitar, 1936's Gibson ES-150. And Kay was unafraid to take chances—just look at this thing.

"The Customer Is Always Wrong"

MODEL: **"SINGLE MALT" ALEXANDER**
BUILDER: **FYLDE, 2002**
TYPE: **FLATTOP ACOUSTIC**

OF NOTE: Solid Oregon pine top that's been aged for more than forty years in alcohol • Not visible: the back and sides are made of American oak, also from whiskey barrels

That bit about the customer is Roger Bucknall's secret to building a great guitar. He focuses on making guitars that suit him, concentrating on tone rather than volume and being obsessive about matching timbers. Obviously, it works: Fylde guitars have wound up in the hands of some of England's top musicians, including Pete Townshend, Sting, Keith Richards, John Renbourn, Robyn Hitchcock, Davey Graham, and Steve Howe, plus Americans like Bob Dylan and Pat Metheny. Founded in the early 1970s and named after an area on the coast of northwest England where Bucknall established his first full-time workshop, Fylde and Bucknall have had up-and-down success. At one point he had to shift to making snooker cues. Today, Fyldes are premium handmade guitars—sometimes, like this one, built from wood used in barrels to age single-malt whiskey.

Worlds Collide

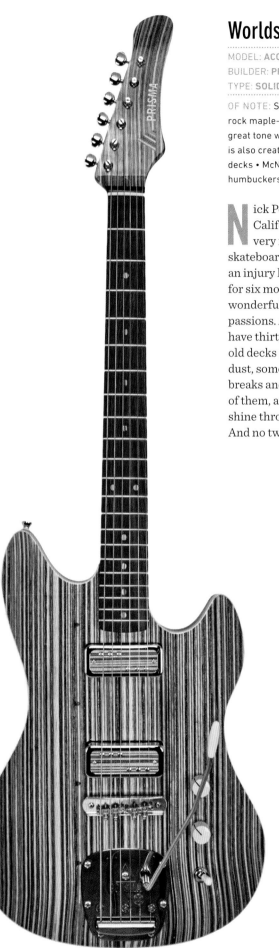

MODEL: **ACCARDO**
BUILDER: **PRISMA GUITARS, 2018**
TYPE: **SOLID-BODY ELECTRIC**

OF NOTE: Skateboards are built of dense rock maple—so are some guitars, as it's a great tone wood for an electric • Headstock is also created from layered skateboard decks • McNelly "Stagger Swagger" humbuckers, with the Prisma design

Nick Pourfard was a Southern California kid who, like so very many of his peers, loved skateboards and guitars, and when an injury left him unable to walk for six months, he had the crazy, wonderful idea to combine his passions. As he says, skateboarders have thirty, sometimes fifty or more old decks sitting around gathering dust, some scarred with cracks and breaks and blood: Build a guitar out of them, and not only do the colors shine through, but so do the stories. And no two guitars are the same.

Throw It in the Car and Hit the Beach

MODEL: **PALOMINO**
BUILDER: **FENDER, 1970**
TYPE: **FLATTOP ACOUSTIC**

OF NOTE: So very Fenderish: fast-action bolt-on neck with a six-on-a-side Stratocaster headstock • Not visible: Fender acoustics are nicknamed "broomsticks" for their internal aluminum support rod

Known almost exclusively for it solid-body electrics, Fender decided to dabble in acoustics as the guitar boom was taking off. But despite the effort, the esteemed name, the marketing—a robust campaign showing teenagers! in convertibles! with guitars by the beach! surrounded by girls!—something wasn't working. Fender put them into the hands of famous players. They kept adding models—including the Kingman, Malibu, Redondo, Newporter, and this Palomino. Above all, they graced their acoustics with the innovations that made their electrics so successful. But maybe that was the crux of the problem—who wants an acoustic with a bolt-on neck?

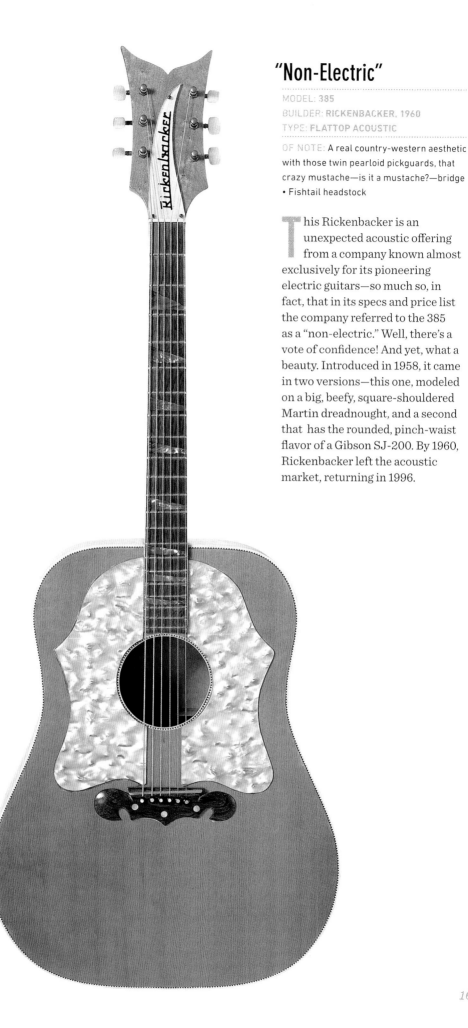

"Non-Electric"

MODEL: **385**
BUILDER: **RICKENBACKER, 1960**
TYPE: **FLATTOP ACOUSTIC**

OF NOTE: A real country-western aesthetic with those twin pearloid pickguards, that crazy mustache—is it a mustache?—bridge
• Fishtail headstock

This Rickenbacker is an unexpected acoustic offering from a company known almost exclusively for its pioneering electric guitars—so much so, in fact, that in its specs and price list the company referred to the 385 as a "non-electric." Well, there's a vote of confidence! And yet, what a beauty. Introduced in 1958, it came in two versions—this one, modeled on a big, beefy, square-shouldered Martin dreadnought, and a second that has the rounded, pinch-waist flavor of a Gibson SJ-200. By 1960, Rickenbacker left the acoustic market, returning in 1996.

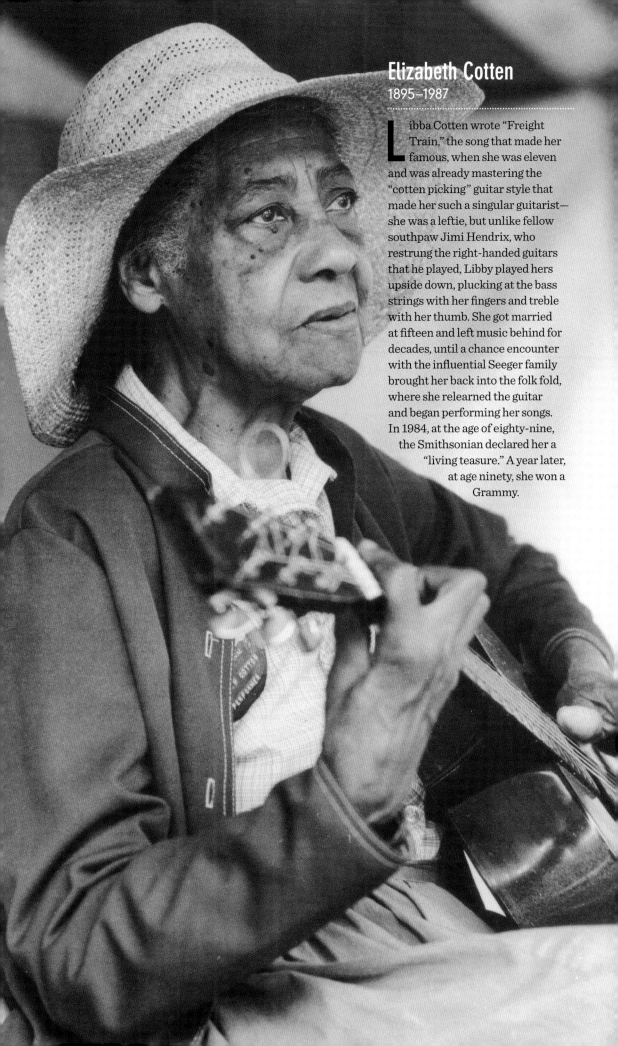

Elizabeth Cotten
1895–1987

L ibba Cotten wrote "Freight Train," the song that made her famous, when she was eleven and was already mastering the "cotten picking" guitar style that made her such a singular guitarist— she was a leftie, but unlike fellow southpaw Jimi Hendrix, who restrung the right-handed guitars that he played, Libby played hers upside down, plucking at the bass strings with her fingers and treble with her thumb. She got married at fifteen and left music behind for decades, until a chance encounter with the influential Seeger family brought her back into the folk fold, where she relearned the guitar and began performing her songs. In 1984, at the age of eighty-nine, the Smithsonian declared her a "living teasure." A year later, at age ninety, she won a Grammy.

Shake It, Sugaree

MODEL: **000-18**

BUILDER: **MARTIN, 1950**

TYPE: **FLATTOP ACOUSTIC**

OF NOTE: Unexpected wear on the bass side of the top—a lefty, Libba played her guitar upside down

I n 1902, Martin introduced the 000, its largest body option yet, a 15-inch orchestra model designed to give the player more volume. Fast-forward almost fifty years, as in this instrument that belonged to Elizabeth Cotten, and the changes are minimal—steel strings now, and a neck that meets the body at the 14th fret, an innovation that arrived with the OM around 1930 (see page 108). As for the "18," it designates choice of tone woods—spruce top, mahogany back and sides—and minimal decoration. (No herringbone here!) By the way, what distinguishes a contemporary 000 from an OM are scale length (the 000 has a shorter scale) and width of the neck, making the 000 brighter and the OM a possibly better choice for fingerpicking.

Gypsy Jazz Redux

MODEL: "EMY"
BUILDER: **SHELLEY D. PARK, 2011**
TYPE: **FLATTOP ACOUSTIC**

OF NOTE: Engelmann spruce top and, not visible, back and sides made out of a stunning piece of quilted mahogany (see page 190) • Oval sound hole (*petite bouche*) on that wide, Selmer-style body

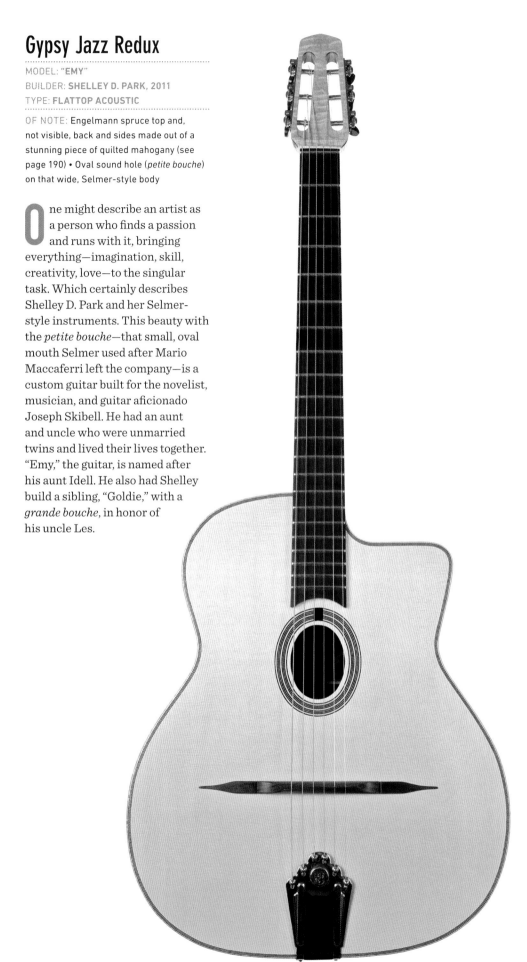

One might describe an artist as a person who finds a passion and runs with it, bringing everything—imagination, skill, creativity, love—to the singular task. Which certainly describes Shelley D. Park and her Selmer-style instruments. This beauty with the *petite bouche*—that small, oval mouth Selmer used after Mario Maccaferri left the company—is a custom guitar built for the novelist, musician, and guitar aficionado Joseph Skibell. He had an aunt and uncle who were unmarried twins and lived their lives together. "Emy," the guitar, is named after his aunt Idell. He also had Shelley build a sibling, "Goldie," with a *grande bouche*, in honor of his uncle Les.

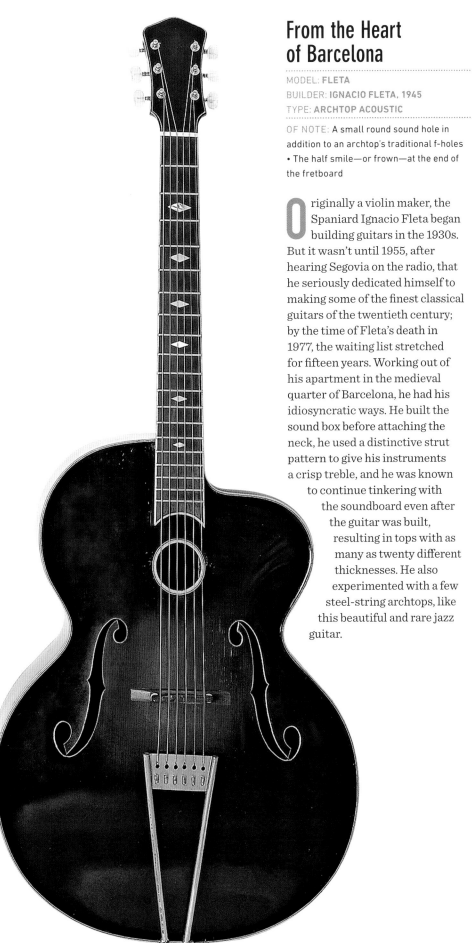

From the Heart of Barcelona

MODEL: **FLETA**
BUILDER: **IGNACIO FLETA, 1945**
TYPE: **ARCHTOP ACOUSTIC**

OF NOTE: A small round sound hole in addition to an archtop's traditional f-holes • The half smile—or frown—at the end of the fretboard

Originally a violin maker, the Spaniard Ignacio Fleta began building guitars in the 1930s. But it wasn't until 1955, after hearing Segovia on the radio, that he seriously dedicated himself to making some of the finest classical guitars of the twentieth century; by the time of Fleta's death in 1977, the waiting list stretched for fifteen years. Working out of his apartment in the medieval quarter of Barcelona, he had his idiosyncratic ways. He built the sound box before attaching the neck, he used a distinctive strut pattern to give his instruments a crisp treble, and he was known to continue tinkering with the soundboard even after the guitar was built, resulting in tops with as many as twenty different thicknesses. He also experimented with a few steel-string archtops, like this beautiful and rare jazz guitar.

Light Metal

MODEL: **ORIGINAL**
BUILDER: **JOHN VELENO, 1972**
TYPE: **SEMI-HOLLOW-BODY ELECTRIC**

OF NOTE: Gold-plated aluminum body • Swooping "V" (for Veleno) headstock set with a "ruby," a nod to the birthstone of John Veleno's wife • Not visible—the lack of a truss rod, as the aluminum neck won't ever warp

Long before there was bling, there was glam, a reaction born in the early 1970s against the earthy, crunchy late '60s. One beneficiary of this shift in taste was Florida engineer and guitar teacher John Veleno, who handcrafted all-aluminum guitars. This may seem like a gimmick, but in fact, Velenos really struck a chord—once John got them in the hands of musicians touring through Florida. The roster of famous players who owned a Veleno includes Marc Bolan, Eric Clapton, Johnny Winter, Ace Frehley, Alvin Lee, Todd Rundgren, Jeff Lynne, Mark Farner of Grand Funk Railroad, Sonny Bono, and Lou Reed. And Gregg Allman, who exclaimed, "Oh my god, a motorcycle in a guitar case!" when John unveiled the model he brought to the show. Pretty good success rate, though Veleno made only between 145 and 185 instruments. By the end of the decade, John Veleno moved on to his next profession—wedding photographer—while his guitars have accrued cult status.

"The Ultimate in Professional Electric Guitars"

MODEL: **BARNEY KESSEL ARTIST**
BUILDER: **KAY, 1957**
TYPE: **ARCHTOP ELECTRIC**

OF NOTE: The "Kelvinator" headstock • Sparkly plastic "Kleenex box" pickup covers • The batwing pickguard with Kessel's name right there in gold • Melita bridge, for individual string adjustment

Kays always had an iffy reputation, particularly in the postwar era, so it meant a lot to have jazz great Barney Kessel endorse a guitar and put his moniker on the pickguard. And, of course, why have one when you could have three—the top-of-the-line Barney Kessel Special, the next-tier-down Artist, and the semi-solid Pro. For whatever reasons, the partnership didn't last, as Kay dropped Kessel by 1960. Perhaps it wasn't Kessel's fault, though— Gibson signed him and produced the Barney Kessel Custom in 1961, a model that lasted for ten years.

"The Greatest Guitar of Our Epoch"

MODEL: **HAUSER**
BUILDER: **HERMANN HAUSER, SR., 1937**
TYPE: **CLASSICAL ACOUSTIC**

OF NOTE: The Hauser triple arch headstock • Utter simplicity and classical proportions • For players who've never picked up a nylon string guitar, details show how the strings are attached

Looking as plain as plain could be, especially to eyes accustomed to the candy store opulence of a Guitar Center, for example, this guitar is the work of one of the first great non-Spanish builders of classical guitars. Germany's Hermann Hauser studied deeply the designs and innovations of Torres (see page 70), but instead of merely copying the Spaniard's work, he brought to it "his Teutonic engineering principles" (to quote the classical guitarist Julian Bream). A great part of his development is due to Andrés Segovia, who brought him his own Ramirez for inspiration. Twelve years later, after sending Segovia a dozen or so guitars that were never quite good enough, Hauser delivered, in 1937, this instrument that virtually never left Segovia's side until it was struck by a microphone in 1960.

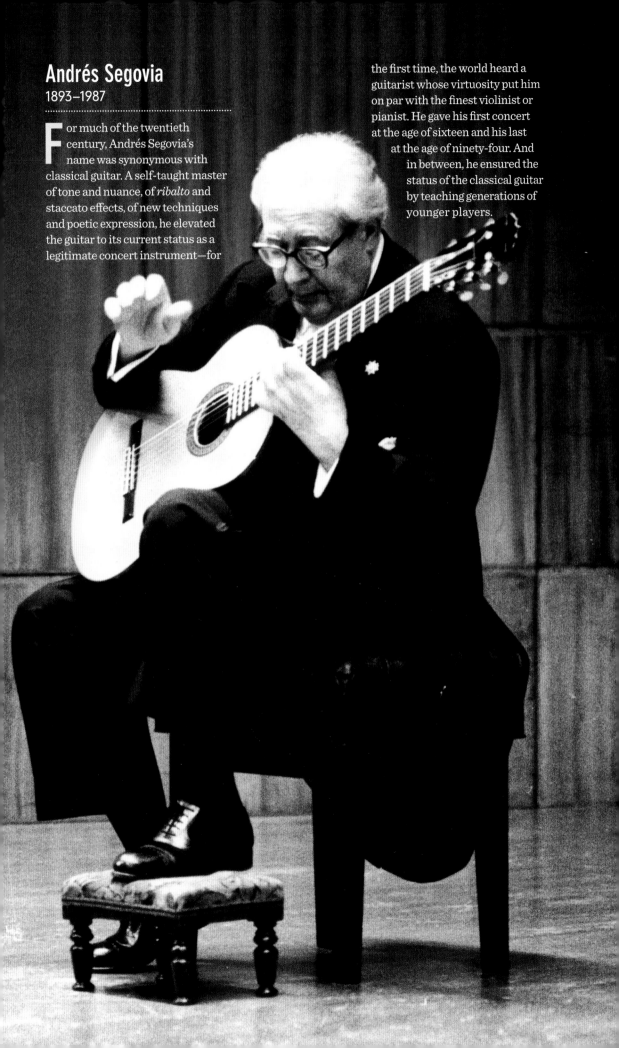

Andrés Segovia

1893–1987

For much of the twentieth century, Andrés Segovia's name was synonymous with classical guitar. A self-taught master of tone and nuance, of *ribalto* and staccato effects, of new techniques and poetic expression, he elevated the guitar to its current status as a legitimate concert instrument—for the first time, the world heard a guitarist whose virtuosity put him on par with the finest violinist or pianist. He gave his first concert at the age of sixteen and his last at the age of ninety-four. And in between, he ensured the status of the classical guitar by teaching generations of younger players.

Breaking the Mold

MODEL: **BF-96**
BUILDER: **STEVE KLEIN, 1998**
TYPE: **SEMI-HOLLOW-BODY ELECTRIC**

OF NOTE: Ergonomic body shape •
A headless neck with tuners at the
bottom, borrowed from Ned Steinberger
(see opposite)

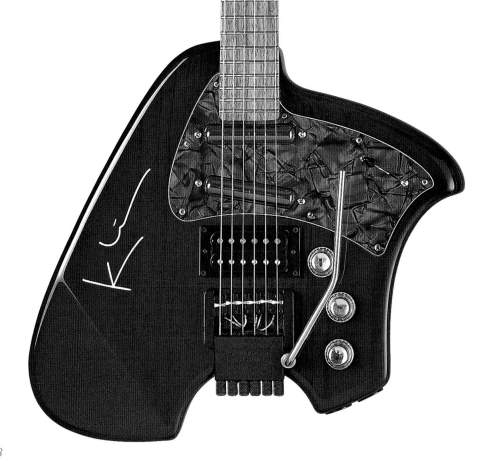

Steve Klein is one of those rare luthiers whose client list is as remarkable as his ideas are revolutionary. The intention behind his love-it-or-hate-it "ergonomic" guitar is to keep the neck at just the right angle so that, when seated, a player can move his or her arm and hand freely, without any undue stretch or strain, up and down the fretboard. Klein, who brought fresh ideas to acoustics as well, has attracted musicians like Joe Walsh, Andy Summers, Will Ackerman, Leo Kottke, David Lindley, Lou Reed, Ronnie Montrose, Steve Miller, and Joni Mitchell.

Headless

MODEL: **STEINBERGER**
BUILDER: **STEINBERGER, 1986**
TYPE: **SOLID-BODY ELECTRIC**

OF NOTE: EMG pickups • Tuners at the end
of the body • TransTrem tremolo system

For all the flash that can be added to it, the solid-body electric is fairly conservative in its essential design principles: wooden body, one or two cutaways, long neck, trademark headstock. And then there are those avant-garde builders like Ned Steinberger, whose purest designs discarded not only the headstock and much of the body, but used a resin and fiber composite instead of wood. These are not solely aesthetic choices: Without a headstock, there's no nut, which improves the sound of open notes and intonation in general. The instrument is also shorter and lighter, shifting the balance of weight to the body and easing strain on the player's strap shoulder. Steinberger also created very precise gearless tuners, developed a "TransTrem" vibrato system that allows you to bend the pitch of entire chords without the strings going out of tune, and outfitted his guitars and basses with EMG pickups, bringing these avant-garde European favorites new popularity in the states.

The Wow Factor

MODEL: **ZEMAITIS METAL FRONT**
BUILDER: **TONY ZEMAITIS, 1970s**
TYPE: **SOLID-BODY ELECTRIC**

OF NOTE: Ornately engraved duralumin metal front over a three-piece mahogany body • Not so visible: the curved top allows stage light to glint off the guitar at any angle

The Lithuanian-born luthier Tony Zemaitis put his incredible-sounding guitars in the hands of some of the most famous British rockers of the 1970s, including Keith Richards, George Harrison, Eric Clapton, Ronnie Wood, Marc Bolan, and David Gilmour. He started with acoustics, building for the likes of British blues and fingerstyle players like Davey Graham, then moved on to electrics, where in the process of shielding the pickups, he had the idea to give his instruments a metal front. Talk about the right move at the right time! In 1971, when the first metal-front guitar appeared in Ronnie Wood's hands (he was still with the Faces), the world of rock was ready for a little glam. Also a brilliant stroke: He hired the gun engraver Danny O'Brien to decorate the instruments. This classic Zemaitis looks like a Les Paul impersonating a cowboy belt buckle.

"Love Box"

MODEL: **"IVAN THE TERRIBLE"**
BUILDER: **TONY ZEMAITIS, 1969**
TYPE: **12-STRING ACOUSTIC**

OF NOTE: Touted as the largest acoustic 12-string in the world, big as a mariachi bass • Fingerboard bound and inlaid with silver • Like one of those visual puzzles: How many hearts can you find?

Eric Clapton met the guitar maker Tony Zemaitis in the late 1960s and asked him to build a 12-string—"bigger than he'd ever done before, and inlaid with silver." The other brief: Make it "incredibly ornate." Clapton used "Ivan the Terrible" on the *Blind Faith* album, and he also loaned it to George Harrison, where it was heard on "My Sweet Lord." Bob Dylan supposedly called it the "Love Box" because of all the hearts. Anyway, in a moment of passion, Clapton smashed the original to bits, then brought the neck back to Zemaitis, who meticulously reconstructed it. At the 2004 Crossroads Guitar Auction, "Ivan" fetched $253,900.

Labor of Love

MODEL: **TGE**
BUILDER: **TURNSTONE, C. 2018**
TYPE: **FLATTOP ACOUSTIC**

OF NOTE: The "E" indicates that every bit of wood in this guitar comes from England, including the back and sides, made from rare, five-thousand-year-old Fenland bog oak—timbers that have been submerged in the peat bogs of East Anglia and preserved for millennia—and rippled ash on the neck

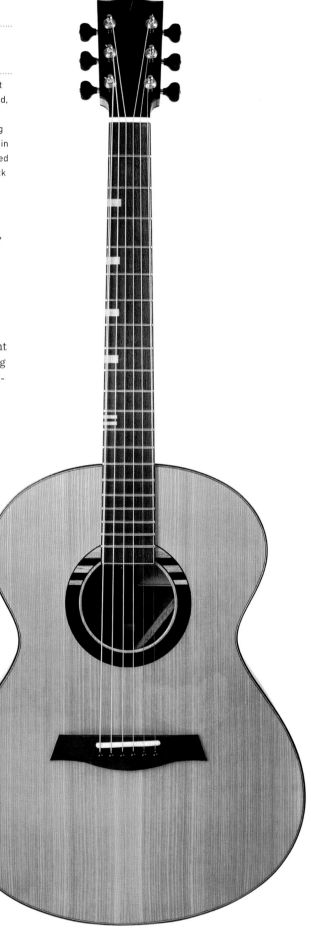

Named after a little shorebird that shows an unexpected flash of beauty when in flight, Turnstone is an English company founded and run by a skillful luthier named Rosie Heydenrych, who underpins her passion for building beautiful instruments with grit and determination that fuel the countless hours she's spent learning her craft and now running her shop. Her specialty is the steel-string acoustic built from English woods like yew, English walnut, London plane, rippled chestnut, and the rare and richly colored five-thousand-year-old English bog oak, with a weight and density comparable to tropical hardwood and the sustain to match.

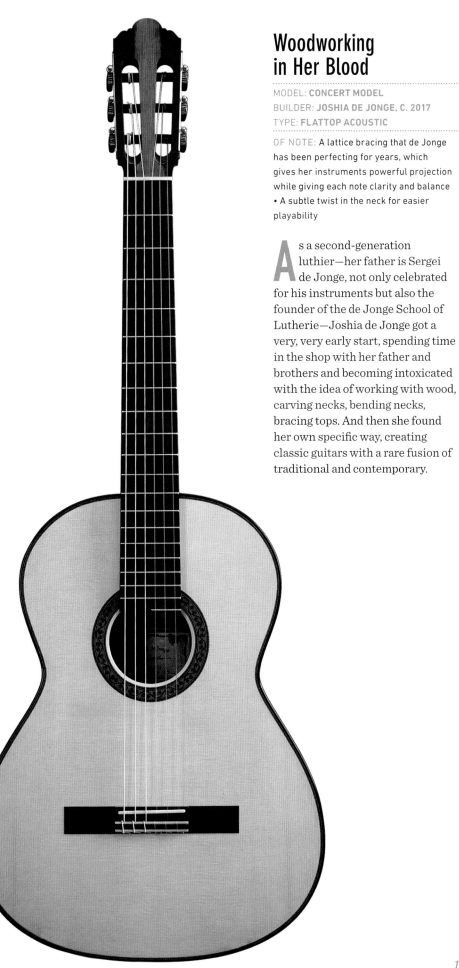

Woodworking in Her Blood

MODEL: **CONCERT MODEL**
BUILDER: **JOSHIA DE JONGE, C. 2017**
TYPE: **FLATTOP ACOUSTIC**

OF NOTE: A lattice bracing that de Jonge has been perfecting for years, which gives her instruments powerful projection while giving each note clarity and balance • A subtle twist in the neck for easier playability

As a second-generation luthier—her father is Sergei de Jonge, not only celebrated for his instruments but also the founder of the de Jonge School of Lutherie—Joshia de Jonge got a very, very early start, spending time in the shop with her father and brothers and becoming intoxicated with the idea of working with wood, carving necks, bending necks, bracing tops. And then she found her own specific way, creating classic guitars with a rare fusion of traditional and contemporary.

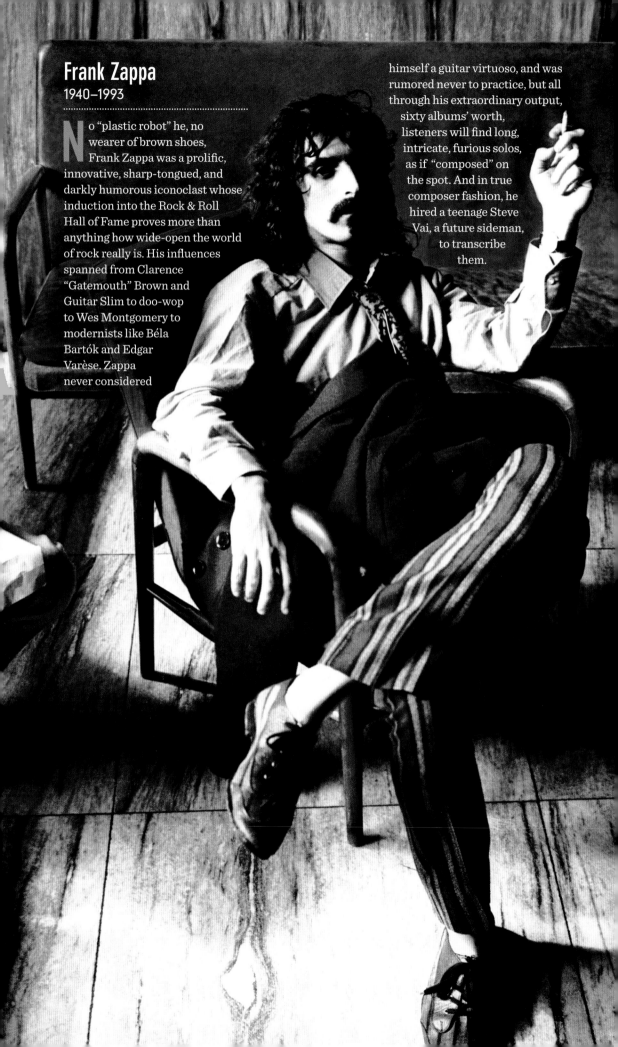

Frank Zappa
1940–1993

No "plastic robot" he, no wearer of brown shoes, Frank Zappa was a prolific, innovative, sharp-tongued, and darkly humorous iconoclast whose induction into the Rock & Roll Hall of Fame proves more than anything how wide-open the world of rock really is. His influences spanned from Clarence "Gatemouth" Brown and Guitar Slim to doo-wop to Wes Montgomery to modernists like Béla Bartók and Edgar Varèse. Zappa never considered himself a guitar virtuoso, and was rumored never to practice, but all through his extraordinary output, sixty albums' worth, listeners will find long, intricate, furious solos, as if "composed" on the spot. And in true composer fashion, he hired a teenage Steve Vai, a future sideman, to transcribe them.

Rock Solid

MODEL: **SG**
BUILDER: **GIBSON, 1961**
TYPE: **SOLID-BODY ELECTRIC**

OF NOTE: Les Paul's name on the headstock, which would be removed by 1963 because of issues with Paul's divorce from Mary Ford • Neck joins the body at the 22nd fret for maximum access to the highest notes • Deluxe sideways Vibrola tremolo—dicey at best

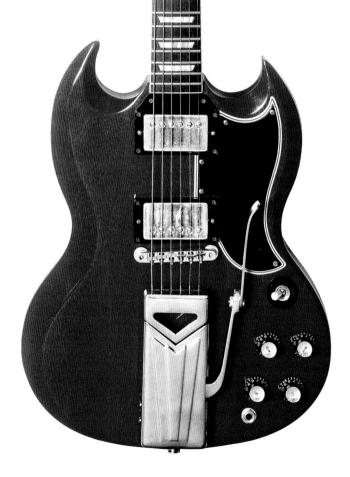

Think about this if you're ever daydreaming about traveling back in time to buy a fresh Les Paul "burst" in the late 1950s, paying comparatively nothing for what is today a six-figure collector's item: Sales of Les Pauls were so dismal by the end of the '50s that Gibson phased out the model, replacing it in 1961 with the SG. Though the SG—an acronym for the somewhat lazy name, "Solid Guitar"—originally bore a Les Paul signature on the headstock, the guitar, with its thinner single-slab mahogany body, has a very different feel. SGs lack the sustain and darker voice of the heavier Les Paul, but offer plenty of appeal with a tone that has more of a midrange bite and a fast, playable neck. Gibson claims it's their overall bestselling solid-body electric. It's earned the love of some serious players too, including Tony Iommi, Angus Young, Frank Zappa, and Eric Clapton of Cream's *Disraeli Gears* years.

Shrewd Move

MODEL: **RECORDING D**
BUILDER: **EPIPHONE, C. 1928**
TYPE: **ARCHTOP ACOUSTIC**

OF NOTE: Steep, pointed cutaway, as if the treble bout were surgically removed—an extremely rare design except for Epiphone Recording models • Engraved celluloid headstock with banjo tuners

Epiphone rode the jazz-age wave of banjo playing, then in the late '20s introduced the Recording line of guitars, their first concerted effort to move into the guitar market—which was perfect timing, given that the 1929 crash effectively ended the "Roaring Twenties" and with it the reign of the tenor banjo. Epiphone introduced five Recording models in 1928, each of which stood out immediately because of its distinctive and unusual sloping cutaway design. They weren't particularly successful—Epiphone discontinued the line a few years later, in 1931—but did establish the company as a significant guitar brand, particularly as it evolved into a maker of serious jazz guitars.

"Exotic Genius"

MODEL: **CRAVIOLA CRA6S**
BUILDER: **GIANNINI, 1970**
TYPE: **FLATTOP ACOUSTIC**

OF NOTE: Asymmetrical body shape with sloping cutaway that allows easy access to the upper frets • Reverse Gumby-like headstock • Semicircular sound hole

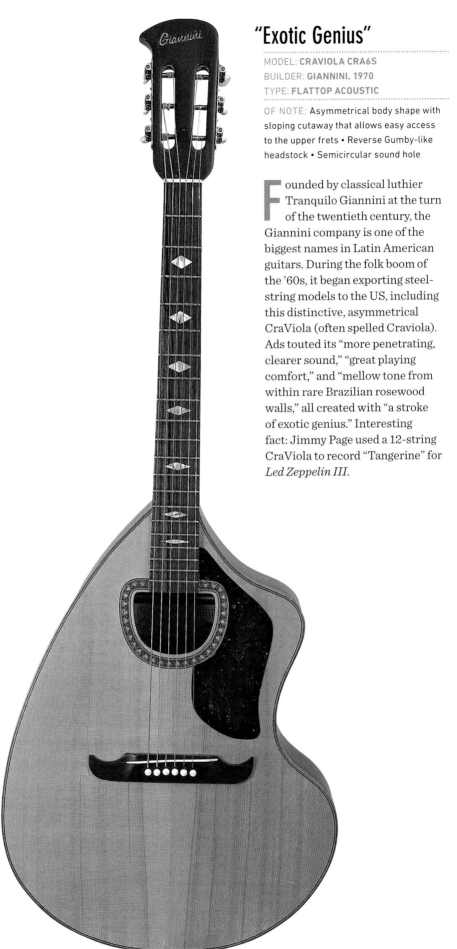

Founded by classical luthier Tranquilo Giannini at the turn of the twentieth century, the Giannini company is one of the biggest names in Latin American guitars. During the folk boom of the '60s, it began exporting steel-string models to the US, including this distinctive, asymmetrical CraViola (often spelled Craviola). Ads touted its "more penetrating, clearer sound," "great playing comfort," and "mellow tone from within rare Brazilian rosewood walls," all created with "a stroke of exotic genius." Interesting fact: Jimmy Page used a 12-string CraViola to record "Tangerine" for *Led Zeppelin III*.

The Guitar That Never Was

MODEL: **MODERNE**
BUILDER: **GIBSON, 1982**
TYPE: **SOLID-BODY ELECTRIC**

OF NOTE: The shark-fin shape, with an extended bass bout and shallow treble bout • Gumby-like headstock

I n 1957, Fender announced the future's arrival with its release of the Stratocaster, which really caught Gibson's attention. Gibson president Ted McCarty directed his designers to think outside the traditional curved lines of guitar-body styling and explore an edgy, straight-line aesthetic. The result, a trio of "Modernistic" guitars—the Flying V (see page 203), the Explorer, opposite, and the Moderne. Except that the Moderne never made it into production—reception to the V and Explorer was so dismal that Gibson shelved it. Rumors did swirl that a few were made in the late '50s . . . and, spookily, that prototypes and raw guitar bodies were burned in a bonfire outside the Kalamazoo factory. Whatever the truth then, the truth now is that Gibson finally put a few into production in the early 1980s, like this one, and again today.

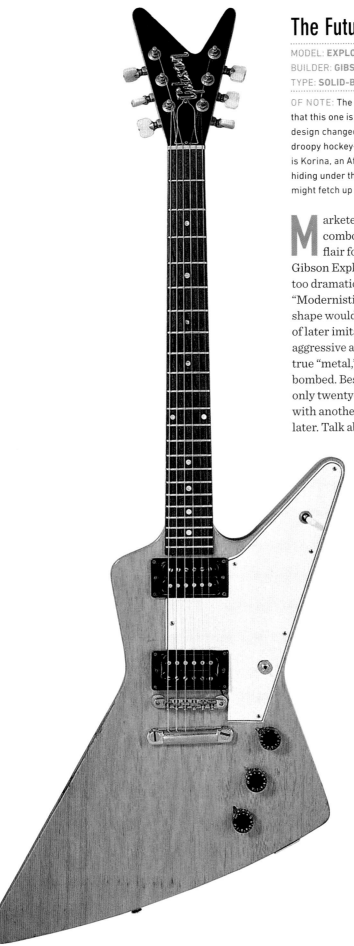

The Future Is Calling

MODEL: **EXPLORER**
BUILDER: **GIBSON, 1958**
TYPE: **SOLID-BODY ELECTRIC**

OF NOTE: The split headstock denotes
that this one is the rarest of the rare—the
design changed quickly to a six-on-a-side
droopy hockey-stick headstock • The body
is Korina, an African tone wood • Have one
hiding under the bed? In mint condition, it
might fetch up to a million dollars

Marketed as "an asset to the
combo musician with a
flair for showmanship," the
Gibson Explorer was perhaps
too dramatically avant-garde and
"Modernistic." Though the body
shape would inspire a number
of later imitators who saw in its
aggressive angles the feeling of
true "metal," the original Explorer
bombed. Best estimates believe that
only twenty-two were produced,
with another sixteen assembled
later. Talk about a collector's item!

BEYOND A BRAZILIAN

T raditionally, when making a guitar, serious builders had three basic choices for the back and sides: Brazilian rosewood, mahogany, or maple, depending on whether it was a flattop or an archtop. But then Brazilian rosewood became scarce to the point that the harvesting of new trees was outlawed (stockpiled wood is available), so luthiers began branching out, no

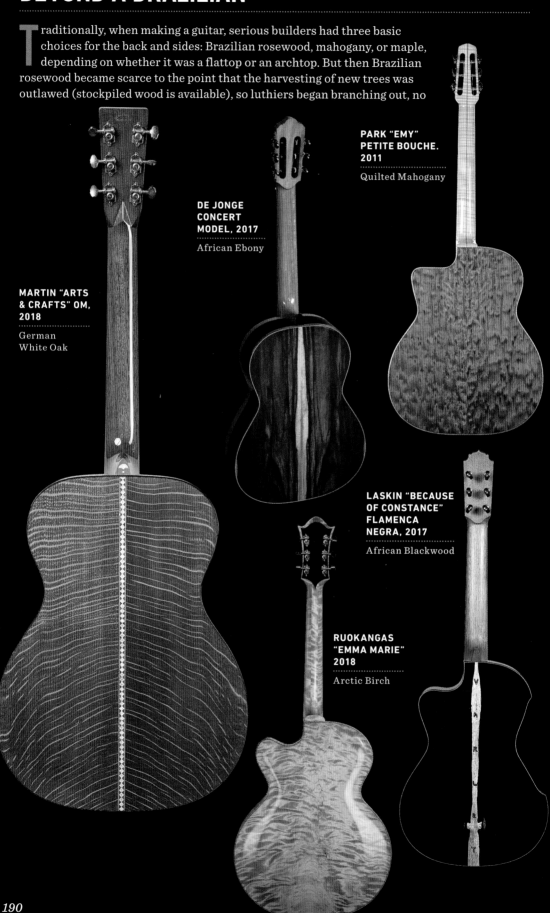

PARK "EMY" PETITE BOUCHE, 2011

Quilted Mahogany

DE JONGE CONCERT MODEL, 2017

African Ebony

MARTIN "ARTS & CRAFTS" OM, 2018

German White Oak

LASKIN "BECAUSE OF CONSTANCE" FLAMENCA NEGRA, 2017

African Blackwood

RUOKANGAS "EMMA MARIE" 2018

Arctic Birch

pun intended, experimenting with many other options, not only for ecological reasons but to explore a different palatte of sounds. Below are a dozen woods, including, on the far right, a guitar built from "The Tree"—a legendary mahogany tree found in Honduras, wider than a bus, first logged in 1965 and yielding a tone wood of spectacular beauty and uncommon clarity.

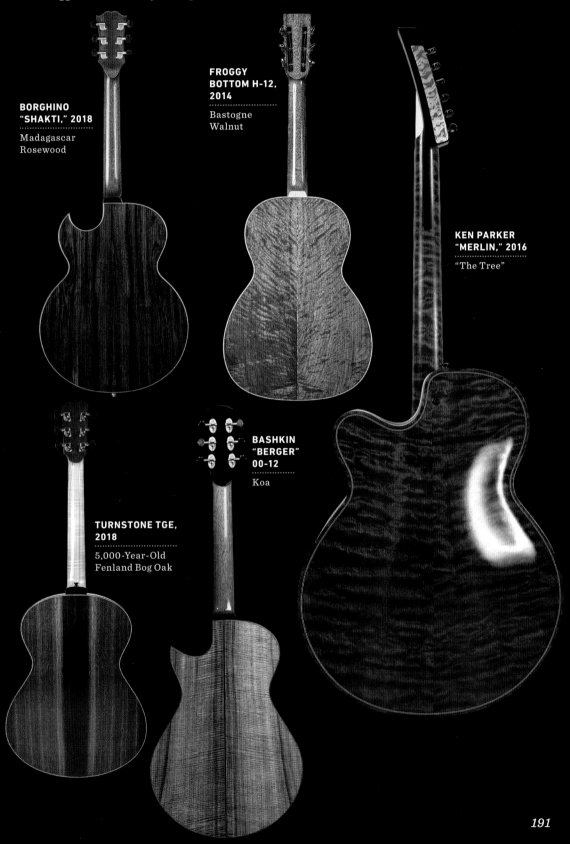

BORGHINO "SHAKTI," 2018

Madagascar Rosewood

FROGGY BOTTOM H-12, 2014

Bastogne Walnut

KEN PARKER "MERLIN," 2016

"The Tree"

TURNSTONE TGE, 2018

5,000-Year-Old Fenland Bog Oak

BASHKIN "BERGER" 00-12

Koa

Boston's Finest

MODEL: **DELUXE CUTAWAY**
BUILDER: **STROMBERG, 1951**
TYPE: **ARCHTOP ACOUSTIC**

OF NOTE: Only 640 or so Strombergs were made—among the rarest is this Deluxe Cutaway in a natural finish • Massive 19-inch width, braced by a single diagonal running under the top • George Gruhn called them "the loudest guitars in creation"

Set up in the early 1900s by Charles A. Stromberg, a Swedish cabinetmaker, to produce banjos and drums, Stromberg the company began in the 1930s, under the direction of Charles's son Elmer, to develop what would in a decade become a premium line of American jazz guitars, building archtops on par with the best Gibsons and D'Angelicos. The main difference between Strombergs and those other two builders is power—big bodies and big presence for big band guitarists like Freddie Green from the Count Basie Orchestra, who loved playing his Stromberg because it could be heard cutting through the brass.

We're Bigger Than You Are

MODEL: **EMPEROR**
BUILDER: **EPIPHONE, 1949**
TYPE: **ARCHTOP ACOUSTIC**

OF NOTE: Epiphone's iconic "Tree of Life" headstock • Patented "Frequensator" tailpiece, designed to allow the bass strings to be longer and have more harmonics, and for the shortened treble strings to be taut and punchy

Gibson can rest fairly easy today on its reputation and history as the finest maker of factory archtops, but in the 1930s, the New York–based Epiphone was a strong rival. Thus, when Gibson fired a big shot with its 18-inch-wide Super 400 in 1934 (page 104), Epiphone needed to act immediately. Shortly thereafter, in a case of incremental one-upmanship, Epiphone unveiled the 18½-inch Emperor. Curiously, the name came out of 1936's biggest news story: The Prince of Wales renounced the throne to marry an American commoner, and Epiphone spun it as the Emperor and the Maid, introducing the guitar in a photograph showing it posed with a naked woman (strategically covered by the guitar, of course!).

Wake Up, Little Gibson

MODEL: **EVERLY BROTHERS**
BUILDER: **GIBSON, 1968**
TYPE: **FLATTOP ACOUSTIC**

OF NOTE: Those pickguards, so reminiscent of Mary Tyler Moore's signature '60s hairdo • The star-shaped fret markers • Oversize adjustable bridge designed by Don and Phil's father, country singer Ike Everly

The Everly Brothers' close harmony work made them a pop sensation in the late 1950s and early 1960s, becoming such big stars that Gibson sought them out for an endorsement model based on the J-200, the Everlys' guitar of choice. Believe it or not, the flashy, symmetrical pickguards on this 1968 issue are restrained compared to the sound-deadening amount of tortoise-grain pickguard used on the inaugural models released in 1962. Quirky as it is, the Everly Brothers guitar was used by dozens of artists not named Everly, including Paul McCartney, Bob Dylan, Elvis Presley, Cat Stevens, George Harrison, Keith Richards, Jimmy Page, and even Madonna.

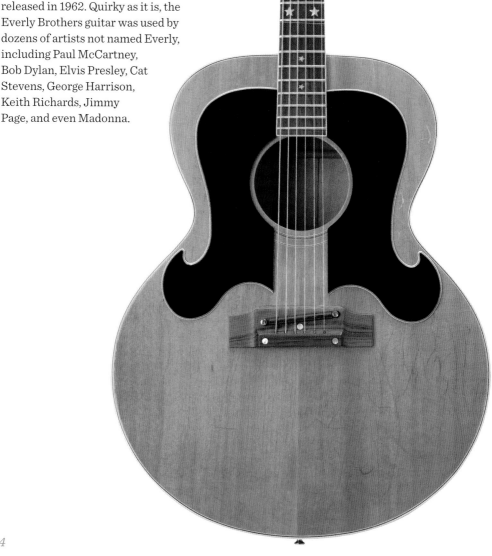

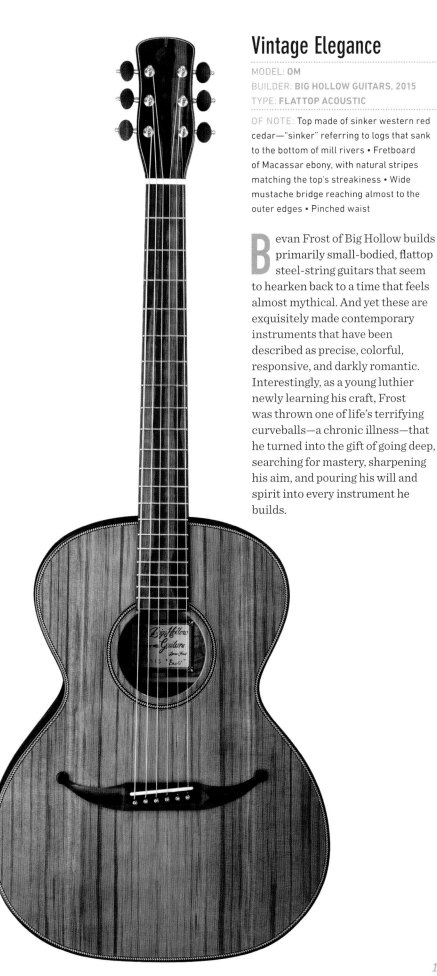

Vintage Elegance

MODEL: **OM**
BUILDER: **BIG HOLLOW GUITARS, 2015**
TYPE: **FLATTOP ACOUSTIC**

OF NOTE: Top made of sinker western red cedar—"sinker" referring to logs that sank to the bottom of mill rivers • Fretboard of Macassar ebony, with natural stripes matching the top's streakiness • Wide mustache bridge reaching almost to the outer edges • Pinched waist

Bevan Frost of Big Hollow builds primarily small-bodied, flattop steel-string guitars that seem to hearken back to a time that feels almost mythical. And yet these are exquisitely made contemporary instruments that have been described as precise, colorful, responsive, and darkly romantic. Interestingly, as a young luthier newly learning his craft, Frost was thrown one of life's terrifying curveballs—a chronic illness—that he turned into the gift of going deep, searching for mastery, sharpening his aim, and pouring his will and spirit into every instrument he builds.

Bonnie Raitt
1949–

B.B. King once called Bonnie Raitt "the best damned slide player working today." She got her first guitar at the age of eight, a Stella, but it wasn't until the 1960s, when she was a student at Radcliffe haunting the folk and blues cafes around Cambridge, that she really emerged as a musician—both fully formed and an anomaly, a white girl learning from and playing with the likes of Son House and Mississippi Fred McDowell. It took her lots of albums and lots of hard living before finally breaking out with the album *Nick of Time*. But always there, before the Grammys and after, is the sound of her glass slide on a Strat in an open key sounding like every fleeting human emotion—the joy, the sadness, the melancholy, the yearning.

Blues Machine

MODEL: **FENDER STRATOCASTER "LENNY"**
BUILDER: **FENDER, YEAR 1965**
TYPE: **SOLID-BODY ELECTRIC**

OF NOTE: Bought from a pawn shop for $350 as a gift to Stevie Ray Vaughan by his wife, Lenora (it later sold at Clapton's Crossroads Guitar Auction for $623,500) • As a thank-you, Vaughan wrote the song "Lenny" with it • Originally it had a rosewood fretboard, but Vaughan replaced it with maple Charvel neck, a gift from ZZ Top guitarist Billy F. Gibbons

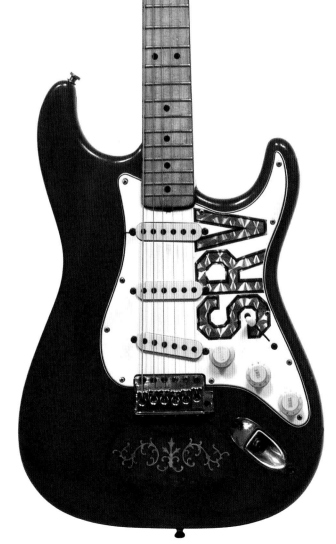

Though it was revolutionary in all ways, the Strat truly excelled for playing the blues. It's Bonnie Raitt's guitar of choice—she bought her favorite, "Brown," in 1969 for $120. It was certainly Stevie Ray Vaughan's—this model shown joined the famous "Number One" as part of SRV's arsenal. Other players include Jimi Hendrix, Buddy Guy, Guitar Slim, Rory Gallagher, Clapton of course, Jeff Beck, Robert Cray, John Frusciante, John Mayer, Ike Turner, Otis Rush, and on and on. A big reason is the Strat's multitude of tones—you not only have an easy vibrato, but with three single-coil pickups and five different configurations, the sound can range from clean and wailing bright to warm and almost thick, all controlled by tone and volume pots and an angled pickup selector within easy reach of a player's fingertips.

The Most Important
Electric Guitar
Ever Made

MODEL: **BROADCASTER**
BUILDER: **FENDER, 1950**
TYPE: **SOLID-BODY ELECTRIC**

OF NOTE: Ash body, rock maple neck, adjustable truss rod, all for $170 • Single-coil pickups that introduced the world to the bright, clean Fender sound developed out of Leo Fender's love of the lap steel guitar • Some guitars from this period have only Fender on the headstock and are known as "Nocasters"

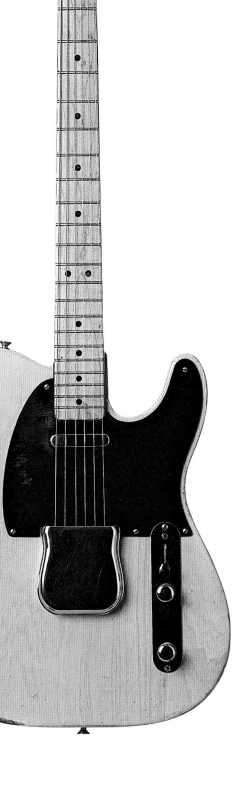

Like a Henry Ford of lutherie, Leo Fender changed everything by applying mass-production techniques to the manufacture of guitars—and creating a function-follows-form masterpiece that made the solid-body electric guitar a reality. And in the case of the Broadcaster—the name was changed to Telecaster in the late '50s to avoid a possible trademark conflict with Gretsch—it's a masterpiece that continues to shine more than half a century later. It's stripped down, unpretentious, virtually indestructible, easy to play, and it serves up that legendary twang.

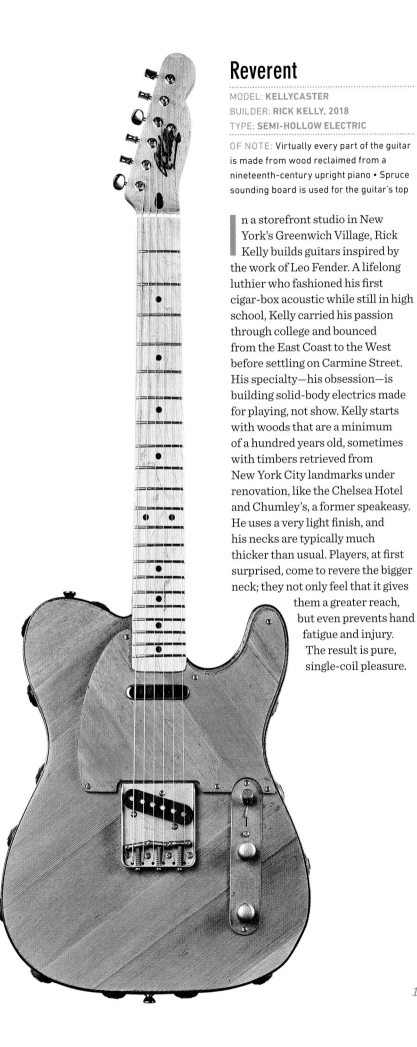

Reverent

MODEL: **KELLYCASTER**
BUILDER: **RICK KELLY, 2018**
TYPE: **SEMI-HOLLOW ELECTRIC**

OF NOTE: Virtually every part of the guitar is made from wood reclaimed from a nineteenth-century upright piano • Spruce sounding board is used for the guitar's top

In a storefront studio in New York's Greenwich Village, Rick Kelly builds guitars inspired by the work of Leo Fender. A lifelong luthier who fashioned his first cigar-box acoustic while still in high school, Kelly carried his passion through college and bounced from the East Coast to the West before settling on Carmine Street. His specialty—his obsession—is building solid-body electrics made for playing, not show. Kelly starts with woods that are a minimum of a hundred years old, sometimes with timbers retrieved from New York City landmarks under renovation, like the Chelsea Hotel and Chumley's, a former speakeasy. He uses a very light finish, and his necks are typically much thicker than usual. Players, at first surprised, come to revere the bigger neck; they not only feel that it gives them a greater reach, but even prevents hand fatigue and injury. The result is pure, single-coil pleasure.

Pinch Yourself

MODEL: **CREATIVE SPIRIT EAGLE**
BUILDER: **TOM RIBBECKE, 2012**
TYPE: **FLATTOP/ARCHTOP ACOUSTIC**

OF NOTE: Employs Ribbecke's Halfling™ top—bass side is flat for more response and sustain on the low end, treble side is arched for the kind of punch, precision, and clarity of a jazz guitar's sound • 17" single-piece carved back from the legendary "The Tree" tone wood (see pages 89 and 191) • By locating the louvered sound hole closer to the player, the Halfling creates an unusual connection between musician and instrument

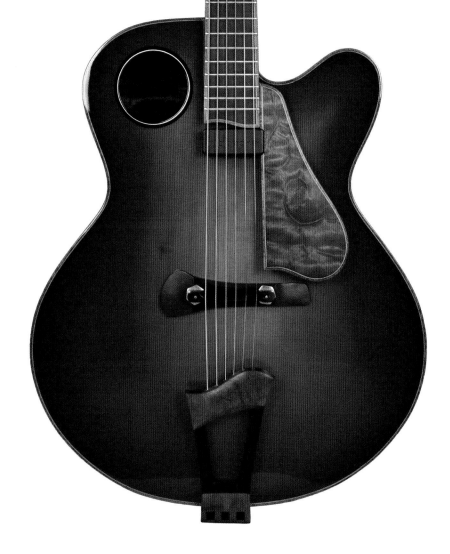

Players who get their hands on a Ribbecke guitar with its patented Halfling carve think they're dreaming. Created by Tom Ribbecke and bassist (and friend) Bobby Vega, the Halfling employs a unique design that combines the best of both worlds—a bass-y, Martin-style flattop on the bass side with the punch of an archtop on the treble side. The result is a sound that is astonishingly even and balanced across the spectrum, allowing all the notes of even the most complex chord to ring out clearly. This particular model was commissioned as part of a set—the Legacy Trio—by a veteran who is a private collector. On the back of the headstock is a twenty-five-cent piece from 1806 that belonged to Dr. Benjamin Rush, an original signer of the Declaration of Independence and medical supervisor to the Lewis & Clark expedition.

"Wouldn't You Rather Buy a Guitar from a Perfectionist?"

MODEL: **PICASSO**
BUILDER: **MCPHERSON, 2012**
TYPE: **FLATTOP ACOUSTIC**

OF NOTE: Offset half-moon sound hole designed to give the top as much uninterrupted vibration as possible • "Cubist"-style wood inlay fret markers and headstock • Ingenious, under-over bracing system in which no individual brace ever touches another • Every bead of glue is sanded smooth—talk about perfectionist

Matt McPherson has two passions—archery and guitars—and he's made his mark in both worlds. Additionally, while both passions have sprung out of his love of wood, he's done groundbreaking work in the use of graphite, offering a full line of carbon guitars (and, wearing his other hat, carbon-fiber bows). None of this would matter much if the guitars didn't deliver. But they do. People call the sound "divine."

Jimi Hendrix
1942–1970

It is hard to remember that the guitar god of all guitar gods enjoyed a paltry four years of fame before dying at the age of twenty-seven. And it only adds to the sense of otherworldliness of his life. He chased sounds that no one heard, tied his sonic, soaring flights to the earthiness of blues and rock and roll. But to get there he had to travel a well-worn slog on the chitlin' circuit, playing with the likes of Little Richard, The Isley Brothers, and Ike and Tina Turner until 1965 when he was in New York with his own band, Jimmy James and the Flames, impressing Animals bassist Chas Chandler, who "discovered" him at the Café Wha? and persuaded him to come to England where he formed The Experience. By 1967 he was the top act at Woodstock (earning $18,000), performing an unforgettable version of "The Star-Spangled Banner." A few short years later he was gone, but he left behind hundreds of hours of music recorded at his own studio, Electric Ladyland.

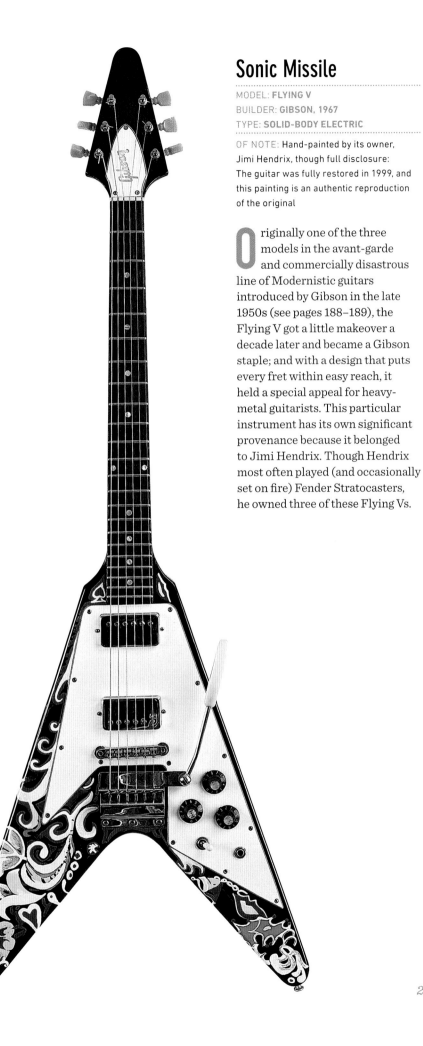

Sonic Missile

MODEL: **FLYING V**
BUILDER: **GIBSON, 1967**
TYPE: **SOLID-BODY ELECTRIC**

OF NOTE: Hand-painted by its owner,
Jimi Hendrix, though full disclosure:
The guitar was fully restored in 1999, and
this painting is an authentic reproduction
of the original

Originally one of the three models in the avant-garde and commercially disastrous line of Modernistic guitars introduced by Gibson in the late 1950s (see pages 188–189), the Flying V got a little makeover a decade later and became a Gibson staple; and with a design that puts every fret within easy reach, it held a special appeal for heavy-metal guitarists. This particular instrument has its own significant provenance because it belonged to Jimi Hendrix. Though Hendrix most often played (and occasionally set on fire) Fender Stratocasters, he owned three of these Flying Vs.

Giddyup

MODEL: **GENE AUTRY ROUND-UP**
BUILDER: **HARMONY, 1938**
TYPE: **FLATTOP ACOUSTIC**

OF NOTE: A surprisingly decent little guitar, with a solid spruce top and solid mahogany back and sides • Stenciled scene captures the dynamism of a round-up against a Western mountain background

O n radios all across the country, Americans were listening to WLS and an up-and-coming cowboy crooner named Gene Autry. This led to an interesting marketing opportunity. WLS was owned by Sears, Roebuck & Company (the call letters stood for "World's Largest Store"), and the catalog retailer also sold its own guitars— so, in 1932, Sears began selling the Round-up for $9.75, featuring a cowboy swinging a lariat and Gene Autry's signature under the stenciled scene. Soon these cowboy crooners were on par with the Hawaiian guitarists, and cowboy guitars proliferated in just the same way, featuring Autry, the Lone Ranger, Roy Rogers, and others.

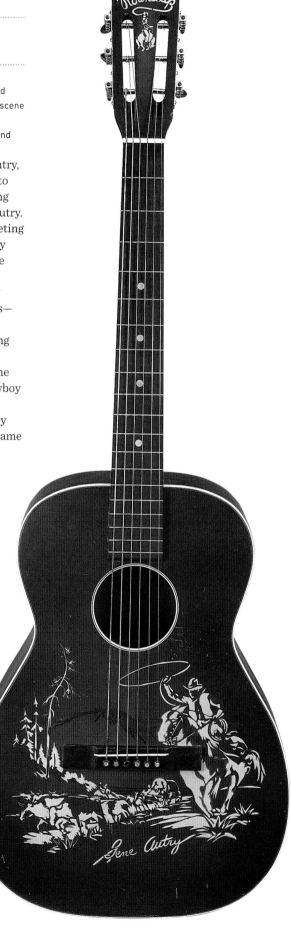

Aloha 'Oe

MODEL: **HAWAIIAN "SUNSET"**
BUILDER: **UNKNOWN, 1930s**
TYPE: **FLATTOP ACOUSTIC**

OF NOTE: A full-on stencil of a gorgeous sunset over a tropical lagoon, complete with swaying palm trees • Raised nut, indicating that this one was set up for slide playing

t's a common theme in early guitar history that by the 1920s, Hawaiian guitarists like Sol Hoopii were dazzling mainland audiences with their slack-key playing. And so a trend was born and marketed both high—see, for example, the Gibson Hawaiian on page 159—and low. Novelty guitars of the '30s were decorated with romantic scenes of tropical life, offering a lovely escape from the daily grind during the Great Depression. These instruments, though cheap and sold through department stores, were made of real wood. Later on, they devolved into little more than children's toys made out of pressed cardboard or plastic.

East Meets West

MODEL: **SHAKTI**
BUILDER: **BORGHINO, C. 2018**
TYPE: **FLATTOP ACOUSTIC**

OF NOTE: Seven sympathetic strings running diagonally across the sound hole to create shimmering overtones • Bearclaw spruce top, Madagascar back and sides, abalone trim, Florentine cutaway • Just visible: scalloped frets—fingers can really fly across the guitar without the friction of a fretboard to slow them down, and it's easy to get the fast, extreme bends of a sitar

The guitarist John McLaughlin is acclaimed for pushing boundaries. The Italian luthier Mirko Borghino aims to do the same. Their worlds came together, as Borghino created this flattop with a few sitar-like elements for McLaughlin after he was inspired by Shakti, McLaughlin's Indian fusion band from the 1970s.

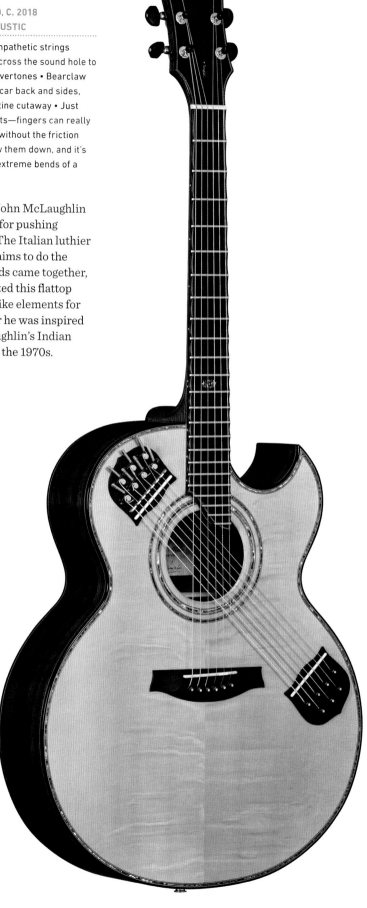

Metamorphosis

MODEL: **CHRYSALIS**
BUILDER: **TIM WHITE, 1999**
TYPE: **ACOUSTIC-ELECTRIC**

OF NOTE: Modular body with all structural parts made of epoxy-graphite composite • The lacy-looking top is modeled on a dragonfly's wing with its strong structural properties • Piezo pickup under the bridge

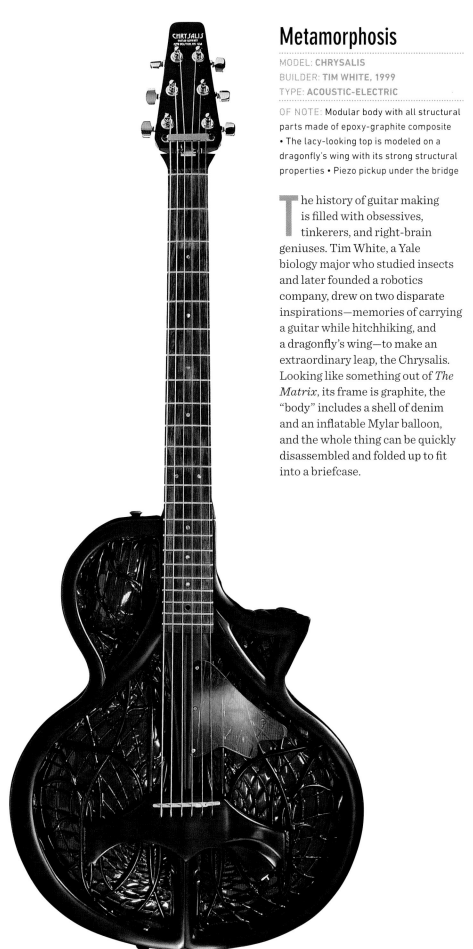

The history of guitar making is filled with obsessives, tinkerers, and right-brain geniuses. Tim White, a Yale biology major who studied insects and later founded a robotics company, drew on two disparate inspirations—memories of carrying a guitar while hitchhiking, and a dragonfly's wing—to make an extraordinary leap, the Chrysalis. Looking like something out of *The Matrix*, its frame is graphite, the "body" includes a shell of denim and an inflatable Mylar balloon, and the whole thing can be quickly disassembled and folded up to fit into a briefcase.

INDEX

FOR MY GUITAR GURUS BILL, JOHN, LARRY, AND BILL, AND THE ETERNALLY PERFECT BAND THE SEVEN STUDS

THANKS

The guitar world is an unusually generous one. Everyone we reached out to, without exception, made the time to share their work. Thank you especially to Michael Bashkin, Mirko Borghino, Tony Duggan-Smith, Gordon French, Rudy Pensa and everyone at Rudy's Music, Bevan Frost, Avi Goldfinger, Michael Greenfield, Rosie Heydenrych, Richard Hoover and the folks at Santa Cruz, Joshia de Jonge, Rick Kelly and Carmine Street Guitars, Murray Kuun, Mark Lacey, William "Grit" Laskin, Benoit Lavoie, Linda Manzer, Michael Millard, Shelley D. Park, Ken Parker, Claudio and Claudia Pagelli, Nick Pourfard, Tom Ribbecke and Ray Boyda, Juha Ruokangas, Erich Solomon, and Ulrich Teuffel. And, retroactively, to all the luthiers, builders, mavens, and photographers who contributed to the earlier book, *Guitars*, and whose work helped shape this one. Plus thank you to the novelist and author Joseph Skibell, who not only shared "Emy" from his personal collection but acted as a bit of a Virgil to the world of contemporary luthiers.

A special thank-you to Lia Ronnen for her endless support, inspiration, and keen eye.

And finally, serious thank-yous too to all the people at Workman who helped make this book real, including Lisa Hollander, Barbara Peragine, Kenneth Yu, James Williamson, Bruce Tracy, Beth Levy, Doug Wolff, John Passineau, and Suzie Bolotin.

DAVID SCHILLER is an author of eclectic interests whose books include *The Little Zen Companion, The Little Book of Prayers, See Your Way to Mindfulness,* and *Guitars.*